NEW DEAL PHOTOGRAPHS OF WEST VIRGINIA

1934–1943

EDITED BY BETTY RIVARD

FOREWORD BY CARL FLEISCHHAUER

INTRODUCTION BY JERRY BRUCE THOMAS

WEST VIRGINIA UNIVERSITY PRESS · MORGANTOWN 2012

Copyright 2012 by West Virginia University Press

All rights reserved

First edition published 2012 by West Virginia University Press

Printed in the United States of America

21 20 19 18 17 16 15 14 13 9 8 7 6 5 4 3 2

Cloth: 978-1-933202-88-4

Library of Congress Cataloging-in-Publication Data

New Deal photographs of West Virginia, 1934–1943 / edited by Betty Rivard; foreword by Carl Fleischhauer; introduction by Jerry Bruce Thomas. — 1st ed.

 p. cm.

Includes bibliographical references.

ISBN-13: 978-1-933202-88-4 (cloth : alk. paper)

ISBN-10: 1-933202-88-2 (cloth : alk. paper)

1. West Virginia—Social life and customs—20th century—Pictorial works. 2. West Virginia—Social conditions—20th century—Pictorial works. 3. New Deal, 1933–1939—West Virginia—Pictorial works. 4. World War, 1939–1945—West Virginia—Pictorial works. 5. Documentary photography—West Virginia. I. Rivard, Betty.

F242.N49 2012

975.4'042—dc23

2012010847

Front cover image: Coal miner's child taking home kerosene for lamps. Company houses, coal tipple in background. Pursglove, Scotts Run, West Virginia. Marion Post Wolcott. September 1938. LC-USF33-030180-M2.

Back cover image: Washing a prize bull at the dairy barn. Part of Eleanor project. Red House, West Virginia. Ben Shahn. 1937. LC-USF33-006345-M5.

Page vi (funders page) image: Omar, West Virginia. Ben Shahn. October 1935. LC-USF33-006135-M2.

Book design by Than Saffel with Alcorn Publication Design.

To Jesse and Ry

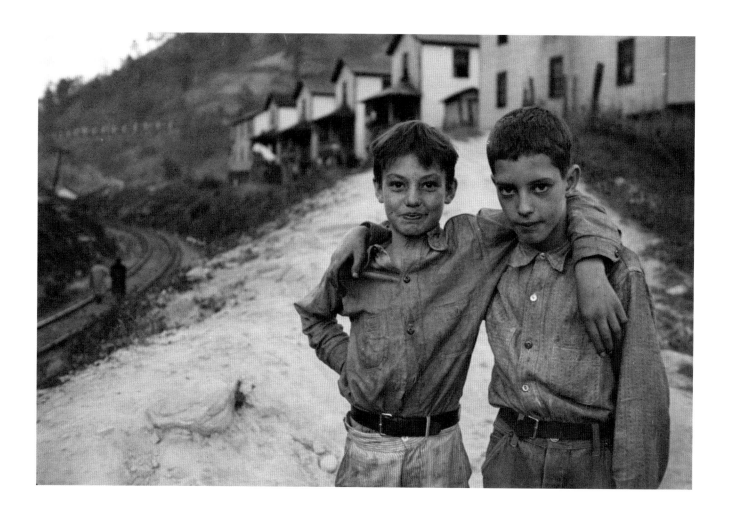

West Virginia University Press gratefully acknowledges the financial assistance provided for this book by **The West Virginia Humanities Council** and **Furthermore,** a program of the J. M. Kaplan Fund.

CONTENTS

Editor's Note ix

Foreword *Carl Fleischhauer* xi

West Virginia in the Era of the Great Depression and World War II *Jerry Bruce Thomas* xvii

1 **On the Road** 1

2 **Towns and Cities** 13

3 **Non-Coal Industries: Agriculture, Manufacturing, Logging, Retail** 31

4 **Northern Coalfields: 1935** 47

5 **Northern Coalfields: 1938** 65

6 **Model Communities: Arthurdale** 83

7 **Model Communities: Eleanor** 101

8 **Model Communities: Tygart Valley Homesteads** 113

9 **Southern Coalfields: 1935** 131

10 **Southern Coalfields: 1938** 143

11 **Wartime Photo-Essays: Richwood and Point Pleasant** 161

A West Virginia Perspective *Betty Rivard* 177

Acknowledgments *Betty Rivard* 219

Bibliography 223

About the Authors 231

Editor's Note

SELECTING 150 IMAGES from among the over sixteen hundred FSA Project photographs taken in West Virginia was difficult. I began by determining which images I thought would work best in a photography exhibit. After screening the photographs online, I made rough prints of about two hundred of the scans and consulted with Jenine Culligan, Senior Curator at the Huntington Museum of Art, to narrow the selection to about one hundred.

At the time we were contemplating organizing a museum exhibit prior to the production of the book. However, when it became clear that a book would come first, I used this selection as a base. I added over fifty photographs and subtracted a few others to strike the various balances needed for the book: geographical spread, socioeconomic and industrial variety, coverage of the full period of the FSA Project, and a sampling from each of the ten photographers associated with the Project who visited the state.

The focal areas of the FSA Project in West Virginia were the northern and southern coalfields, the three subsistence homestead communities, and two specific wartime assignments in Nicholas and Mason counties. Within these focal areas, the photographs are generally presented in chronological order, based on available information. The quotations at the beginning of each section are designed to provide additional insight into the context of the photographs without relationship to a particular subject or image.

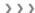

For more information on these interviews and archives, please see the Original Documents and Online Resources sections of the Bibliography.

The captions on the photographs in the Library of Congress online collection are the result of a multistep process that started with the photographer's completion of caption sheets, developed through various edits over the years, and continues to evolve as part of enhancing the website. In most instances, the captions in this book are taken directly from the Library of Congress online files. Where necessary, however, descriptive detail has been added, cuts made, and important corrections included. In some cases, the Library of Congress captions include detailed background information that I have chosen to retain for the reader because it enhanced my own experience of viewing the photograph.

In all cases, the Library of Congress negative file numbers are included so that interested readers may access the original materials electronically through the Library of Congress Web site. The primary access point for the online photographs is http://www.loc.gov/pictures/collection/fsa. As of this writing, a secondary access point is http://memory.loc.gov/ammem/fsahtml/fahome.html. An excellent source of more detailed background information about the cataloging of the photographs may be found at http://www.loc.gov/pictures/collection/fsa/cataloging.html.

—*Betty Rivard*
September 10, 2012

Foreword

THIS BOOK PRESENTS a handsome set of photographs of West Virginia produced by the staff of a photographic unit that operated successively in three federal government agencies: the Resettlement Administration (1935–37), the Farm Security Administration (1937–42), and the Office of War Information (1942–43). Although for most of its life the official name for this photographic unit was the Historical Section, in this foreword I'll call it the FSA-OWI photographic unit or photographic unit for short.

Jerry Thomas's essay provides a well-rounded account of the larger context in which the photographs take their place, while Betty Rivard's text explains how these particular images came to exist. We learn about the photographic unit's role in support of the three agencies and, by extension, of President Franklin Roosevelt's New Deal and wartime administrations. We also learn about a special connection between West Virginia and a fourth government entity created in 1933, Roosevelt's first year in office: the Subsistence Homestead Program.

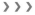

During 1934, the Subsistence Homestead Program developed the community of Arthurdale, just south of the Preston County town of Reedsville. Arthurdale resettled transplants from throughout north-central West Virginia, including out-of-work coal-mining families from a cluster of hamlets in or near the Scotts Run watershed just west of Morgantown: Pursglove, Osage, Jere, Chaplin, Bertha Hill, and Maidsville.[1] In 1934, Subsistence Homestead Program photographer Elmer Johnson was the first to document Arthurdale, with captions that identify the unincorporated community's location as Reedsville. In 1935, Johnson, his photographs, and the homestead program itself were rolled into the newly created Resettlement Administration.

The story of the Subsistence Homestead Program provides an insight into the early formation of New Deal social welfare programs. The plight of the residents of Scotts Run and the promise of a better life in Arthurdale were personal causes for First Lady Eleanor Roosevelt. Rivard's essay connects Eleanor's engagement with this topic to her friendship with Clarence Pickett of the Quaker-related American Friends Service Committee and, as time passed, with supporters like the philanthropist Bernard Baruch. The essay also reminds us of Eleanor's keen disappointment that the circumstances of the time allowed only the "native white" residents of Arthurdale to be resettled while leaving African American and recent European immigrant families behind. The historian Ronald Lewis's analysis of the 1920 census indicates that native whites represented only 20 percent of the population of Scotts Run.[2]

Whatever the programmatic details, the White House's focused attention on this corner of north-central West Virginia helps account for the many photographs made in the vicinity from 1934 to 1938. In addition, the Arthurdale story serves to illustrate how the subject matter of many FSA-OWI photographs—and indeed many in this book—reflects the varied missions of the government agencies that sponsored the work. Although a considerable oversimplification, we might say that the Subsistence Homestead and Resettlement

1. The Scotts Run area is part of the Cassville District of Monongalia County, and its history is the subject of a special issue of *West Virginia History* (vol. 53, 1994; available online at http://www.wvculture.org/history/journal_wvh/wvh53.html). Arthurdale's history is presented online by the community organization Arthurdale Heritage, Inc. (http://www.arthurdaleheritage.org/). Both Web sites were consulted January 8, 2012.

2. *West Virginia History* v. 53, op. cit. Lewis's discussion of 1920-census demographics is available online at http://www.wvculture.org/history/journal_wvh/wvh53-1.html (consulted January 8, 2012).

Administration period generated photographs about housing problems and new-community development; the Farm Security Administration period generated photographs about rural and small town life, including community development, and about such topics (with no West Virginia connection) as the Dust Bowl and the migration of displaced farm families to California; while the Office of War Information period expanded a theme that began to emerge in the later Farm Security Administration photographs: America's preparation for World War II and domestic and industrial support for the nation's participation in the war after Pearl Harbor. Some FSA-OWI wartime photographs remind us of little-remembered episodes, like the need to recruit farm workers to replace men now in uniform. Images in chapter 11 document the hiring and transportation of workers from Nicholas County to the farm fields of New York in September 1942.

How did the FSA-OWI photographic unit come to an end? There had been intermittent political controversies throughout the unit's existence. Some in Congress complained that the Roosevelt administration used the pictures in news releases and other publications to build political support, in effect, to support domestic propaganda.

Congressional antipathy intensified after America entered World War II. By then, the unit was part of the Domestic Operations Branch of the Office of War Information. During budget hearings in 1943, Congress eliminated the funding for the entire Domestic Operations Branch and the photographic unit was disbanded. In 1944, the picture file, eventually named the Farm Security Administration–Office of War Information Photograph Collection, came to the Library of Congress.

The collection at the Library includes about 175,000 negatives, of which about 90,000 had been printed during the photographic unit's active years.[3] Many of these images document the projects and actions of the government agencies. But if documenting government work were all that the photo collection did, it would have little enduring value. In fact, from the start, Roy Stryker, the director of the FSA-OWI photographic unit, saw the long-term value of the images just as clearly as he understood their near-term application to government

3. The makeup of the FSA-OWI collection at the Library of Congress is complex. Not only does it include the few Subsistence Homestead photographs described here, but also thousands of images from the wartime Office of Emergency Management and from other sources. One recent estimate from the Prints and Photographs Division puts the grand total of prints at 107,000. For more information, consult the appendix of Carl Fleischhauer and Beverly Brannan's *Documenting America, 1935–1943*, University of California Press, 1988, pp. 330–42.

communication. Stryker built a picture file, not just pictures-for-the-week. And he sought to maximize the images' visual quality and to assemble a collection with the broadest possible coverage.

Two factors helped Stryker achieve his goal. The first is the inclusion of problem photographs, images of people inhabiting poor housing or staying in migrant farm labor camps, working on unproductive land, or just wearing threadbare clothing. Such pictures are almost always more compelling than the necessary-but-mundane solution photographs: images of spanking new houses, clean school classrooms, or work in a cooperative manufacturing facility, all intended to show the successful outcome of government programs.

The second factor that helped Stryker build a collection with long-term value was the inclusion of images of a wide range of subjects that were not in and of themselves problem or solution statements. Although photojournalists and documentary photographers don't need much encouragement to keep an eye open for pictorial opportunities, Stryker did nudge his team to shoot broadly when he drafted their assignments. Chapter 6 leads off with Stryker's long list of "suggestions" for the photography of homestead communities, including requests for pictures of "members of the family

working in their gardens" and new babies with "their proud parents." Stryker knew that such images would have a public relations payoff, but he and the photographers also knew that well-made examples would evoke universal human experiences and allow the photographer to express his or her creativity. John Vachon, whose 1939 and 1942 West Virginia photographs are included in this volume, once looked back at his first FSA trip, to Nebraska. "In Omaha," he wrote, "I realized I had developed my own style with the camera. I knew that I would photograph only what pleased me or astonished my eye, and only in the way I saw it."[4]

The photographs that Walker Evans made during his 1935 trip to West Virginia represent both factors. His images in chapter 4 include elegant and poignant scenes of coal miners' living conditions in Scotts Run and Morgantown, which, Rivard tells us, "interested [Evans] more than the subsistence homestead community" of Arthurdale. These pictures can be seen as problem statements. Meanwhile, a pair of arresting photographs in chapter 2, made in Morgantown on the same trip, offer Evans's striking views of two hillside residential neighborhoods, one dramatically framed

4. John Vachon, "Tribute to a Man, an Era, an Art," *Harper's*, September 1973, p. 98.

by the grid of wood, metal, and glass insulators at the top of a telephone pole. Neither scene pertains in any direct way to the work of the Resettlement Administration. The latter is one of the artist's best-known photographs.

The photographic unit's wonderfully loose definition of agency-mission coverage and the photographers' artistic proclivities combined to build a rich and diverse national collection, but one that makes an imperfect source for state-based books like this one. The collection contains sets of images of specific government projects, of locales where poor conditions sparked the establishment of those projects, and of a wide variety of affecting and eye-catching subjects that drew a photographer's lens. But the photographic unit made no attempt to carry out systematic pictorial surveys on a state-by-state basis. The several collection-based state books published during the last thirty-odd years—like this one—have made the most of fragmented coverage of their state and of topical segments within their states.

The collection's West Virginia photographs, for example, omit some of the state's regions and provide spotty coverage of key industries. The images depict life in coal camps but barely sketch the overall process of coal mining and

the workplace roles played by the miners. The National Forest Service was a sibling unit to the Farm Security Administration in the Department of Agriculture, but only a few scenes of sawmills in Preston and Nicholas counties represent the lumber industry and there are no photographs of West Virginia lumberjacks or teamsters at work in the woods. At the state level, these pictorial-narrative fragments contrast with the careful and comprehensive textual coverage provided by the Federal Writers Project, another New Deal initiative, in state-based books like *West Virginia: A Guide to the Mountain State*.[5]

Fortunately, the power and impact of many individual photographs overcome what, say, an editor may see as gaps in coverage. And every user of the photographs has benefited from the collection's *availability,* a term with two meanings in this context. First, the pictures have been open for public perusal since shortly after their arrival at the Library of Congress. Prior to their transfer, the archivist Paul Vanderbilt microfilmed the pictures more or less in chronological,

5. *West Virginia: A Guide to the Mountain State* was published by the Oxford University Press, New York, in 1941. The work has been intermittently republished in the following decades and a scanned copy of the original imprint is available online from Google Books (consulted on January 8, 2012).

shooting-assignment order. After the films had been made, Vanderbilt rearranged the photographic prints by region and classified them by subject. Then the classified file, the negatives, a few color transparencies, and the microfilms came to the newly established Photographic Section at the Library, a unit that eventually evolved into today's Prints and Photographs Division. Within a year or two, the classified picture file and the microfilms were open to the public, while the negatives and transparencies were carefully stored away.

In 1978–79, the Chadwyck-Healey publishing company produced a microfiche edition of the classified file and sold copies to a number of research libraries. Then in the 1980s and 1990s, the Library produced a searchable version of the entire negative file, first on laser videodiscs and subsequently as a digital online collection for the Web. The negatives are being rescanned at higher resolution in 2011–13; the new images will replace the scans on the Web today. Tens of thousands of researchers have availed themselves of the collection in these multiple forms.

The second meaning of "availability" results from the fact that most of the photographs are the work of U.S. government employees. (Here and there, the file includes photographs that Stryker collected, some of which were not created by government employees.) Under law, images created by federal government workers are not eligible for copyright protection in the United States, and they can be reproduced by anyone without the payment of a licensing fee. Beginning in the 1930s and 1940s when the three agencies were active and continuing to the present day, the photographs have appeared in countless print publications, films, and television programs, and— these days—Web sites.

This book, of course, demonstrates the benefit of the collection's availability. The Library's online presentation permitted Betty Rivard to carry out her exemplary job of selecting images and organizing them into thematic portfolios. In the context of this book, the photographs can be read, understood, and appreciated as artistic documents from the Mountain State from 1934 to 1943.

—*Carl Fleischhauer*
January 16, 2012

West Virginia in the Era of the Great Depression and World War II

THE ERA OF THE GREAT DEPRESSION and World War II, the setting for Betty Rivard's book, required much resilience and perseverance of the citizens of the Mountain State as they struggled first to meet the challenges of poverty and depression and then to face the demanding sacrifices of war.

During the decade after World War I, West Virginia, like most of the country, underwent remarkable changes. The war had spurred the expansion of the coal industry, and afterward the industry faced the problems of overexpansion. The chemical industry grew in the Kanawha Valley to manufacture explosives and mustard gas and, after the war, turned to the production of synthetics. During the 1920s, other businesses surged, construction boomed, and towns and cities grew.

The state's bureaucracy, services, and government spending also expanded, creating what seemed at the time a reasonable burden of debt.

›››

A good roads movement sought to get farmers out of the mud and to build a system of state roads sufficient to meet the requirements of the automobile age. Bitter struggles between labor and management led to the creation of a state police force. The state and counties financed new government buildings, including a striking new state capitol on the banks of the Kanawha. Looking to the needs of veterans and orphans, the state also began to put together rudimentary elements of a state welfare system.

In the towns and cities where the new roads and electricity reached, West Virginians shared some of the excitement of the Roaring Twenties. Interest in sports and the spread of radio, films, and streetlights offered new forms of recreation and enlivened nightlife. Back in the hills, however, beyond the reach of the new roads and electric transmission lines, West Virginia's traditional rural life and subsistence agriculture faded. Old houses, barns, and abandoned schoolhouses rotted away. Rural churches worried about declining memberships. Young people looked for futures elsewhere.

Also during the 1920s, the timber and coal industries, after an age of pell-mell industrial development, passed their peaks as employers, leaving stranded workers and their families with the choice of using the new roads as escape routes to jobs in industrial centers or eking out a meager living on small mountain farms. The Depression for a time would foreclose the escape option, leaving many unemployed workers little choice but to try to make a living from the land. Because industrialists had heedlessly exploited the land and farmers themselves had used poor agricultural methods, scraping a living from mountain farms had become even more difficult.

By 1927 hard times had already arrived in West Virginia's coal camps and rural districts. The crisis grew in intensity with the stock market crash in the fall of 1929, and then persisted for months and years. Conditions worsened as West Virginia farmers faced parched fields, ruined crops, and starving livestock during the searing droughts in the summers of 1930 and 1932. After the droughts came a time of severe floods. As the Depression deepened in West Virginia, it produced some of the worst conditions in the country. Some 33,000 coal mining jobs disappeared by 1932. From 1929 to 1932, one hundred banks collapsed, accelerating the rate of bank failures, which had already been high in the 1920s. The double blows of drought and depression devastated farmers and miners as well as coal operators, manufacturers, merchants, and bankers.

In addition to the economic blows, workers continued to face dangerous workplaces. One of the worst industrial disasters in the history of the country unfolded in Fayette County virtually unnoticed by the press. There (according to a careful estimate) over 700 men—183 whites and 581 blacks—died drilling the Hawks Nest tunnel to supply water to a Union Carbide and Chemical Corporation metallurgical complex. Most fell victim to a silent killer, silicosis, a lung disease caused by breathing the silica-laden air. The coal industry had already experienced a high rate of death and injury from roof falls and explosions. As machines became more commonplace in the mines, creating a dust-laden atmosphere, miners would suffer from a pneumoconiosis (commonly called black lung), a disease similar to silicosis.

As unemployment and agricultural depression grew, conventional means of relieving distress and hunger through county poor farms and private charities such as the Community Chest, Red Cross, and Salvation Army proved inadequate. President Herbert Hoover called for increased voluntary efforts to help the unfortunate. In addition to the traditional private relief organizations, he persuaded the American Friends Service Committee to help feed children in West Virginia coal mining areas. Shocked by finding "deserving men, women and children actually . . . suffering from hunger, exposure, and cold" in West Virginia, some of Hoover's aides persuaded him to sign a bill providing federal loans to states and corporations. Facing one of the worst unemployment problems in the country, Republican Governor William G. Conley and his director of relief Calvert Estill became early advocates of establishing both a state welfare agency and federal relief.

The election of 1932 brought Franklin D. Roosevelt and the New Deal to Washington and a Democratic administration to Charleston. Roosevelt and his lieutenants pushed emergency relief and recovery legislation through Congress. The new Democratic regime in Charleston, led by Governor Herman Guy Kump, found itself preoccupied and virtually paralyzed by the constitutional, fiscal, and political consequences of the Tax Limitation Amendment, a constitutional change approved by voters in 1932. Put forward as a panacea by those who saw tax relief and less government spending as the solution to all public issues, it severely limited the tax base of county and municipal governments. Charleston now had to play a larger role in education, welfare, and roads. The focus on the issue also inhibited efforts to deal with

unemployment relief and to take advantage of some New Deal programs that made funds available on a matching basis. Kump claimed that the state could not engage in matching plans. He dealt with the increasing cost of relief by reducing relief payments.

While West Virginia struggled, Congress passed numerous measures that would directly affect West Virginians during the hectic first hundred days of the New Deal. One of the most immediate consequences was a stunningly successful organization drive by the United Mine Workers of America (UMWA), taking advantage of the guarantee of collective bargaining by the National Industrial Recovery Act. The act helped bring short-term reemployment of miners and the recovery of mining, but the most important long-term consequence might have been political rather than economic. The UMWA quickly became one of the most powerful political influences in the state, enabling it to work for the improvement of laws governing life and labor in the coalfields. Responding to the trend, Governor Kump's administration ended a law that had long enabled coal companies to cloak the private power of mine guards (which included keeping labor organizers from their gates) with the public authority of county deputies. Although the Supreme Court eventually struck down the National Industrial Recovery Act, the measure and related early New Deal legislation brought some recovery and stirred hopes.

Unemployment remained high, however. Federal relief administrator Harry Hopkins, shocked at the reports of need in West Virginia, urged Governor Kump and the state legislature to give more attention to relief. In July 1933, twelve counties had at least 45 percent unemployed, including a startling 84 percent in Lincoln and 70 percent in Wayne, counties that relied heavily on subsistence agriculture, and more than 50 percent in the coal-mining counties of Raleigh, Mercer, and Mingo. West Virginia became one of fewer than half-a-dozen states where every relief recipient able to work earned relief on a work project rather than as a direct payment. Even so, because the state failed to pay its share of relief, West Virginia relief payments remained below half of the national average for federal emergency relief.

In 1935, Congress established the Works Progress Administration (WPA) to provide work for the able-bodied unemployed through labor-intensive public projects. Social Security would assist the states in providing relief for those unable to work. WPA in West Virginia generated numerous projects in construction,

rehabilitation, conservation, and even programs for unemployed writers, teachers, artists, and musicians. WPA workers built farm-to-market and creek and hollow roads, unpaved roads to reach "the forgotten man" far back in the hills; streets improvements in towns and cities; the Southside Bridge in Charleston; a therapeutic center at the Morris Memorial Hospital for Crippled Children in Huntington; a new high school for African American students in Morgantown; and various other educational buildings around the state. They also constructed sanitary privies, sealed abandoned coal mines, and built or improved airports, swimming pools, and parks.

WPA also generated work relief for women, artists, musicians, librarians, teachers, students, and writers. In 1935 more than two hundred musicians sought work with WPA, and the agency supported municipal bands in Wheeling, Huntington, Clarksburg, and Parkersburg. By 1942 several towns had WPA-sponsored art centers. Unemployed teachers found WPA work teaching adult education and literacy for families on relief.

One of the most controversial WPA projects hired unemployed writers to produce *West Virginia: A Guide to the Mountain State*, a well-written volume criticized as too radical by Governor Homer Adams Holt and others. For women the WPA generated jobs in sewing, teaching crippled children, nursing, library projects, household work, and in a statewide school lunch program.

Two New Deal programs, the Civilian Conservation Corps (CCC) and the National Youth Administration (NYA), provided work for youths in projects that had long-term benefits for the state. At more than sixty sites in West Virginia, CCC youths gained work experience and sent some cash home to their families as they built or improved state parks and worked in game preserves, national forests, and soil conservation projects. They built cabins and lodges, fought forest fires, excavated trails, constructed lookout towers, planted trees, and treated thousands of acres for gully erosion. NYA workers also engaged in construction projects, building community and recreation centers, athletic fields, swimming pools, bus stops, and schools, including a twelve-room high school at Wardensville in Hardy County.

One of the largest NYA projects in the country began in 1939 at the United States Naval Ordnance Plant in South Charleston as the international situation became increasingly menacing. Many young men trained in welding, auto and airplane mechanics, and other metal and mechanical trades

at the Naval Ordnance Plant would go directly to Army and Navy schools for mechanics and serve in World War II.

For African Americans in West Virginia, who had to deal with segregation and discrimination as well as a high level of unemployment and economic privation, the New Deal offered little in the way of special programs, but the relief and welfare available to whites were available to blacks as well, usually in segregated projects. African American coal miners also welcomed the success of the United Mine Workers, for which they credited Franklin D. Roosevelt as well as John L. Lewis, the mineworkers' leader. During the decade, African Americans, traditionally Republican because of the legacy of Abraham Lincoln, moved toward the Democratic column in politics and organized to call attention to their needs and to insist on a fair share from government programs.

Another federal program, the Public Works Administration (PWA) sought to stimulate the economy with capital-intensive public works projects. The PWA encountered some resistance in West Virginia because the Tax Limitation Amendment had left cities and counties with limited revenues to provide the necessary matching funds required for PWA projects. Both Governor Kump and his successor, Homer Adams Holt, opposed the concept of matching funds. Nevertheless, ways were found, especially after Kump left office. WPA projects led to construction or improvement of water systems or sewer systems for fifty-seven communities, and the building of thirteen hospitals, several state college buildings, forty-six county and state educational buildings, courthouses, bridges, state roads, and Kanawha Boulevard in Charleston. Much of the physical infrastructure left behind by the New Deal programs remained useful into the twenty-first century.

New Deal relief and social welfare legislation also led to substantial and enduring changes in the way West Virginia dealt with unemployment, poverty, disability, and old age. The antiquated system of relying on private charity and local care of the indigent and unemployed through county poorhouses collapsed under the challenges of heavy unemployment. The New Deal efforts to relieve unemployment and the establishment of Social Security in 1936 resulted in a more public, bureaucratic, and professional approach to welfare and the care of the elderly and disabled. To help staff state and county agencies with trained social work professionals, West Virginia University established a social work department in 1941. Advocates of the

new system rejected the antiquated philosophy that divided the poor between the worthy and unworthy and held that the poorhouse and private charity sufficed. Because of the state's persistent economic problems, enduring political indifference or even opposition to the new philosophy, and the tendency of politicians to see the welfare bureaucracy as a new patronage tool, the new welfare system did not always serve the unfortunate as well as its advocates had hoped.

From the early days of the Depression, West Virginia farm families suffered, driving the relief rates in some agricultural counties even higher than in the coal-mining counties. Many low-income farms had depended on industrial work to supplement inadequate farm income, but with coal, timber, and other non-farm work no longer available, the inadequacy of marginal farms became more apparent. Relief rolls also grew from the large number of unemployed industrial workers who returned to the land, increasing the number of farmers in West Virginia, the young men and women who might have left but could not, and the rising numbers of worn-out farm laborers left unable to work by a lifetime of hard work, disabling injuries, diseases, and poor diet. For the stranded miner or timber worker who sought to farm mountain lands, they often found the terrain and soils unsuitable. In 1934, surveys of living conditions in rural West Virginia counties found that half of all houses needed structural repairs as porches sagged, roofs leaked, and foundations failed. Few had piped-in water, electricity, or sanitary toilet facilities. Miners' families who tried to live on in abandoned coal or timber camps faced similar conditions.

Most New Deal agricultural legislation looked to the problems of commercial and larger farmers rather than to poor farmers like the subsistence mountain farmers of West Virginia. Similarly the U.S. Department of Agriculture, the land grant colleges, and the extension service tended to ignore the needs of low-income and part-time farmers, but some programs tried to help poor farmers through resettlement, loans, electrification, and soil conservation and erosion control. The most dramatic of these initiatives led to the launching of three resettlement communities, all of which had the enthusiastic support of First Lady Eleanor Roosevelt: Arthurdale in Preston County, Red House in Putnam County, and Tygart Valley in Randolph County. Grateful residents of Red House renamed their community Eleanor. The basic idea of the resettlement communities was to combine

agricultural and industrial functions in a rural setting where residents could raise much of their own food on their small plots and earn money in cooperative manufacturing shops. The communities generally had difficulty attracting industrial employers, because many businessmen disapproved of the concept of a government entity competing with private enterprise. Eventually the government sold the properties. For the subsistence homesteaders who escaped horrible conditions to make a better life for themselves and their families, they regarded the program as a great success even though the communities never worked out quite as they had been planned.

Another New Deal agency, the Farm Security Administration (FSA), tried to help poor farmers stay on their land by improving their methods rather than moving them to new sites; but by the end of the 1930s, a more conservative Congress began to cut the FSA budget. The most enduring impact of FSA came from the effort to call attention to the plight of the rural poor through photography, films, and books. Pare Lorentz, a West Virginian, directed two of the most powerful of the agency's films, *The Plow that Broke the Plains* and *The River*, both of which called attention to the consequences of poor land use. The agency contracted with

several outstanding photographers. Ten of them, notably including Ben Shahn, Walker Evans, Arthur Rothstein, and Marion Post Wolcott, traveled in West Virginia and captured hundreds of poignant and revealing scenes of everyday life, as depicted by the selections in this book.

In 1940, as defense spending drove economic recovery and national policy began to focus more on the threat of renewed world war, West Virginia's Democratic factions fought a bitter battle for control of the statehouse. United States Senator Matthew Mansfield Neely, leader of the pro–New Deal federal faction, ran for governor and led the ticket in a sweep of the primary and general election. For the first time a Democratic governor prepared to cooperate fully with the New Deal held the reins in Charleston, but as Roosevelt's third term began, the New Deal had essentially ended. As President Roosevelt himself said in 1943, Dr. New Deal had been replaced by Dr. Win the War, and like other Americans, West Virginians also turned from fighting the Depression to fighting the war.

— Jerry Bruce Thomas
Professor Emeritus of History
Shepherd University

1

On the Road

Franklin D. Roosevelt,
address at Arthurdale,
May 27, 1938.
The American
Presidency Project.

"A GREAT MANY SINCERE PEOPLE—good citizens with influence and money—have been coming to West Virginia mining towns in the past two or three years, to see the conditions under which American families lived, conditions under which, unfortunately, many American families still live. Many of these people have come to see me after their visit to Scotts Run or similar places, and have expressed to me their surprise and their horror at things they have seen. They have said to me: 'I did not imagine that such conditions could exist in the United States.'

They have wanted me to help at the particular spot they have seen, but the lesson that I have found it difficult to get across to them has been the fact that they have seen only one spot or two spots—tiny, single spots on the great map of the United States, a map that is covered over with hundreds and thousands of similar spots. Un-American standards exist by no means in a few coal towns only. They exist in almost every industrial community and they exist in very many of the farming counties of the country."

—*Franklin D. Roosevelt*

Filling station. Reedsville, West Virginia. Walker Evans. June 1935. LC-USF342-000848-A.

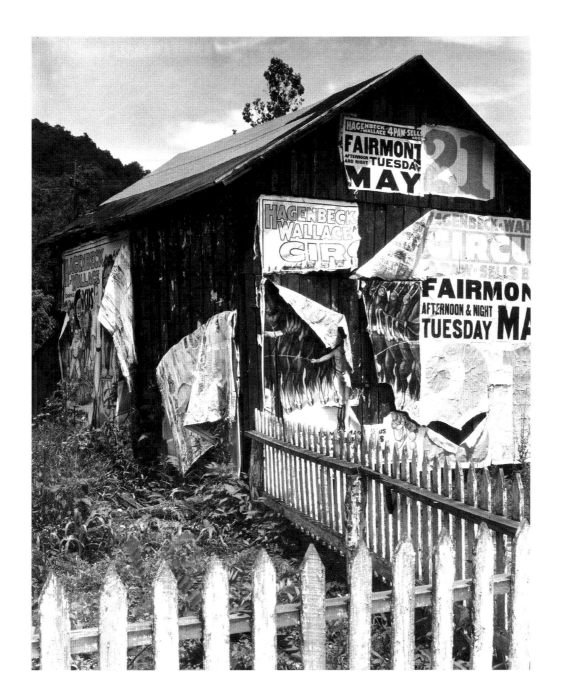

Roadside barn.
Monongalia County,
West Virginia.
Walker Evans.
June 1935.
LC-USF342-000849-A.

Ferry crossing on Kanawha River. Near Red House, West Virginia. Elmer Johnson. September 1935. LC-USF33-008027-M3.

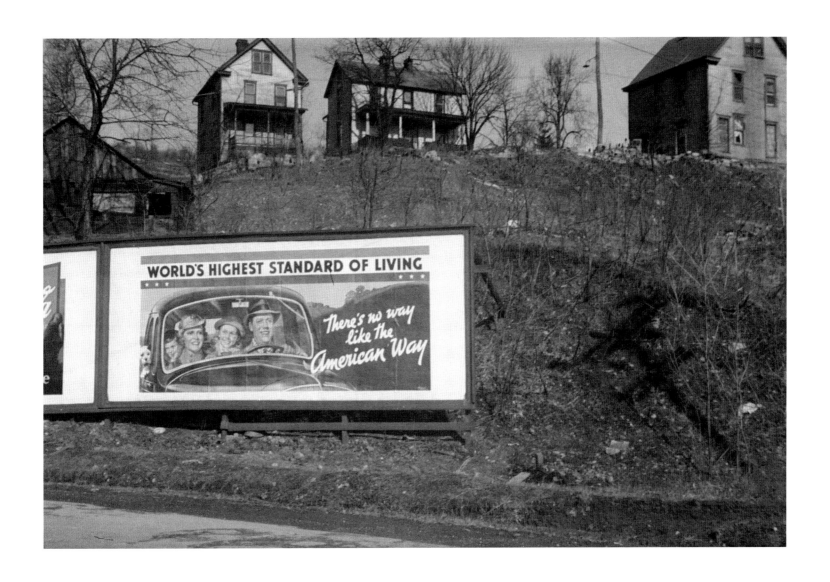

Road sign. Near Kingwood, West Virginia. Edwin Locke. February 1937. LC-USF33-004228-M3.

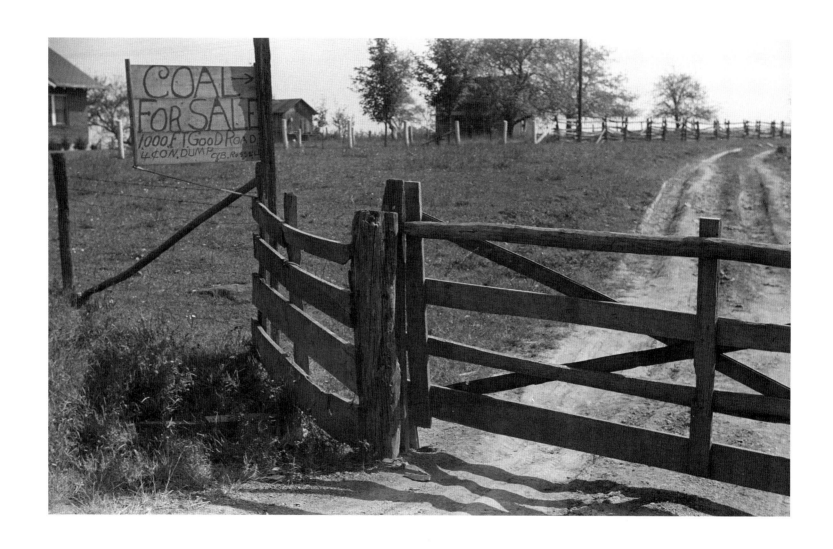

Private property owners who have found a little coal on their land. They mine and sell it along the highway.
North Central West Virginia. Marion Post Wolcott. September 1938. LC-USF33-030281-M4.

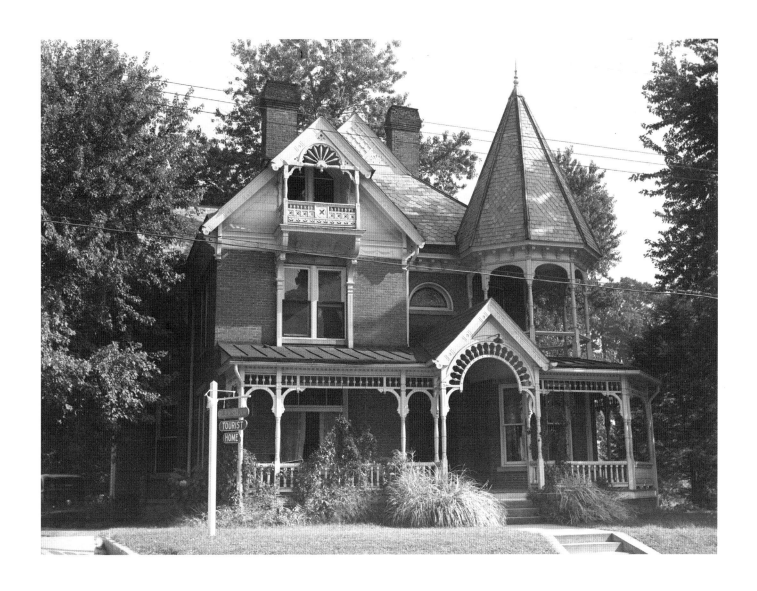

Old private house, now tourist home. Buckhannon, West Virginia. Marion Post Wolcott. September 1938. LC-USF34-050115-D.

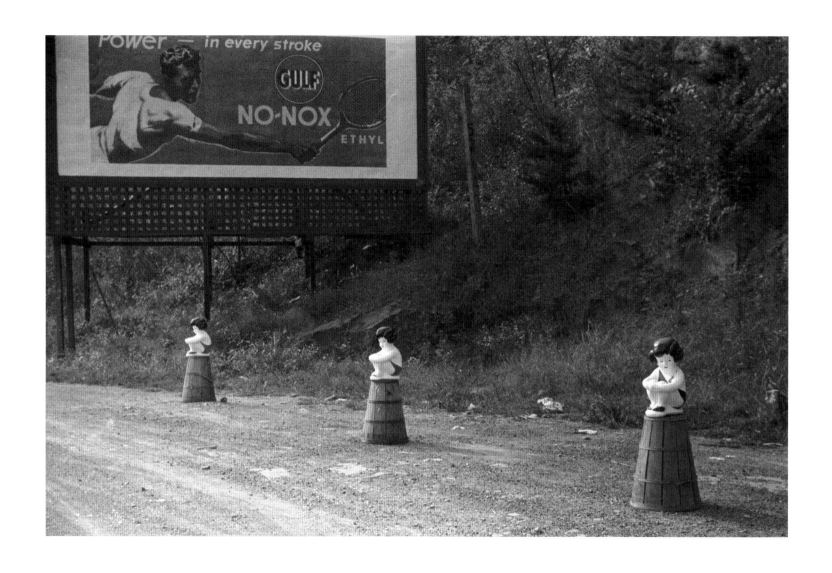

Bathing dolls for sale along the main highway. Near Charleston, West Virginia. Marion Post Wolcott. September 1938. LC-USF33-030270-M2.

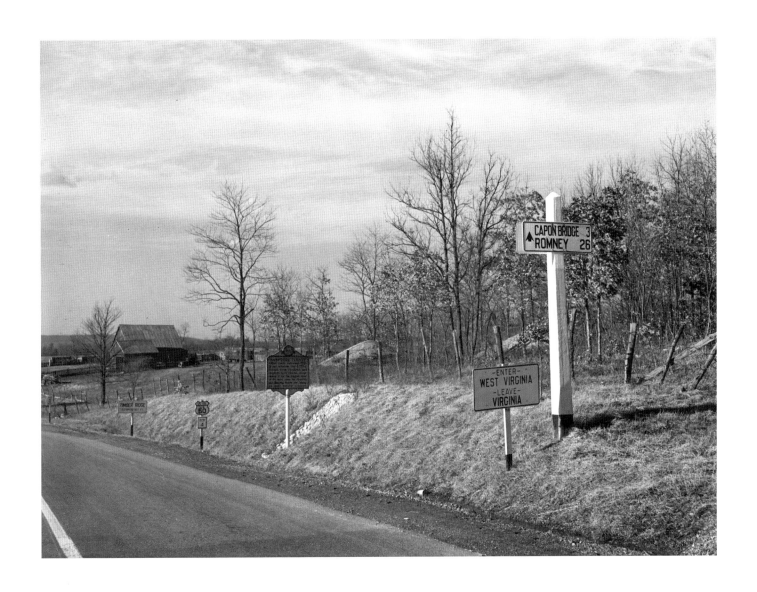

State line, Virginia-West Virginia. Arthur Rothstein. February 1940. LC-USF34-029406-D.

Highway U.S. 50. Mineral County, West Virginia. Arthur Rothstein. February 1940.
LC-USF33-003465-M1.

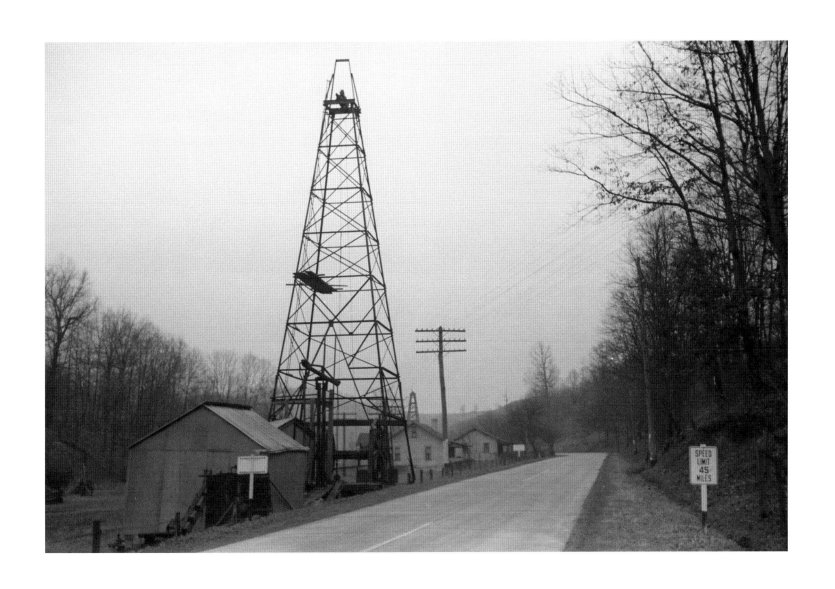

Oil well on Highway U.S. 50. Ritchie County, West Virginia. Arthur Rothstein. February 1940.
LC-USF33-003466-M4.

Towns and Cities

Marion Post Wolcott,
Oral history interview,
January 18, 1964.
Archives of American Art.

"[I] WENT DOWN TO SEE ROY. And, of course, he turned me loose on the files first before really talking to me at any great length. And I was overcome and amazed and fascinated and most interested in working with them, and talked with Roy, so I soon heard that he would take me on as one of their photographers. . . . I had felt in the newspaper work that there wasn't much that I was really interested in that I was photographing and I was looking for something that would be, well, more useful or had more purpose to it, I suppose. . . .

As I say, the impact of the photos in the file was terrific, I guess, and stimulating. I didn't feel very adequate at that point. I hadn't done anything but the newspaper work for the last year and a half or so, but Roy was very understanding and let me browse around in the files and gave me some literature to read, of course, as he was always doing, throwing books at us. . . . And so my first assignments were very close to Washington. I think one of the first ones, if not the very first, was in the coal fields in West Virginia. That was a very short assignment, of course. And it was a very interesting one, too. I found the people not as apathetic as I had expected they might be. They weren't too beaten down. Of course, many of them were but they were people with hope and some of them still had a little drive, although, of course, their health was so bad it was telling."

—*Marion Post Wolcott*

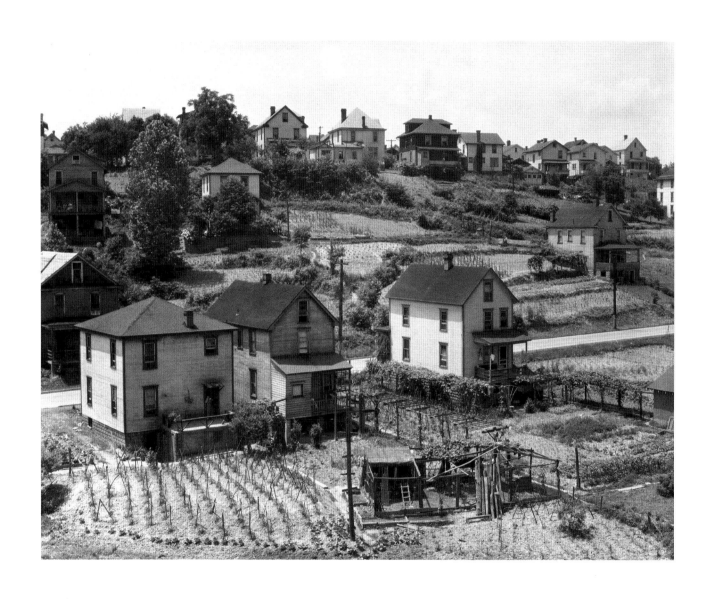

Typical houses. Morgantown, West Virginia. Walker Evans. June 1935. LC-USF342-000850-A.

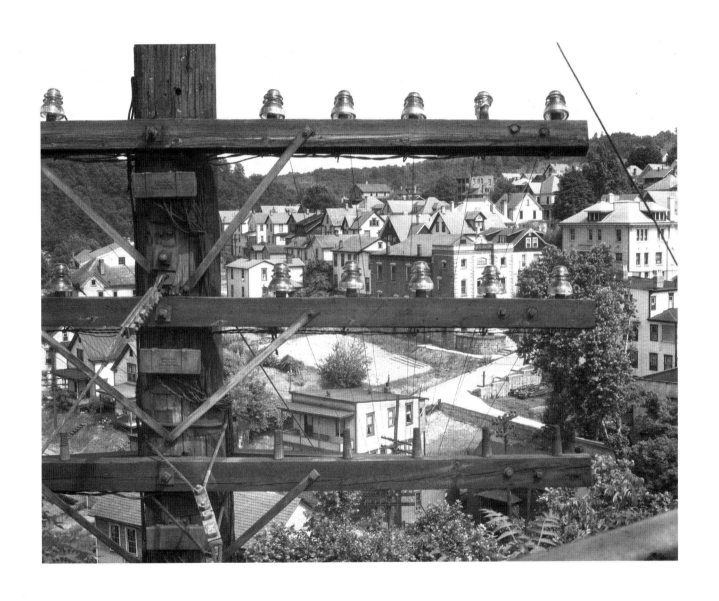

View of town. Morgantown, West Virginia. Walker Evans. June 1935. LC-USF342-000890-A.

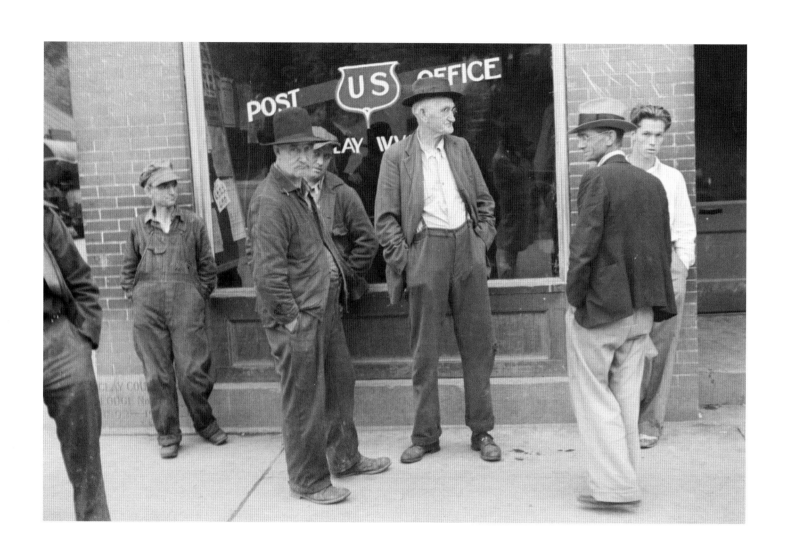

Street scene. Clay, West Virginia. Ben Shahn. October 1935. LC-USF33-006131-M1.

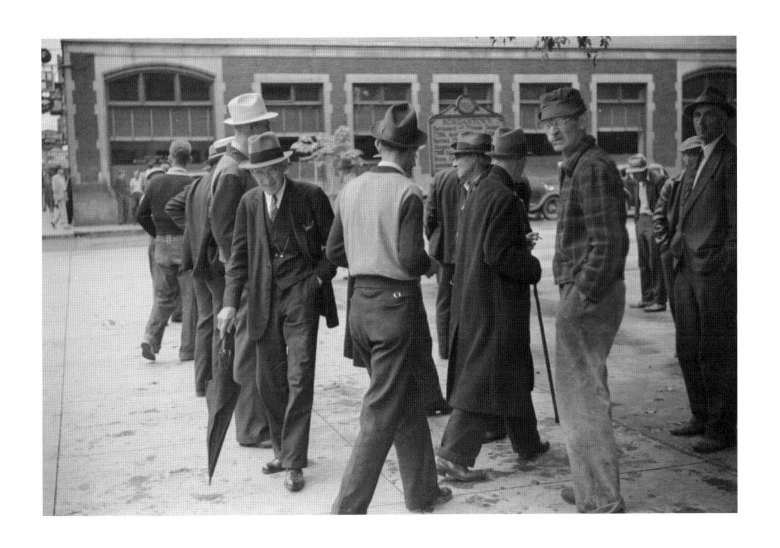

Men by courthouse. Morgantown, West Virginia. Marion Post Wolcott. September 1938.
LC-USF33-030169-M3.

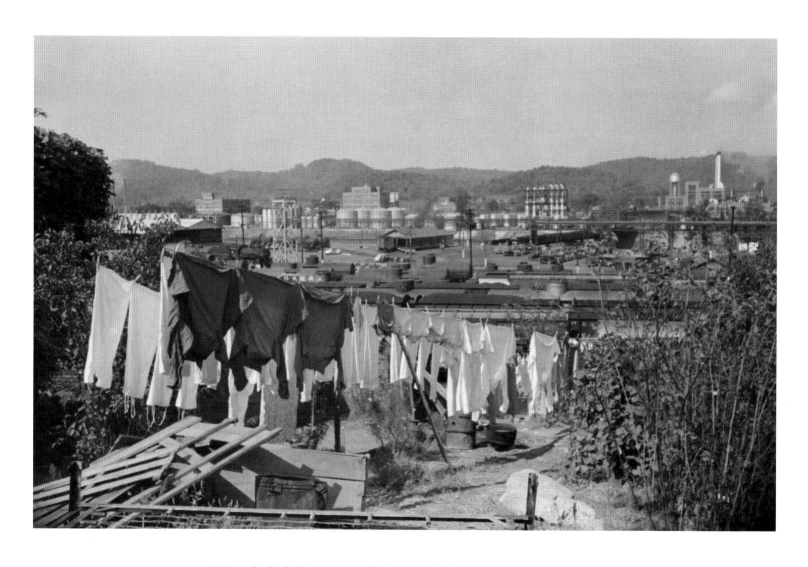

Union Carbide Company in background. Charleston, West Virginia.
Marion Post Wolcott. September 1938. LC-USF33-030051-M4.

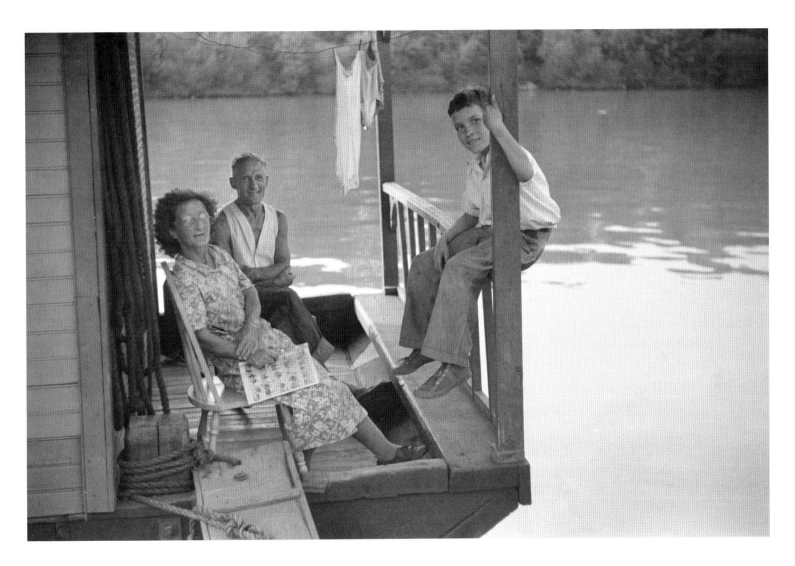

Family on front porch of houseboat on river. Charleston, West Virginia.
Marion Post Wolcott. September 1938. LC-USF33-030079-M5.

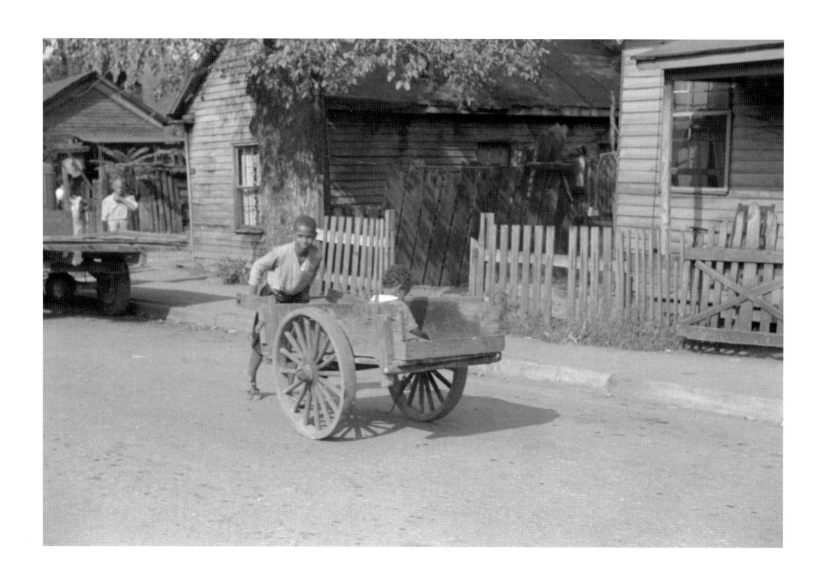

Street in Negro section. Charleston, West Virginia. Marion Post Wolcott. September 1938. LC-USF33-030105-M2.

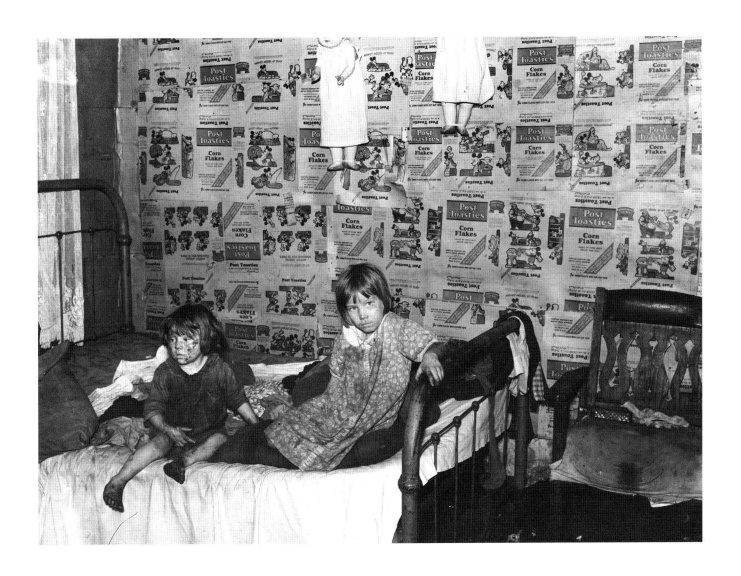

Children in bedroom of their home. . . . Their mother has TB. Father works on Works Progress Administration. Charleston, West Virginia. Marion Post Wolcott. September 1938. LC-USF34-050119-D.

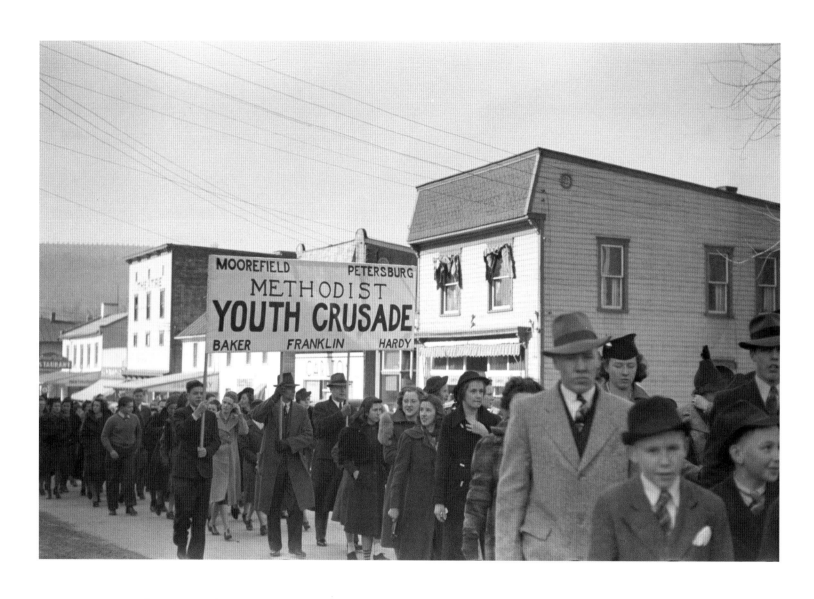

Religious parade. Romney, West Virginia. Arthur Rothstein. January 1939. LC-USF33-003015-M1.

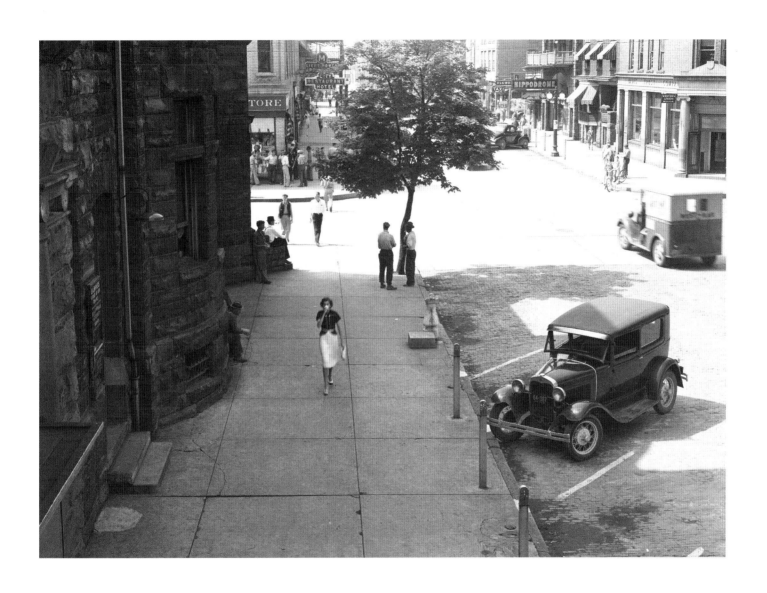

Shady side of Main Street. Elkins, West Virginia. John Vachon. June 1939. LC-USF34-060103-D.

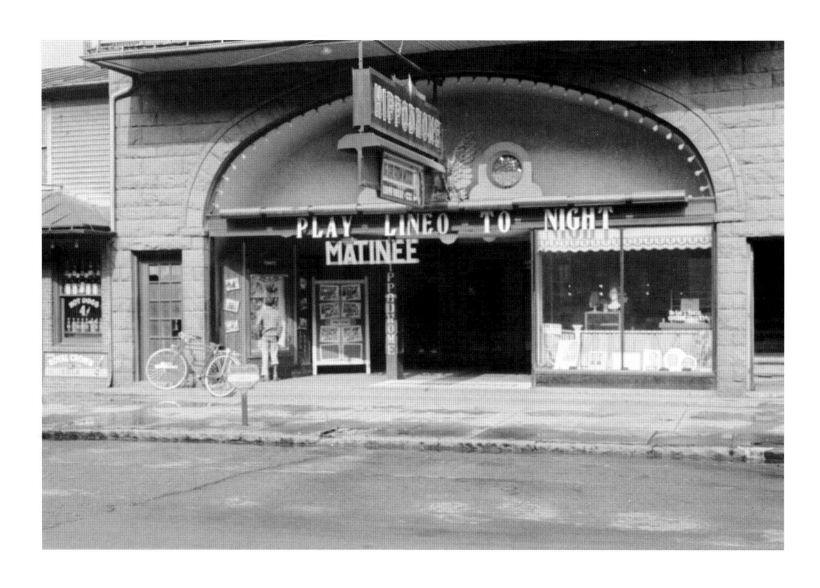

Movie theater . . . There are two movies in town, both offer games of chance, win a dollar, three nights a week. Elkins, West Virginia. John Vachon. June 1939. LC-USF33-001390-M5.

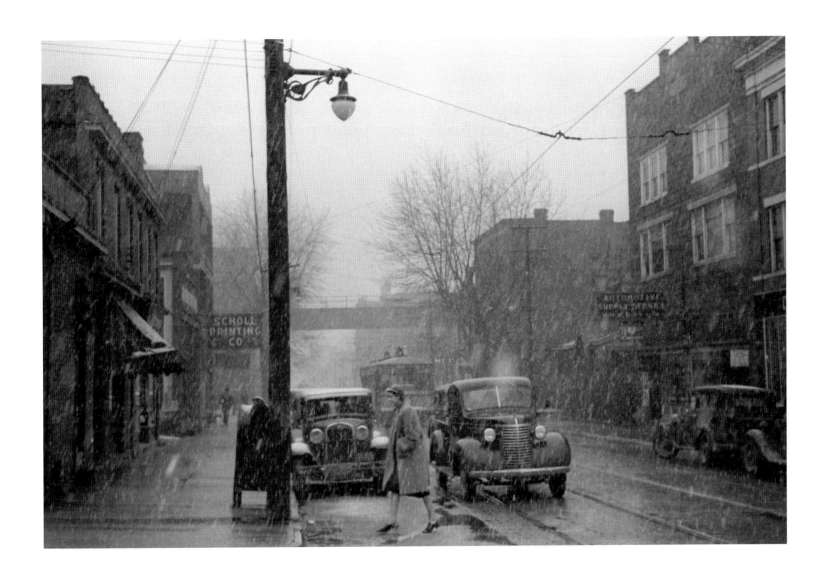

Snowstorm. Parkersburg, West Virginia. Arthur Rothstein. February 1940.
LC-USF33-003467-M4.

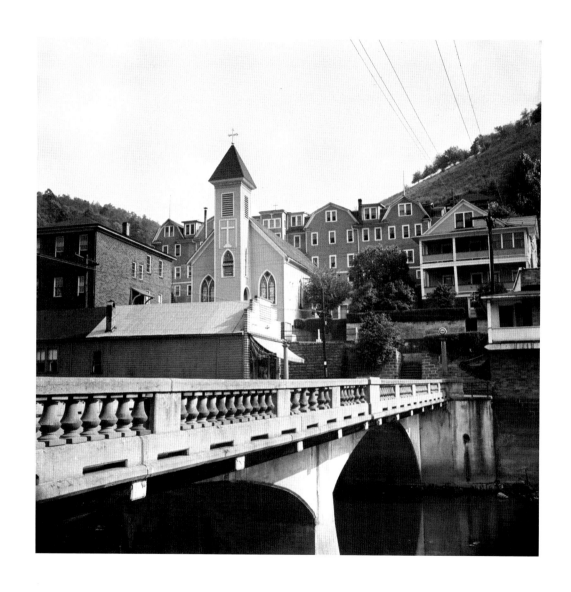

Catholic school, church, and hospital. Richwood, West Virginia.
John Collier. September 1942. LC-USF34-084071-E.

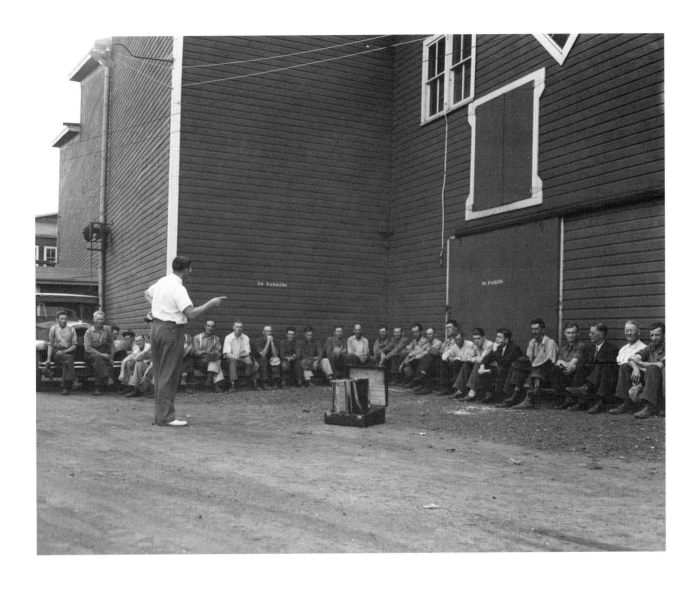

Evangelist preaching in the yard of a lumber mill. Richwood, West Virginia. John Collier. September 1942.
LC-USF34-084020-C.

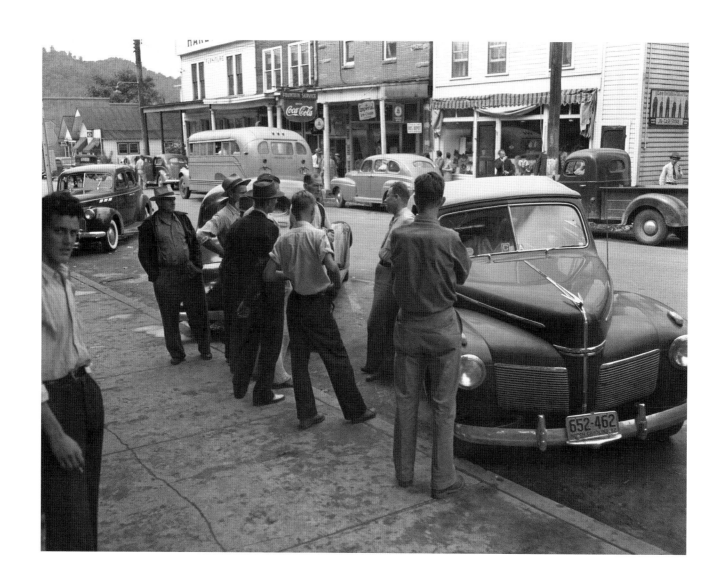

Scene near courthouse. Summersville, West Virginia. John Collier. September 1942. LC-USF34-083954-C.

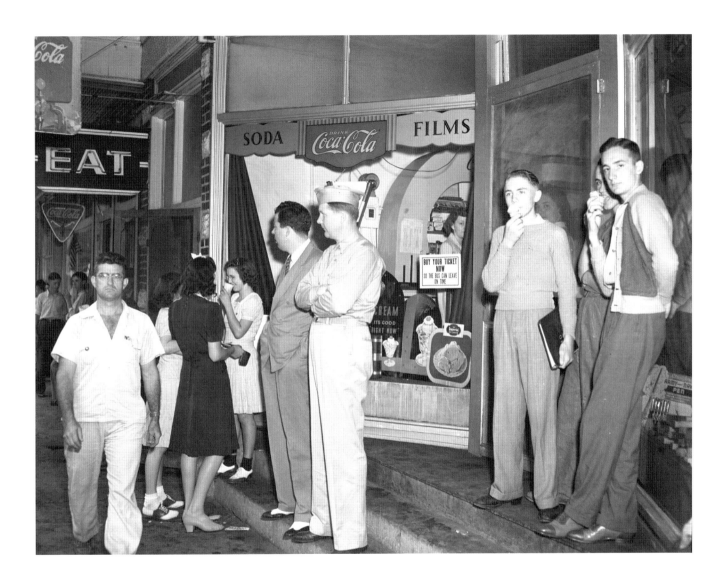

Street scene with uniformed soldier. Summersville, West Virginia. John Collier. September 1942.
LC-USF34-083955-C.

3

Non-Coal Industries:
Agriculture, Manufacturing, Logging, Retail

Carl Mydans,
Oral history interview,
April 29, 1964.
Archives of American Art

"**I CAN REMEMBER** the first time I was going off on a story for his section. My assignment was to go to the South and 'do cotton.' I put my camera together and drew my film and got an itinerary (Roy Stryker's travel secretary got me my reservations) and I came in to say to Roy that I was on my way. He greeted me goodbye, wished me luck, and then he looked at me and said, 'By the way, what do you know about cotton?' I stopped and said, 'Not very much.' He asked me a few more questions and finally he said, 'Sit down. What you indicate is that you know nothing about cotton.' This, of course, was so.

He called in his secretary and said, 'Cancel Carl's transportation. He's going to stay here with me for a while.' He sat down and we talked almost all day about cotton. We went to lunch, we went to dinner, and we talked well into the night. He talked about cotton as an agricultural product, cotton as a commercial product, the history of cotton in the South, what cotton did to the politics and the history of the United States, and how it affected areas outside the U.S.A. By the end of that evening I was ready to go off and photograph cotton in the U.S.A. with a different kind of background than I had when I started."

—*Carl Mydans*

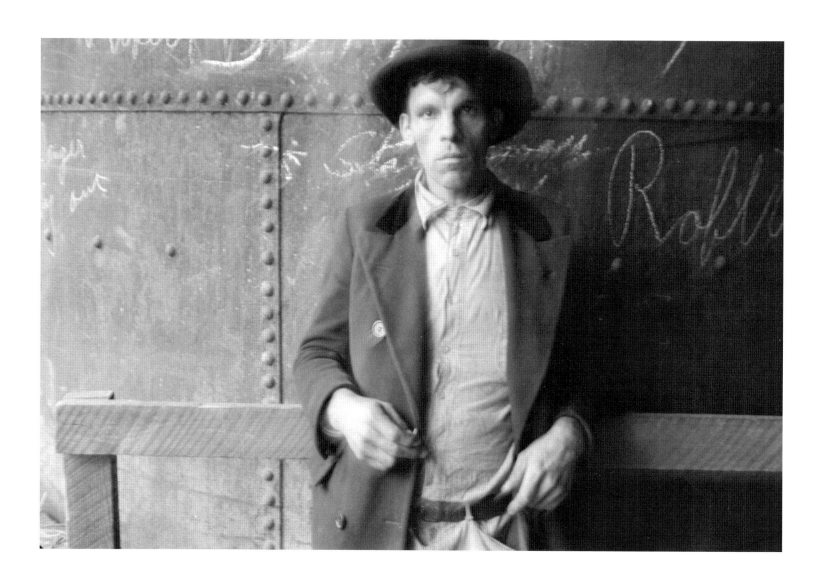

Cattle dealer. Western West Virginia. Ben Shahn. October 1935. LC-USF33-006130-M1.

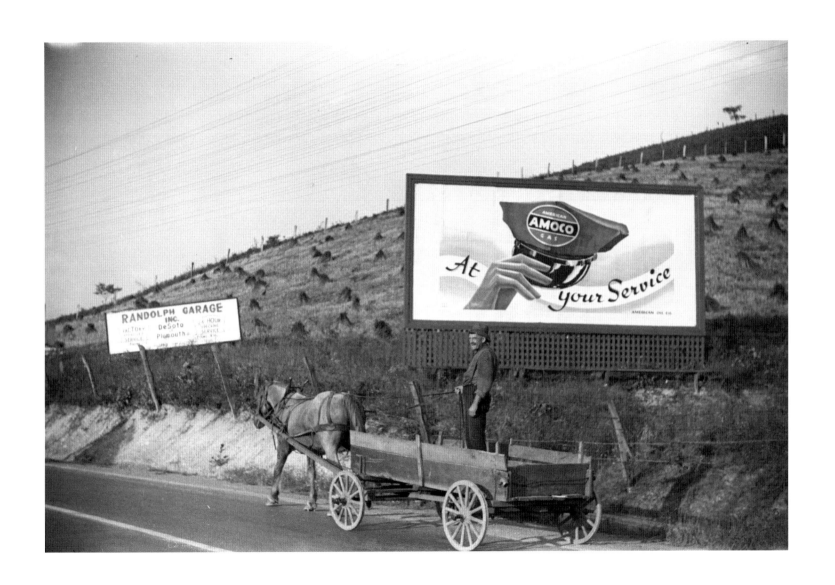

Farmer going to town along the highway. Near Elkins, West Virginia.
Marion Post Wolcott. September 1938. LS-USF33-030282-M3.

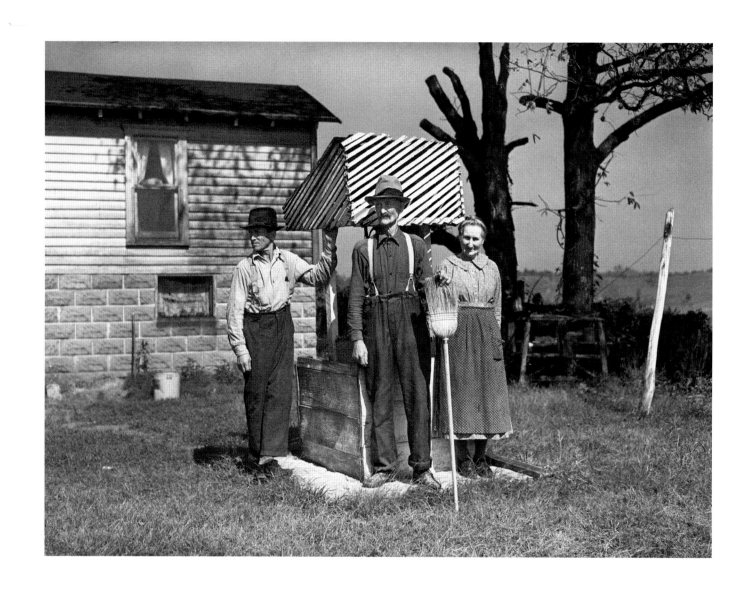

Farmer, his wife and son standing by well. North Central West Virginia.
Marion Post Wolcott. September 1938. LC-USF34-050092-E.

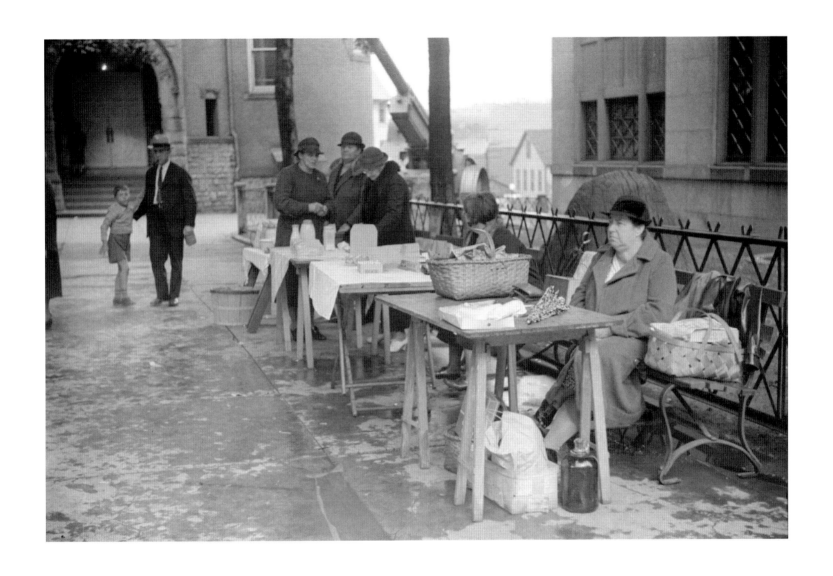

Farm women come to town on Saturday afternoon to sell eggs, milk, cakes, etc., in the courthouse square. Morgantown, West Virginia. Marion Post Wolcott. September 1938. LC-USF33-030169-M1.

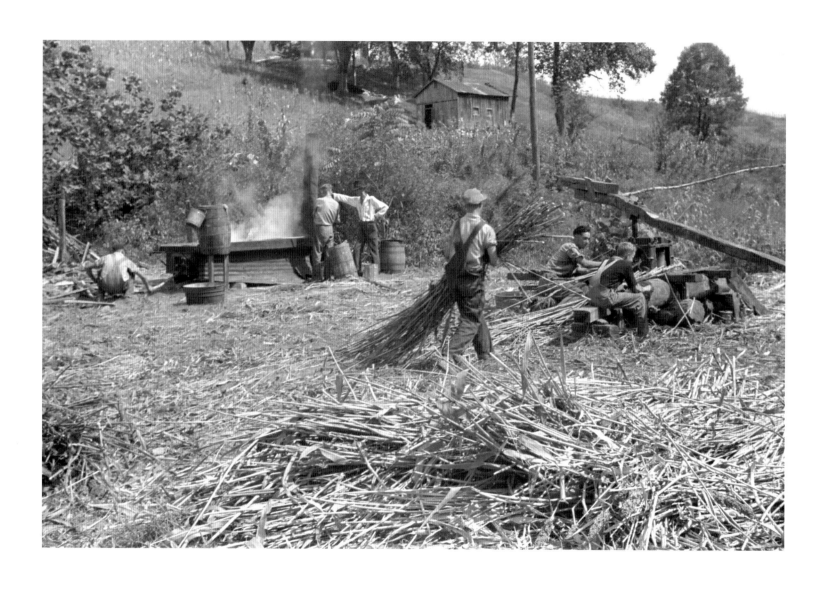

At right, pressing juice from sugarcane. At left, boiling it into sorghum molasses. Boone County, West Virginia. Marion Post Wolcott. September 1938. LC-USF33-030261-M2.

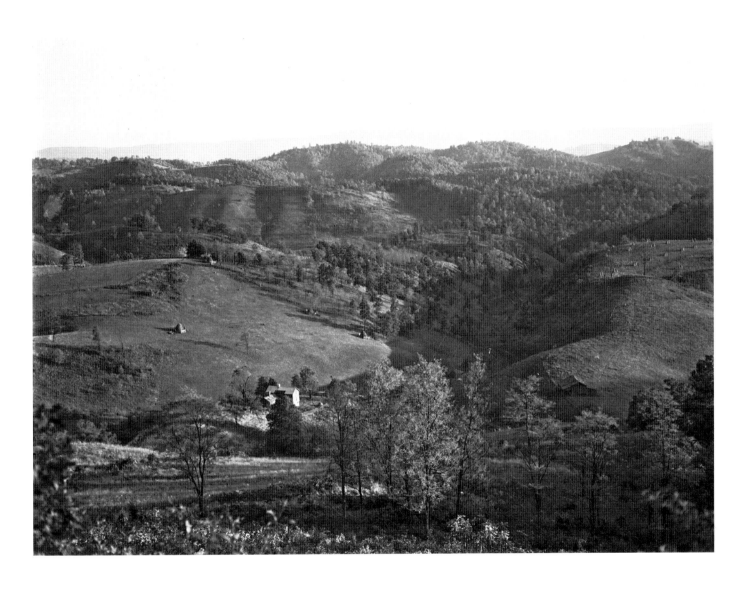

Hilly country with an occasional small farm in coal mining section of southern West Virginia.
Marion Post Wolcott. September 1938. LC-USF34-050127.

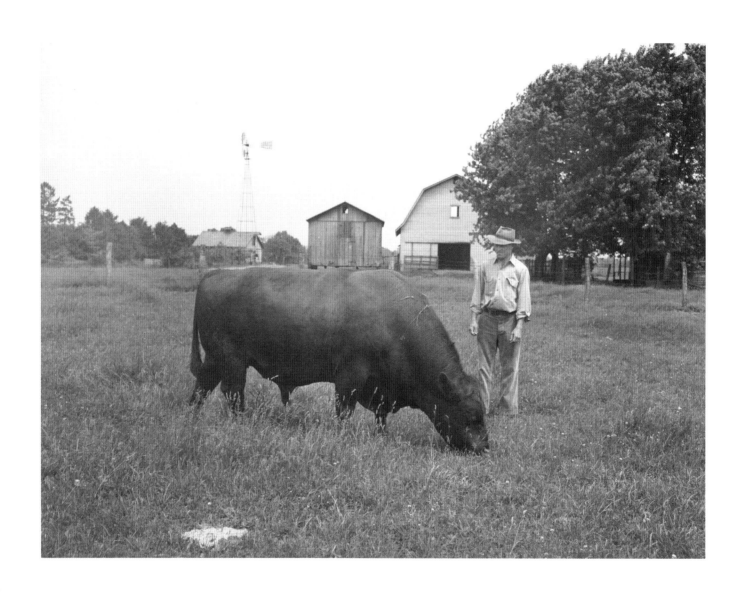

A short-horned bull at the farm of C.C. Lewis and Sons. Point Pleasant, West Virginia.
Arthur S. Siegel. May 1943. LC-USW3-029710-D.

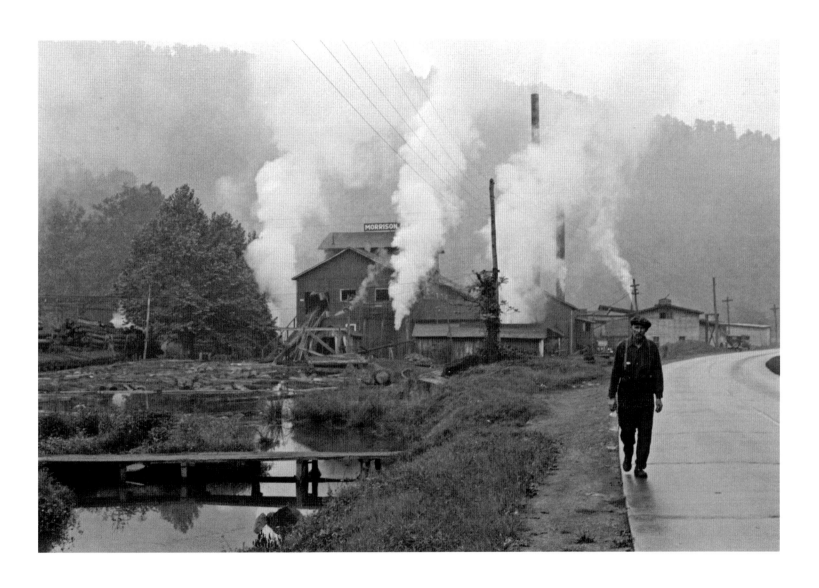

Morrison, Gross and Company, sawmill. Erwin, West Virginia.
Marion Post Wolcott. September 1938. LC-USF33-030303-M5.

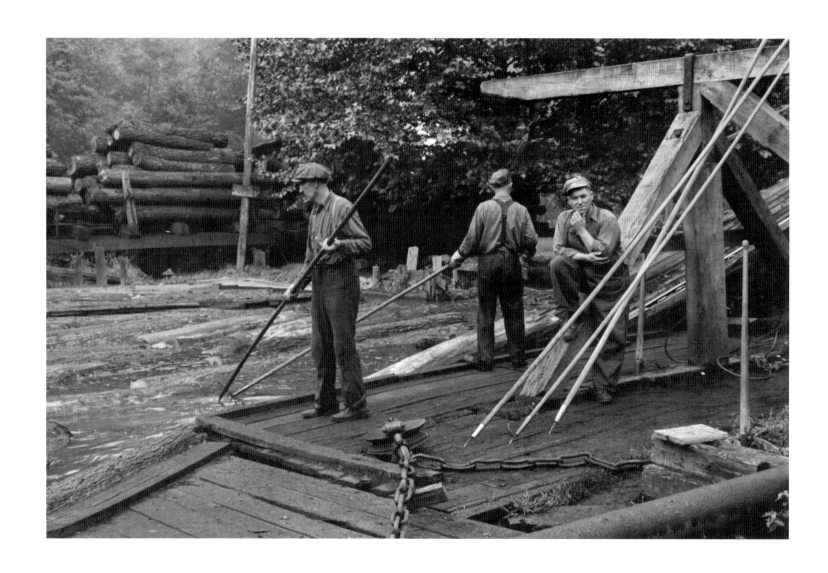

Men spiking logs to go up ramp into sawmill. It was working only halftime and was even slower in winter. "It's kinder hard them times. Concrete and steel's taking the place of lumber nowadays." Erwin, West Virginia. Marion Post Wolcott. September 1938. LC-USF33-030304-M2.

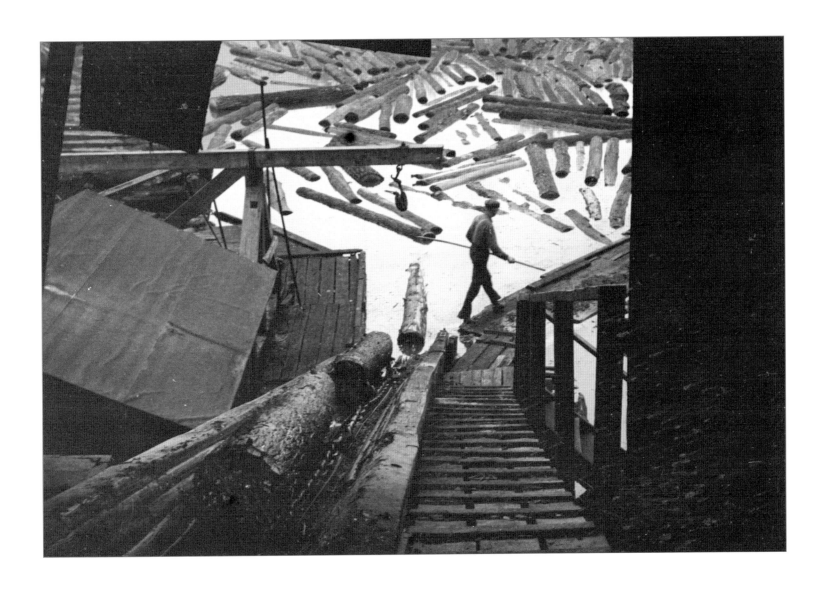

Man viewed from top of sawmill ramp. Erwin, West Virginia.
Marion Post Wolcott. September 1938. LC-USF33-030306-M1.

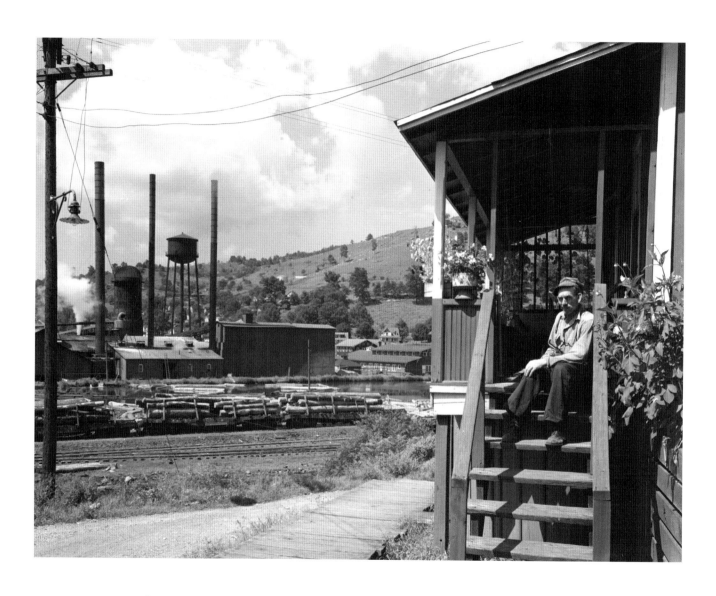

Company-owned worker's home near lumber mill. Richwood, West Virginia.
John Collier. September 1942. LC-USF34-083994-C.

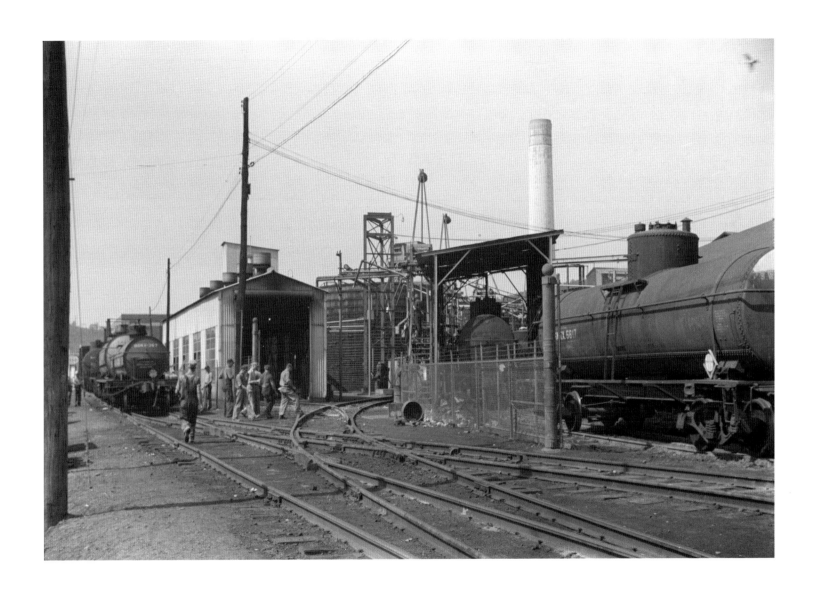

Section of Union Carbide Company plants. South Charleston, West Virginia.
Marion Post Wolcott. September 1938. LC-USF33-030270-M1.

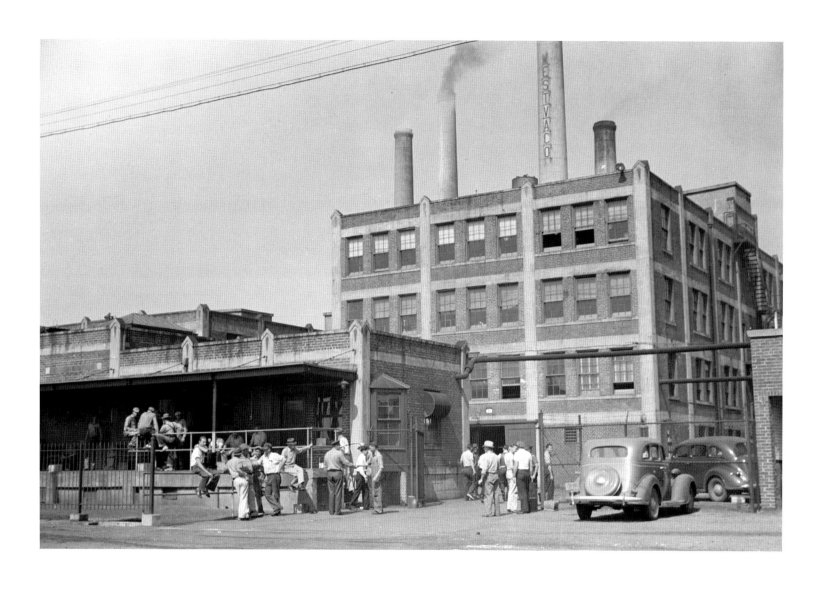

Lunch hour, part of Union Carbide Company, South Charleston, West Virginia.
Marion Post Wolcott. September 1938. LC-USF33-030271-M2.

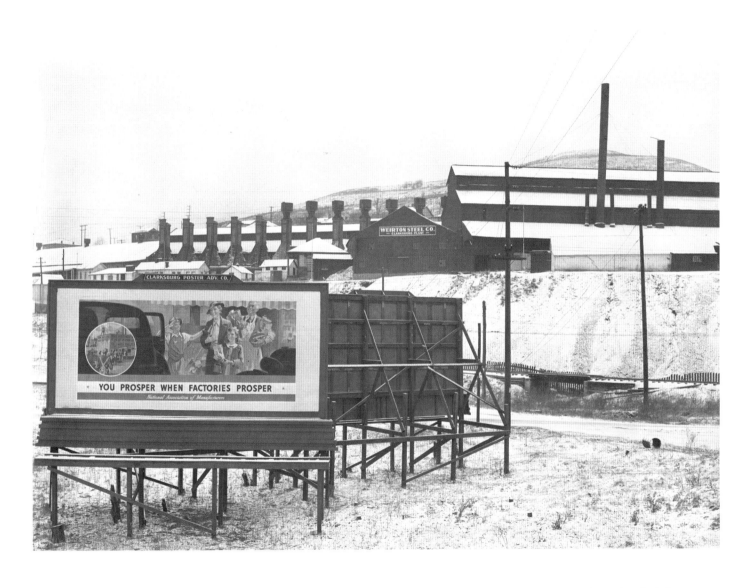

Steel plant not running. Clarksburg, West Virginia. Arthur Rothstein. January 1939. LC-USF34-027068-D.

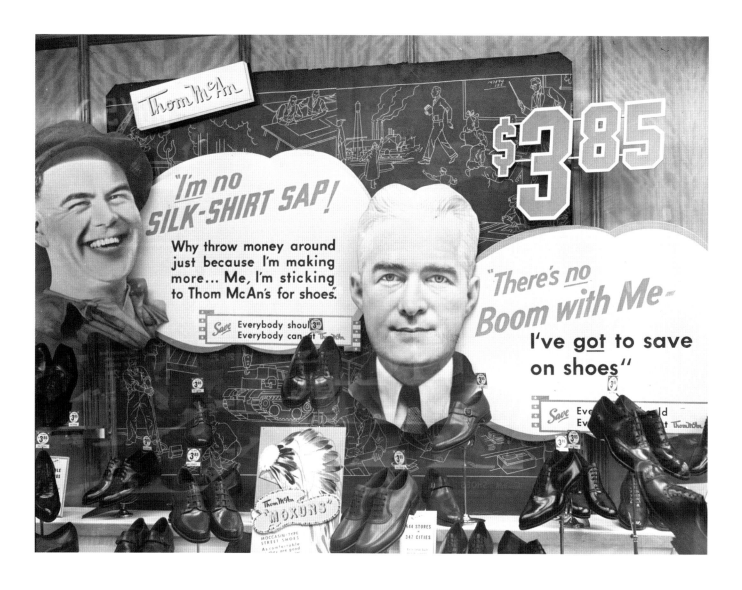

Shoe store window. Clarksburg, West Virginia. John Vachon. January 1942. LC-USF34-064410-D.

4

Northern Coalfields: 1935

Ben Shahn,
Oral history interview,
April 14, 1964.
Archives of American Art.

"SO, I WAS OFFERED THIS JOB to come down there but first it was suggested that I take a trip around the country in the areas in which we worked to see what it's all about, and I tell you that was a revelation to me. . . . It was really a very serious time. . . . I mean the present seemed to be hopeless and I just felt that I'd never get out of New York again. It was a really tough time and when this thing came along and this idea that I must wander around the country a bit for three months. . . . I just jumped out of my skin with joy. And not only that, they were going to give me a salary too! I just couldn't believe it. Anyway, I went and I found things that were very startling to me. For instance, I remember the first place I went to on this trip, where we were active—these resettlements that we built—I found that, as far as I was concerned, it was impossible to photograph. Neat little rows of houses, and this wasn't my idea of something to photograph, and I had the good luck to ask someone, 'Where are you all from! Where did they bring you from?'

〉〉〉

When they told me, I went down to a place called Scot's Run [*sic*] and there it began. I realized then that I must be on my own, find out, you know. . . .

I felt very strongly the whole social impact of that depression, you know, and I felt very strongly about the efforts [that] this Resettlement Administration was trying to accomplish; resettling people, helping them, and so on. I felt completely in harmony with the times. I don't think I've ever felt that way before or since. Totally involved. . . . I thought nothing of working through a night or something like that. . . . to print stuff or make posters or what have you."

—*Ben Shahn*

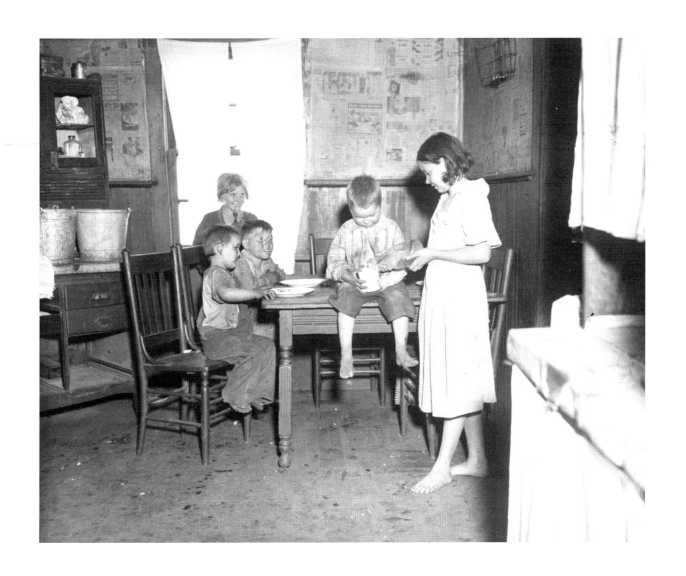

Children of coal miner. Scotts Run, West Virginia. Elmer Johnson. 1935. LC-USF34-015457.

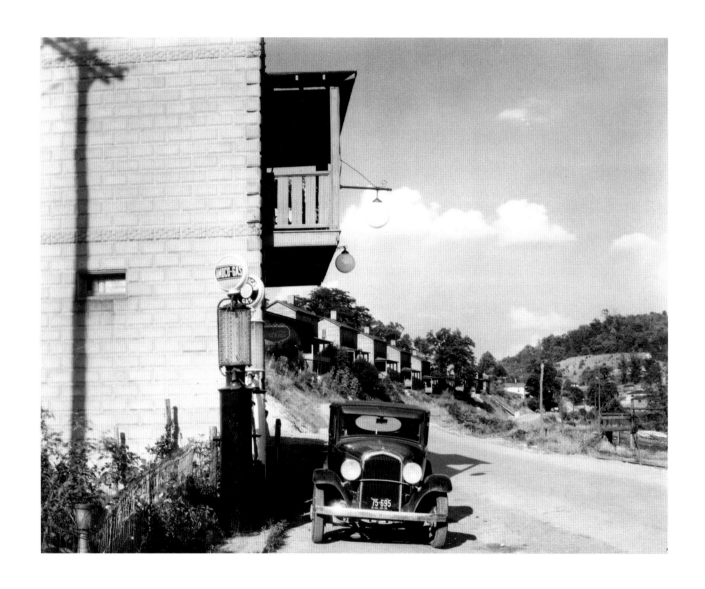

Scotts Run mining camps. Near Morgantown, West Virginia. Walker Evans. July 1935. LC-USF342-000857.

Interior of unemployed
man's house.
Morgantown,
West Virginia.
Walker Evans.
July 1935.
LC-USF342-T01-000889-A.

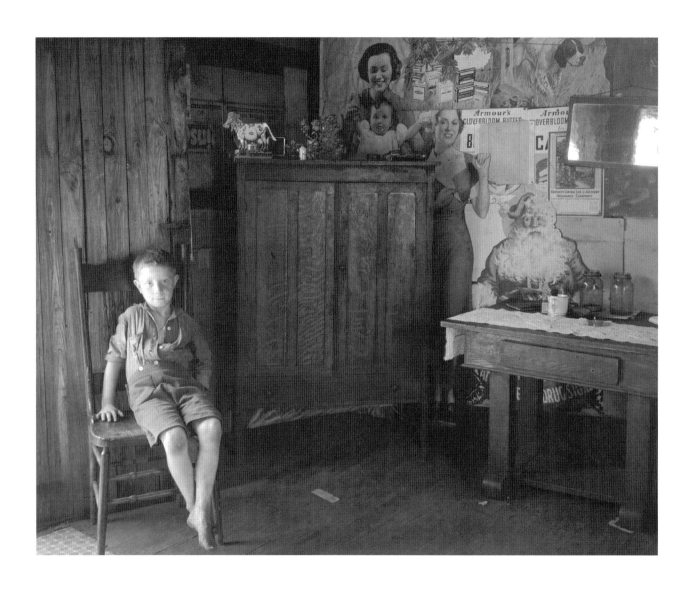

Interior of miner's shack. Scotts Run, West Virginia. Walker Evans. July 1935. LC-USF342-T01-000894-A.

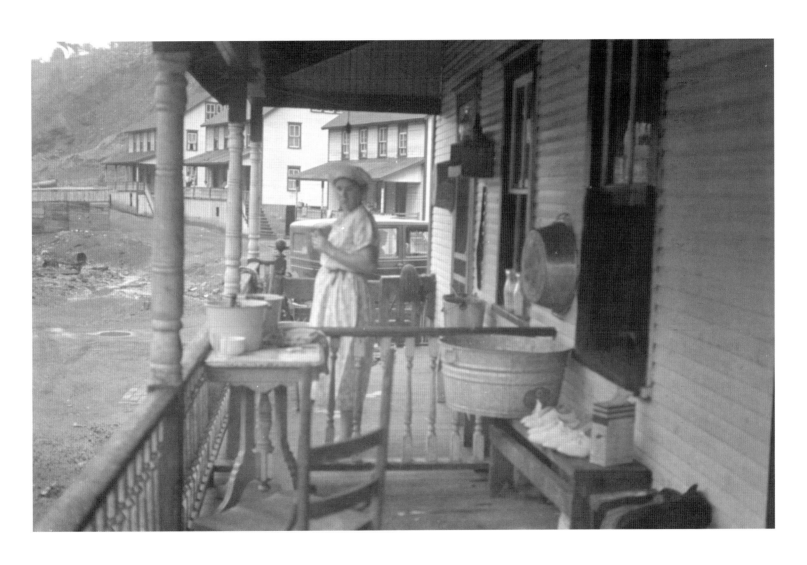

Woman on porch. Location and photographer not identified, but likely at Scotts Run, West Virginia, by Walker Evans. July 1935. LC-USF33-009004-M1.

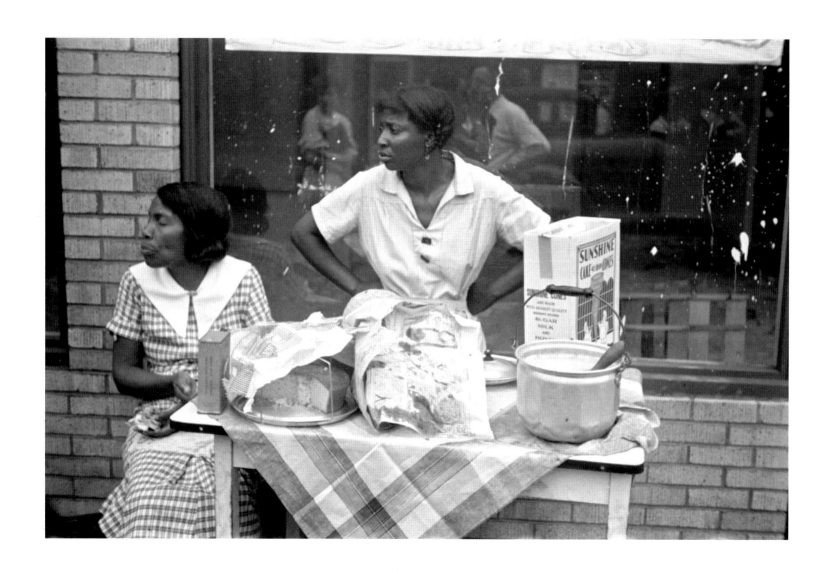

Women selling ice cream and cake. Scotts Run, West Virginia. Walker Evans. July 1935. LC-hUSF33-009005-M1.

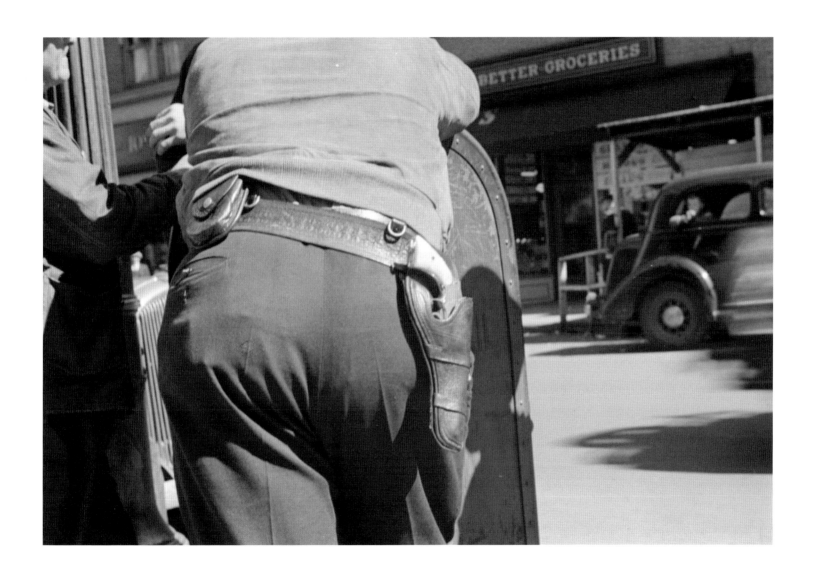

A deputy with a gun on his hip during the September 1935 strike. Morgantown, West Virginia.
Ben Shahn. September 1935. LC-USF33-006121-M3.

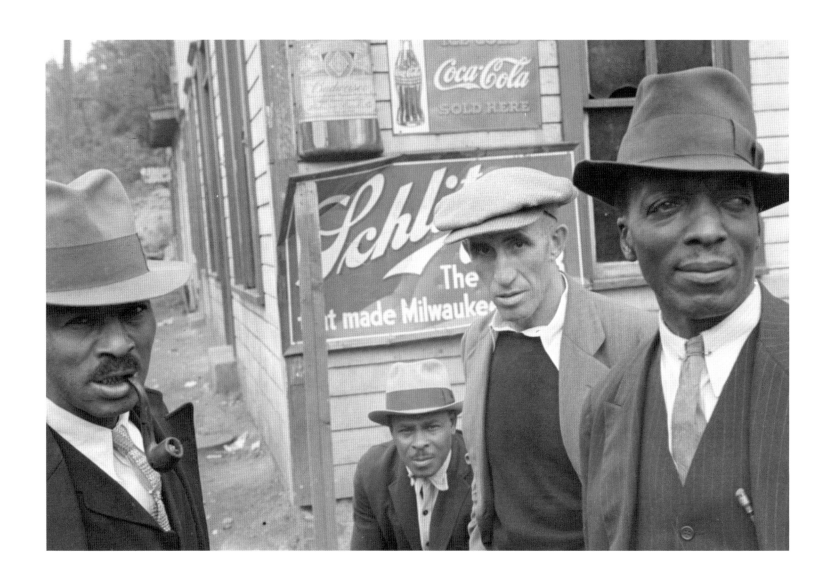

Sunday. Scotts Run, West Virginia. Ben Shahn. October 1935. LC-USF33-006115-M3.

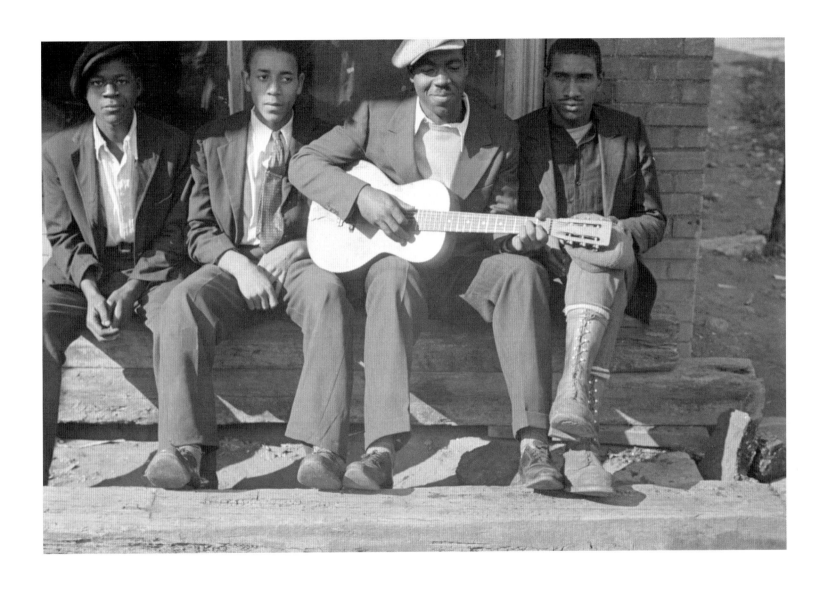

Guitar player and friends. Scotts Run, West Virginia. Ben Shahn. October 1935. LC-USF33-006118-M1.

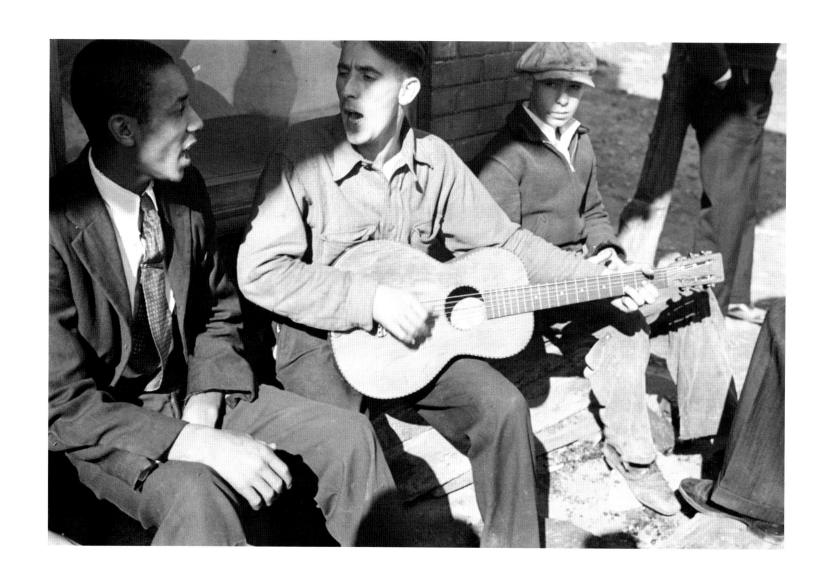

Men singing together. Scotts Run, West Virginia. Ben Shahn. October 1935. LC-USF33-006119-M4.

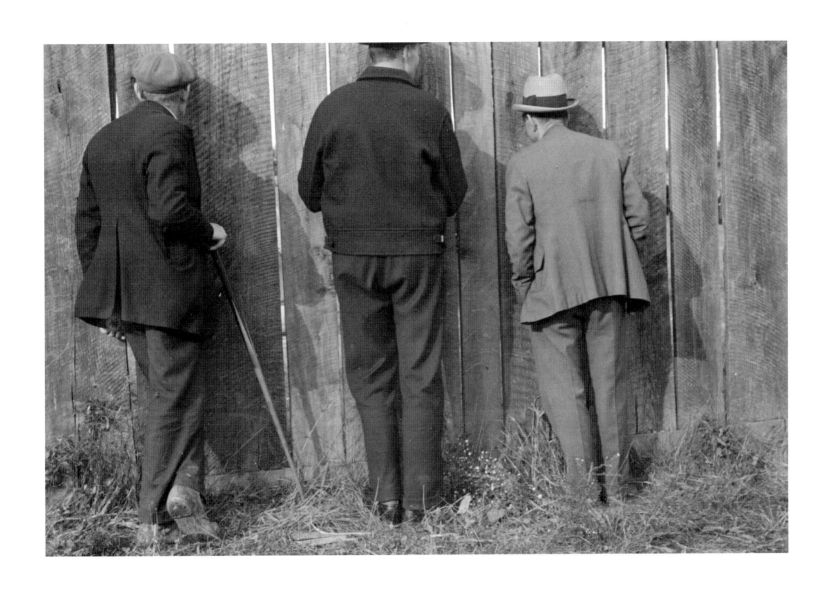

Watching a football game. Star City, West Virginia. Ben Shahn. October 1935. LC-USF33-006120-M5.

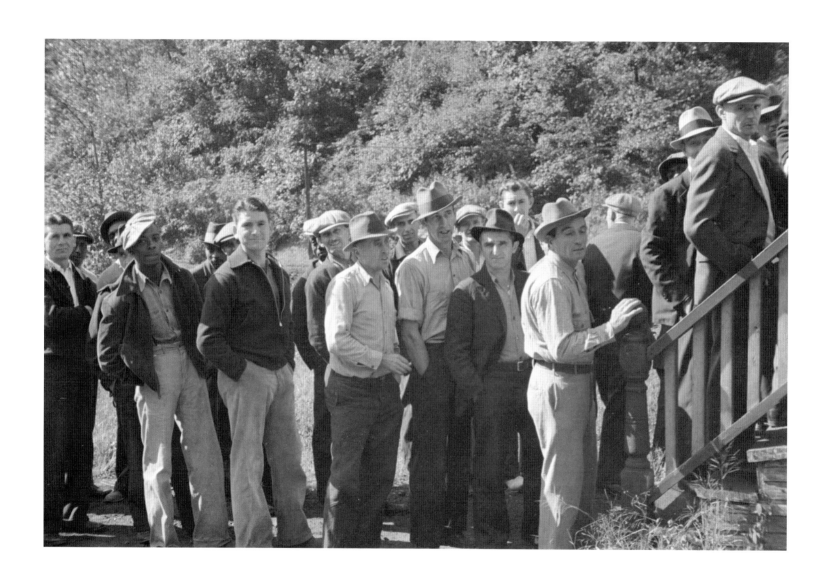

Payoff at Pursglove Mine. Scotts Run, West Virginia. Ben Shahn. October 1935. LC-USF33-006123-M2.

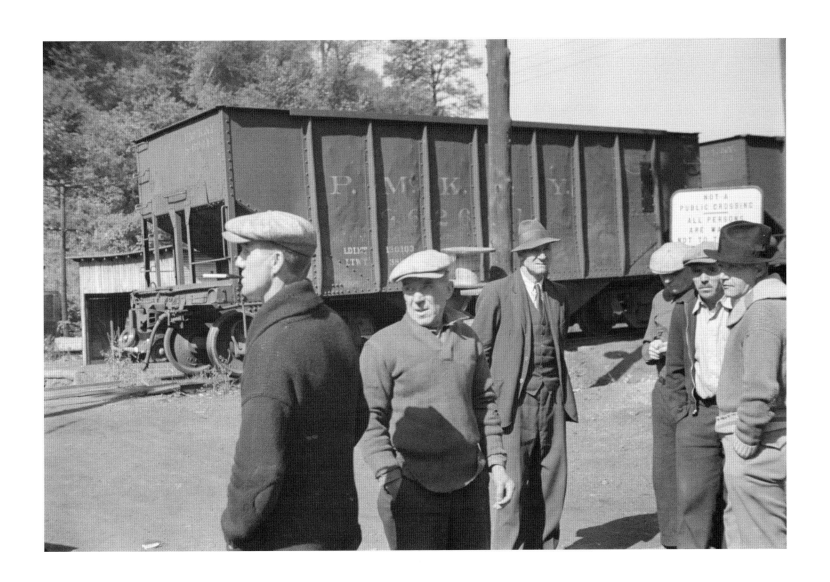

Striking miners. Scotts Run, Morgantown, West Virginia. Ben Shahn. October 1935. LC-USF33-006124-M5.

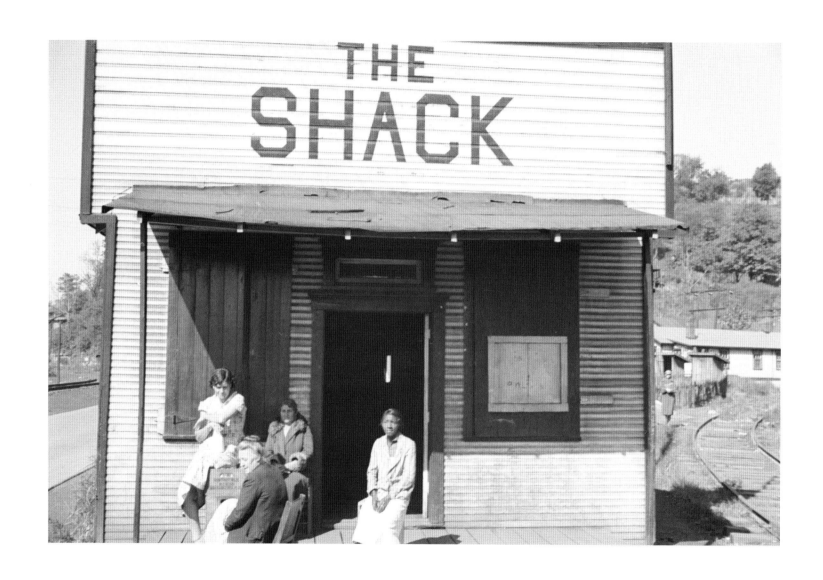

The Shack. Scotts Run, West Virginia. Ben Shahn. October 1935. LC-USF33-006125-M4.

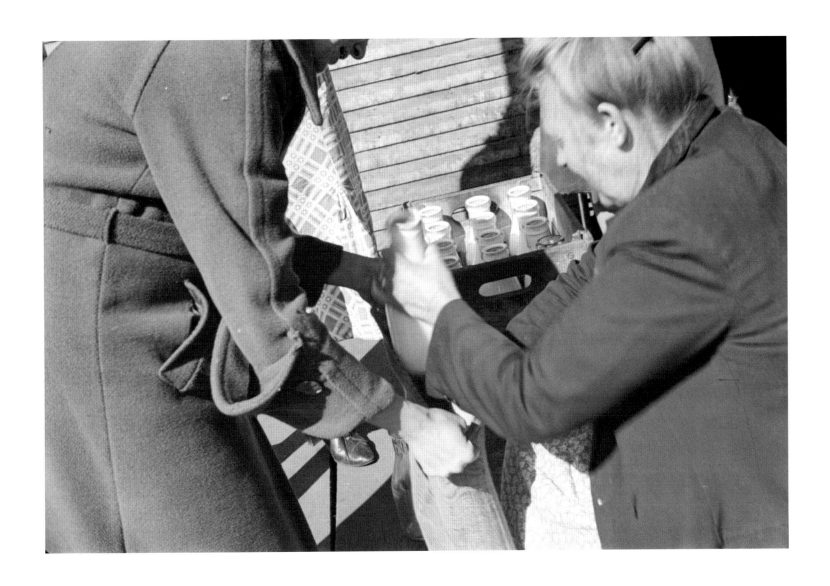

Dispensing milk at The Shack. Scotts Run, West Virginia. Ben Shahn. October 1935. LC-USF33-006125-M3.

5

Northern Coalfields: 1938

Eleanor Roosevelt, "My Day" syndicated column, May 30, 1939. Eleanor Roosevelt Papers Project.

"**WASHINGTON, MONDAY**—I told you yesterday that I would go on with some of the things I could not forget about the miners in Scotts Run, W. Va., so here goes.

One of them is the little girls' club meeting in the community house at Pursglove. Not a very elaborate community house, but it has one good sized room and a place which will someday be a kitchen and pantry if they ever get enough money to buy dishes and equipment. I asked those little girls what they were working for and with one voice they said: 'Some way to get to camp this summer.' Camp costs $3.58 a week for every child. They can't pay that, of course, and the welfare agency probably isn't going to be able to provide much this year. But, to those little girls, camp means three weeks of adequate food and real opportunity for enjoyment and they are going to do their level best to find some way to work for it.

Scotts Run is typical, of course, of many communities, not only mining areas, but in mill areas and farm areas where they have had droughts and floods, in any area in which the industry by which the people have lived has petered out for one reason or another and has left behind a people with no means of support.

〉〉〉

Two things make democracy valuable, freedom and the opportunity to make a living, but freedom without that opportunity is rather valueless. So it seems to me that every one of us who cares about democracy should examine our own communities and make sure that there are no conditions there which are giving democracy a bad name. Perhaps you think you can do nothing about it. If enough people, however, get together something can be done in almost every community and you, as a citizen, are responsible in doing your share to make your community, as part of a democratic nation, a place worth living in.

We will soon be celebrating Decoration Day. On that day we honor the sacrifices made by innumerable people in wars fought, first to free our nation, then to keep it united and free. Today we rejoice that the necessity of fighting a war is not upon us, but if we have any understanding of our times we know that day by day our government and each one of us is on the firing line in a new age, facing new problems, new conditions which have not confronted us in the past, and which we, therefore, do not know just how to meet.

I can imagine how helpless some of the early settlers were when some strange new disease attacked the human beings or the animals which they had brought with them. Over and over again, a family lost several children, perhaps the man of the family or the mother, and sometimes all the cattle. It took years of painstaking research, of living through bad conditions without knowing the answers before many of these pioneering difficulties were finally solved. Our economic ills in the machine age are difficult and yet similar. When I remember my little girls, I know we too will find the solutions."

—Eleanor Roosevelt

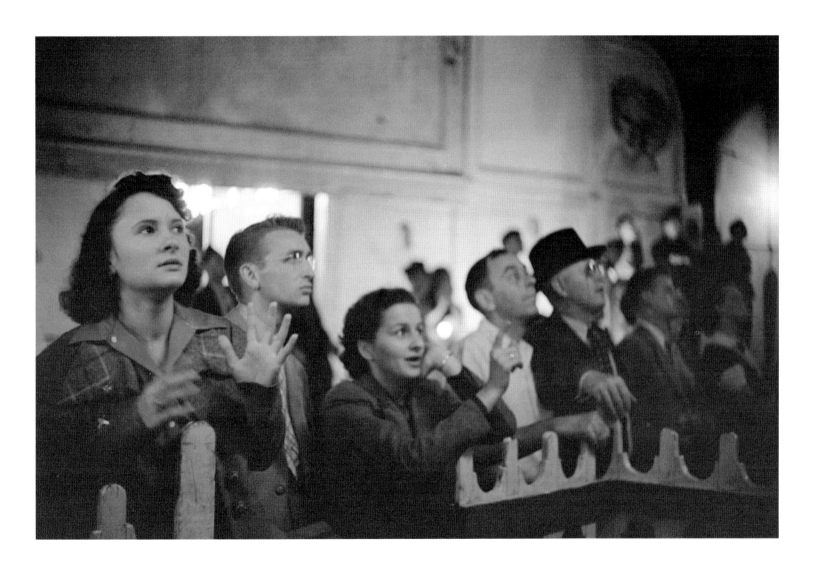

Coal miner's daughter, at left, and others at outdoor carnival watch man being shot from cannon.
Granville, West Virginia. Marion Post Wolcott. September 1938. LC-USF33-030296-M4.

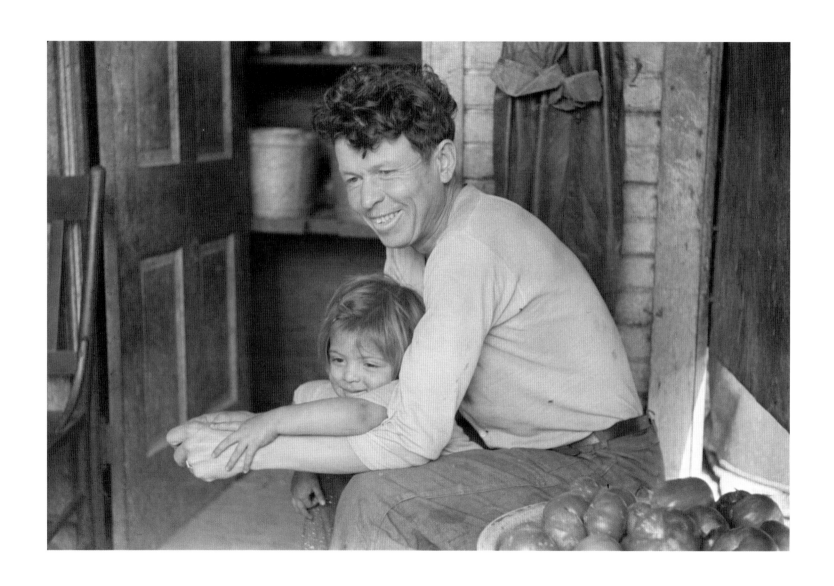

Mexican miner and child. Bertha Hill, Scotts Run, West Virginia. Marion Post Wolcott. September 1938. LC-USF33-030197-M5.

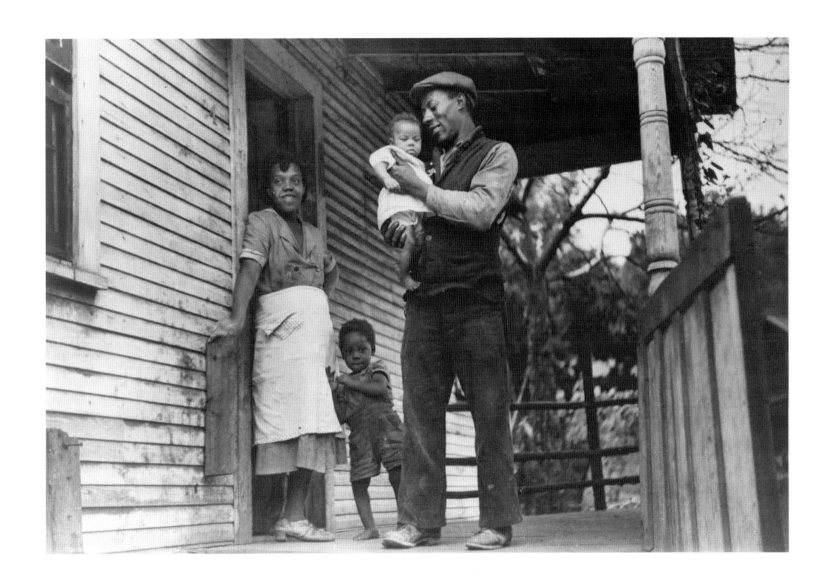

Coal miner, his wife, and two of their children (note child's legs). Bertha Hill, Scotts Run, West Virginia. Marion Post Wolcott. September 1938. LC-USF33-030206-M5.

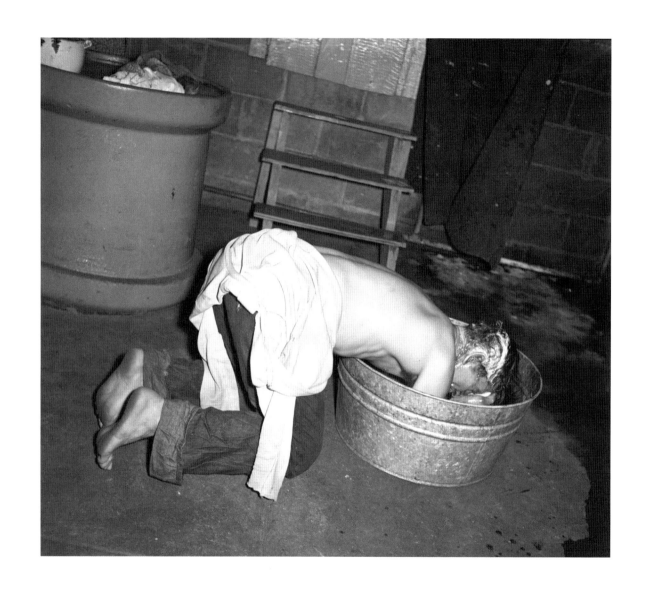

Miner takes washtub bath as most of the families do. Westover, West Virginia.
Marion Post Wolcott. September 1938. LC-USF34-050290-E.

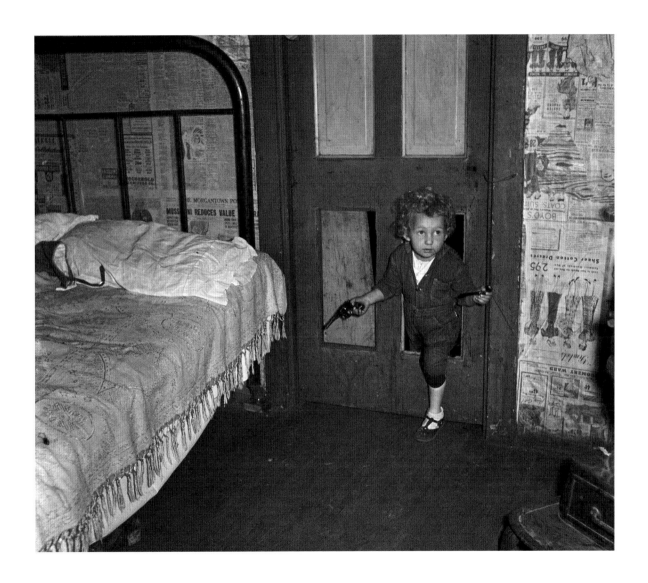

Why open the door, coal miner's child uses the "cat hole." (Note pipe in one hand, gun in other.) Bertha Hill, Scotts Run, West Virginia. Marion Post Wolcott. September 1938. LC-USF34-050348-E.

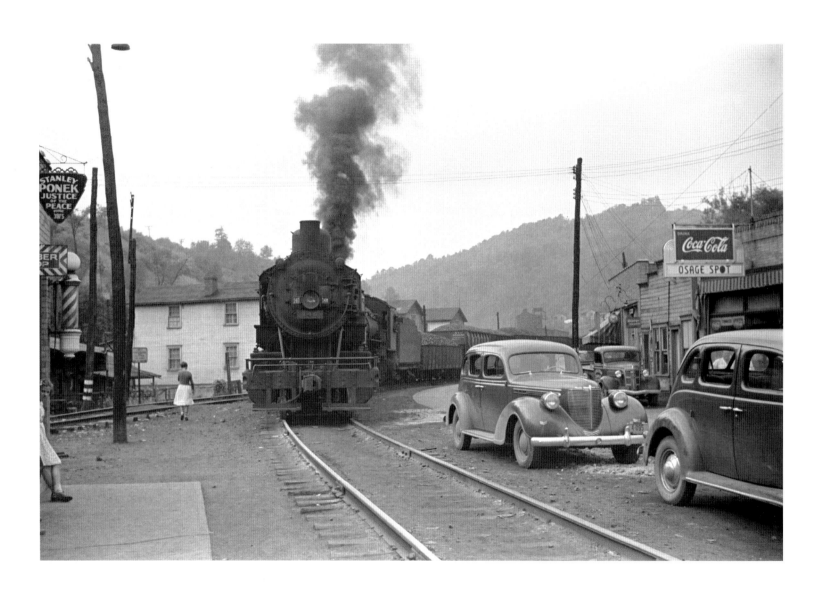

Train pulling coal through center of town morning and evening. Osage, Scotts Run, West Virginia. Marion Post Wolcott. September 1938. LC-USF33-030251-M2.

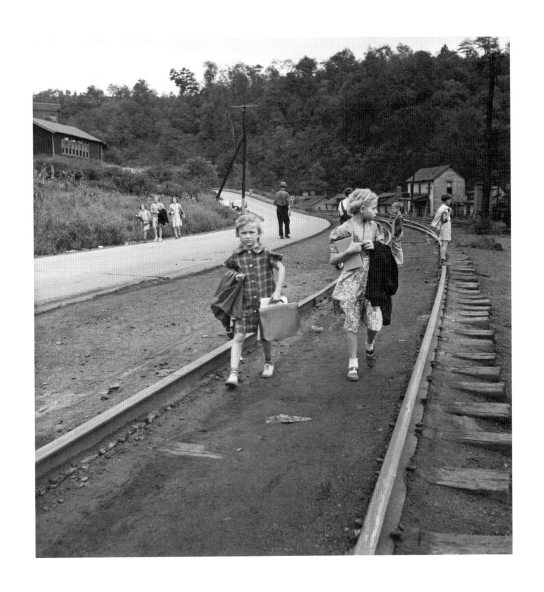

Coming home from school. Mining town. Osage, Scotts Run, West Virginia.
Marion Post Wolcott. September 1938. LC-USF34-050352-E.

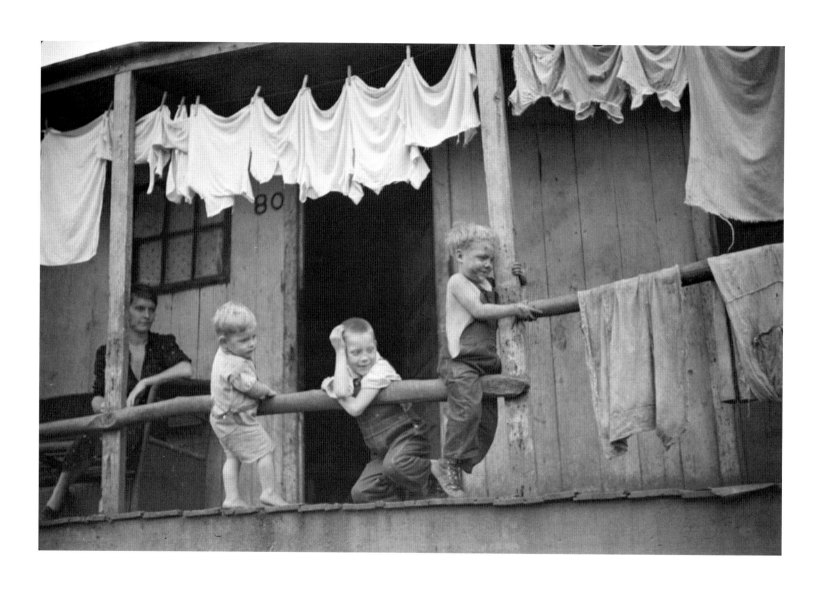

Coal miner's family. Pursglove, Scotts Run, West Virginia. Marion Post Wolcott. September 1938. LC-USF33-030160-M3.

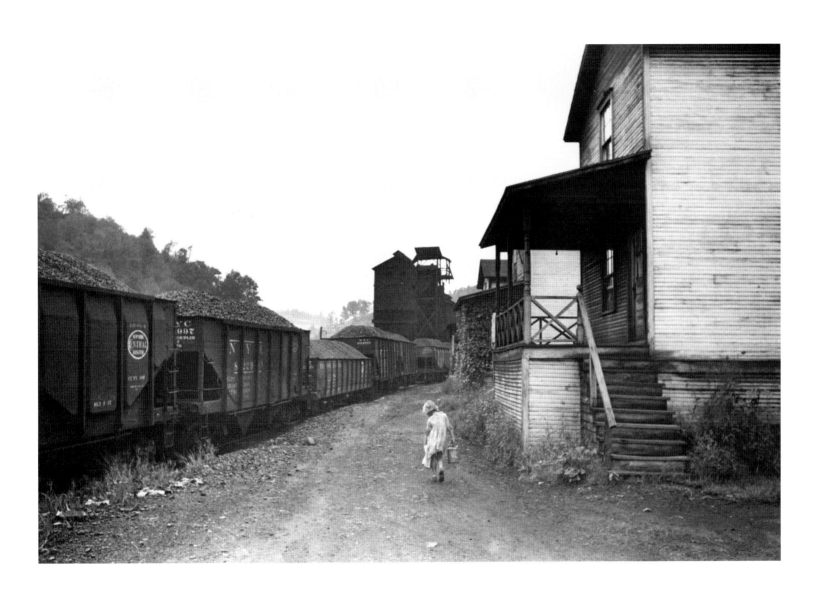

Coal miner's child taking home kerosene for lamps. Company houses, coal tipple in background. Pursglove, Scotts Run, West Virginia. Marion Post Wolcott. September 1938. LC-USF33-030180-M2.

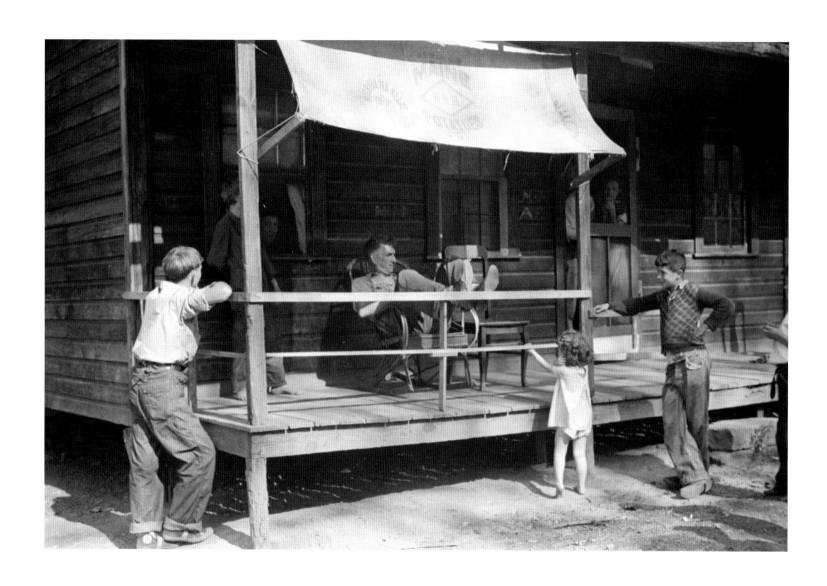

Former coal miner sitting on his front porch. He is the town philosopher. He repairs his home (note railing and potato sack awning). Experiments with an elaborate garden on a hill about seven miles away. Jere, Scotts Run, West Virginia. Marion Post Wolcott. September 1938. LC-USF33-030219-M3.

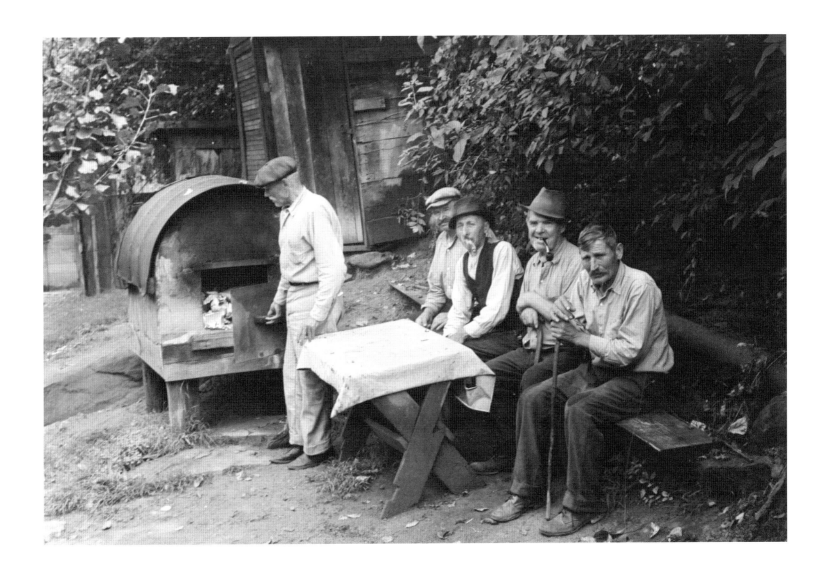

Bohemian miners (coal loaders) unemployed since mechanization of the mines. To the left is an outdoor oven for baking bread. Jere, Scotts Run, West Virginia. Marion Post Wolcott. September 1938. LC-USF33-030289-M3.

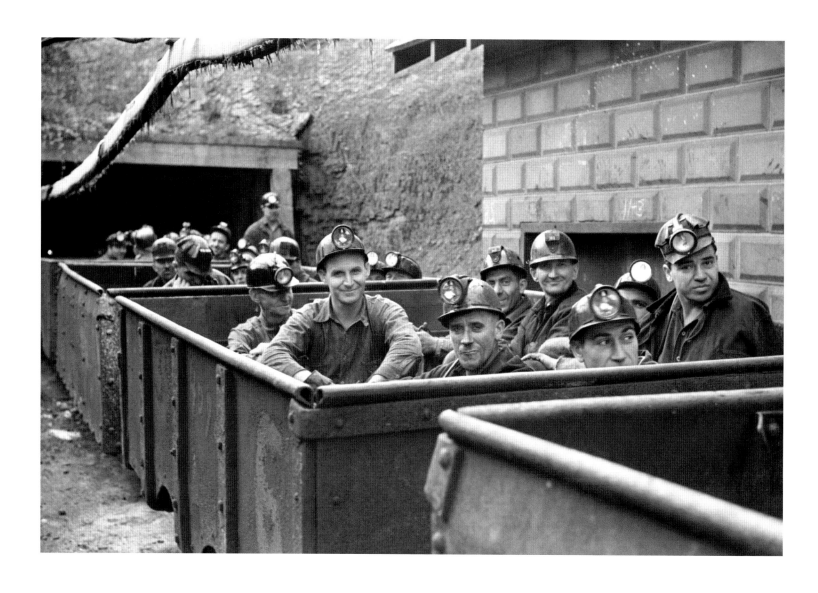

The next "trip." Coal miners ready for next shift to go into the mines. Maidsville, West Virginia. Marion Post Wolcott. September 1938. LC-USF33-030291-M3.

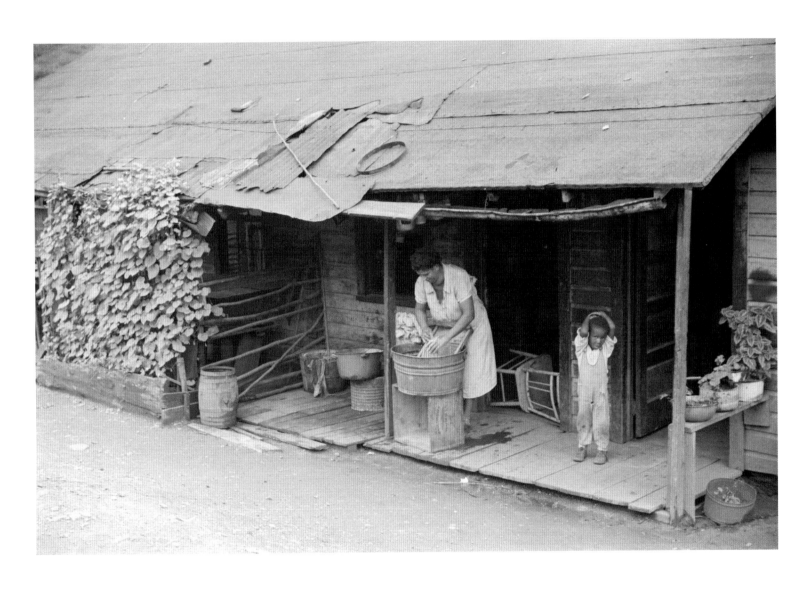

Coal miner's wife washing clothes on the front porch. Chaplin, Scotts Run, West Virginia. Marion Post Wolcott. September 1938. LC-USF33-030141-M4.

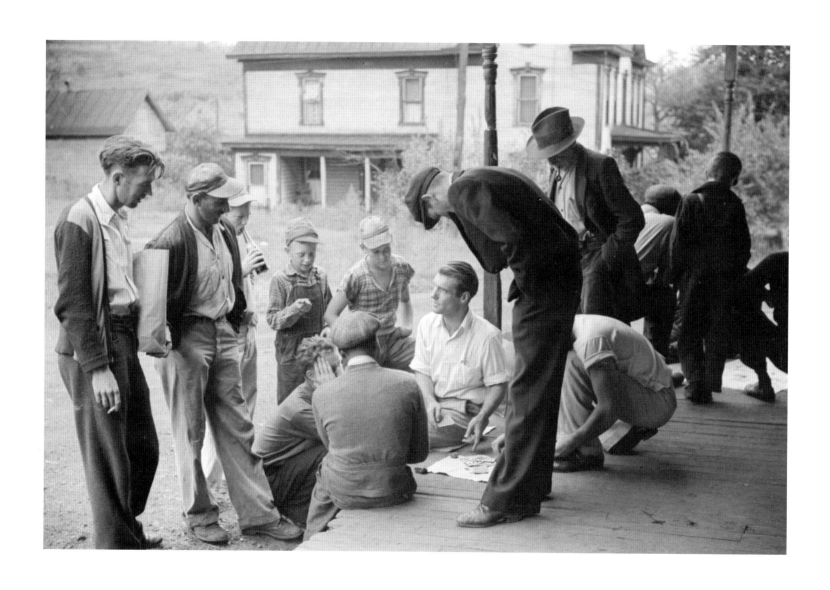

Coal miners card gambling Saturday afternoon on porch of company store. Chaplin, Scotts Run, West Virginia. Marion Post Wolcott. September 1938. LC-USF33-030142-M4.

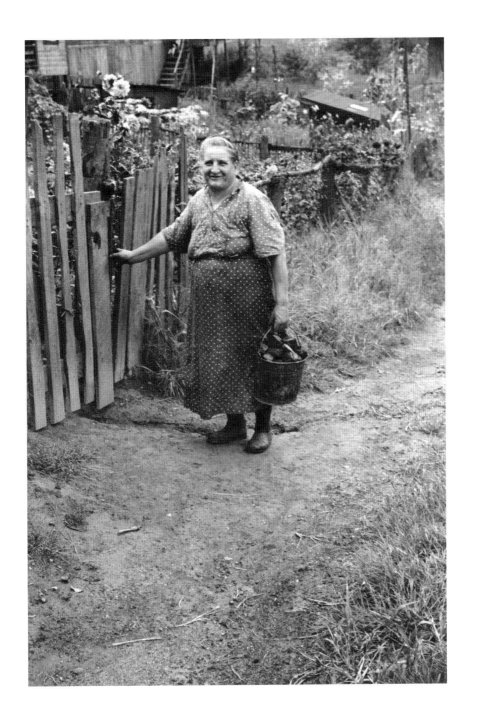

Hungarian miner's wife bringing home coal for the stove from slate pile. Coal camp. Chaplin, Scotts Run, West Virginia. Marion Post Wolcott. September 1938. LC-USF33-030308-M4.

Model Communities: Arthurdale

Roy Stryker,
"Suggestions for
Community Photographs,"
undated.
Roy E. Stryker Papers.

"SUGGESTIONS FOR COMMUNITY PHOTOGRAPHS:

The following 'shots' are suggested for gathering photographic material on 'Life on the Homesteads.' Keep in mind that the purpose is to show that the residents are leading normal, settled lives. The families eat, sleep, work, laugh, raise children, gossip, picnic, read books and wash clothes. There are certain things, however, they are doing that they have never done before—taking part in community association meetings and home demonstration classes, canning their own food supply, planning and planting their gardens, and taking part in cooperative enterprises, i.e. the trading post, ball clubs, pasture committees, poultry projects, weaving and handwork classes, dramatic and art classes. Try to show those new activities against a perfectly normal community background. Stress any incidents that show the residents as responsible, hard working, family loving, settled citizens.

BE SURE TO HAVE AT LEAST ONE HOMESTEADER IN EVERY PHOTOGRAPH.

>>>

Following are suggested 'shots' that might serve as a basic outline for photographs in any of the communities:

1. Panoramic view of the project—Have the project family, husband or children in the foreground, perhaps in profile, with the house and community structures in the background. (A perfect example of this is the still from 'The Plow that Broke the Plains' showing the cow-boy on the hill with the cattle and grass clumps in the background.)

2. The house and family, unposed—Try to arrange that the members of the family are doing something, i.e. the woman canning, shelling peas or hanging out the wash—the man working in the garden, etc.

3. Work pictures—Showing the man working the fields, in the dairy or the community work shop, constructing houses or roads. Try to have the work well enough along so that the picture itself will be sufficiently explanatory, i.e. if it is haying, have the man throwing on the last few forkfuls; if it is road construction, have a portion of the completed road in the background.

4. Women's activities—Group canning in one of the homestead kitchens, a meeting of the community sewing class or garden club. If there are no group meetings, a shot of a homestead wife repainting the kitchen furniture, hanging out a large wash (take that part of the line where the garments will identify the number and sex of the family), or screwing the caps on her latest batch of canned tomatoes, or the woman and her children gathering the garden produce for future canning.

5. Recreation—A meeting of the community association, picnics, cornhuskings, or any one of the scheduled group gatherings showing the homesteaders in a jovial mood.

6. Trading Post—Interior, if possible, showing the homestead clerk and homestead customers. If not, get a group in front of the store and a homestead wife or husband coming out with a laden basket and bundles.

7. Men on the way to work—If it is a subsistence homestead project, try to get the men starting off in carloads to work in the nearby city. If it is an agricultural project, get a group of the men starting off for their work in the fields or house construction. If you cannot get a group, have one of the homestead wives and her children waving to the man as he starts off complete with dinner pail, etc. Or, get the men returning from work.

8. Health—If there is a doctor or nurse on the project, get them examining one of their patients. If there is a clinic, get the patients in the waiting room and the doctor in the background. If there is a medical co-op, get some of the homesteaders discussing things with the doctor or nurse.

9. Community houses—If there is a community house, get a shot of it with the homesteaders in the foreground.

10. New Babies—If there are any, get the proud parents and the other children together with the new arrival—unposed.

11. Gardens—Show members of the family working in their gardens—two adjoining homesteads, if possible, with the two families. Providing there is a fence, you might have the two husbands leaning over the fence discussing things while looking over their joint property.

12. Visitors—If there are a number of visitors, show the line of cars in the foreground and the project houses and buildings in the background—or show some visitors entering a project house with the homestead wife in the doorway— or talking things over with the homestead family on the front porch.

13. Nursery School—If there is one.

14. Cooperative activities—Showing group of the men or women working together on any of the cooperative enterprises, i.e. the poultry or hog projects, dairy farm, cooperative study groups, etc.

15. Any other interesting shots."

—*Roy Stryker*

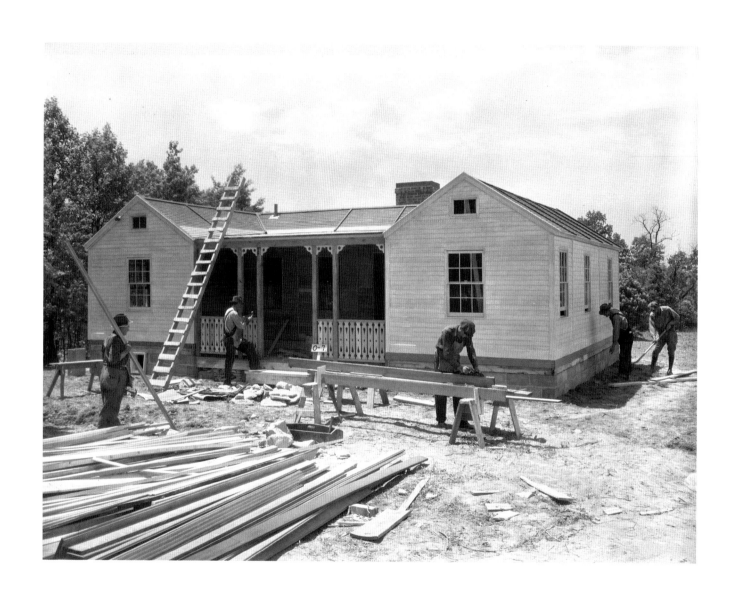

House under construction. Arthurdale project. Reedsville, West Virginia.
Elmer Johnson. May 1934. LC-USF342-001044-A.

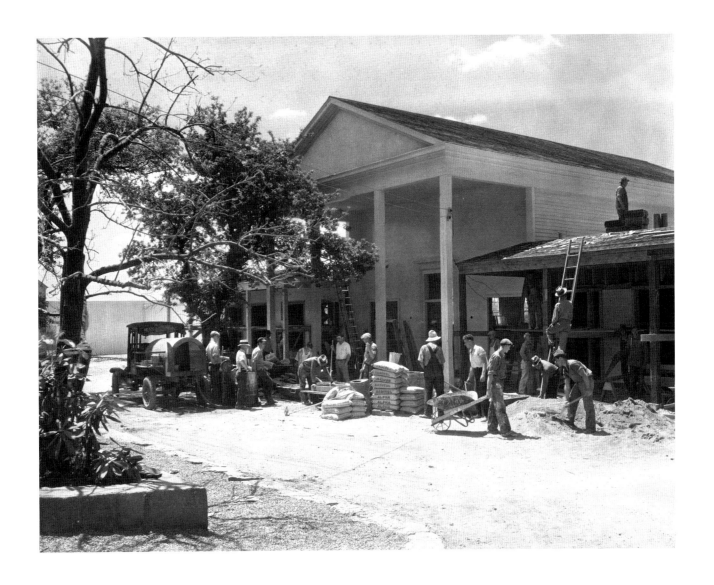

Community center. Arthurdale project. Reedsville, West Virginia.
Elmer Johnson. June 1934. LC-USF342-001066-A.

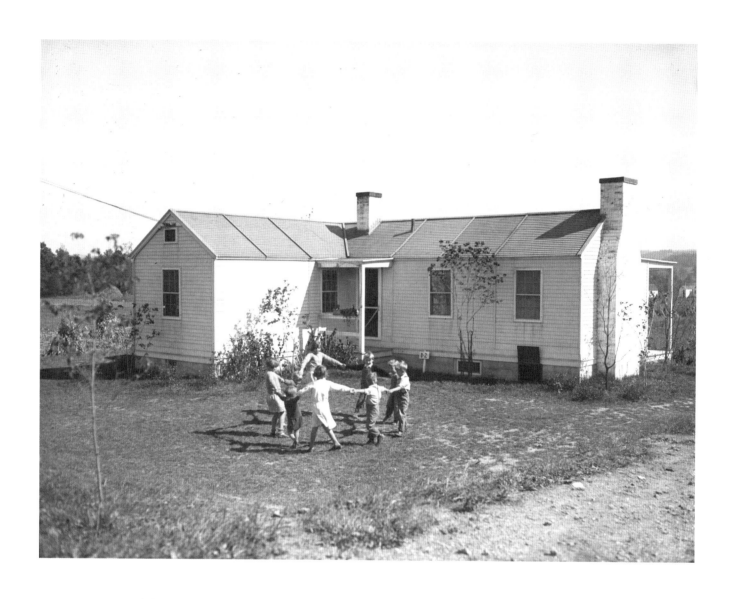

Children in front of their new home. Arthurdale project. Reedsville, West Virginia.
Elmer Johnson. October 1934. LC-USF34-001050-C.

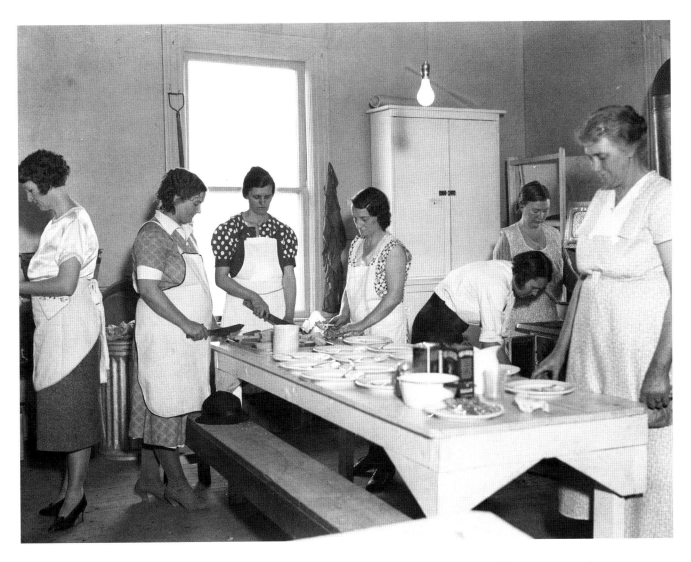

Women volunteers preparing school lunch. Arthurdale project. Reedsville, West Virginia. Elmer Johnson. April 1935. LC-USF34-001004-C.

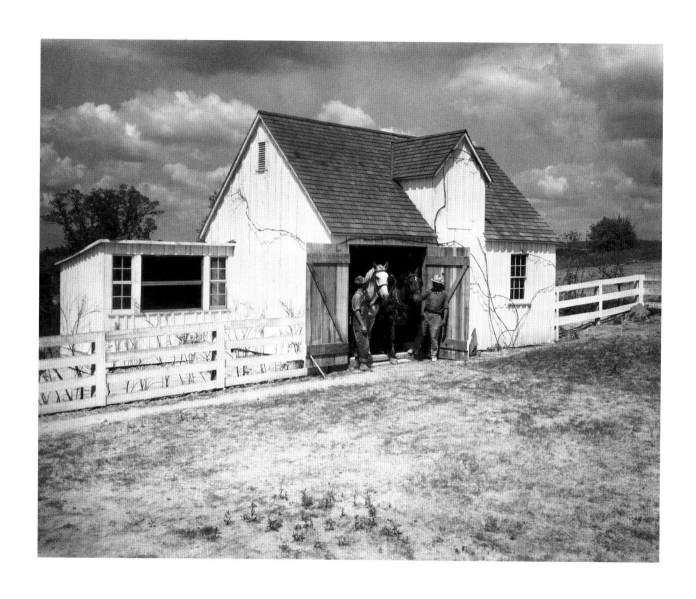

Barn. Arthurdale project. Reedsville, West Virginia. Elmer Johnson. April 1935. LC-USF342-001098-A.

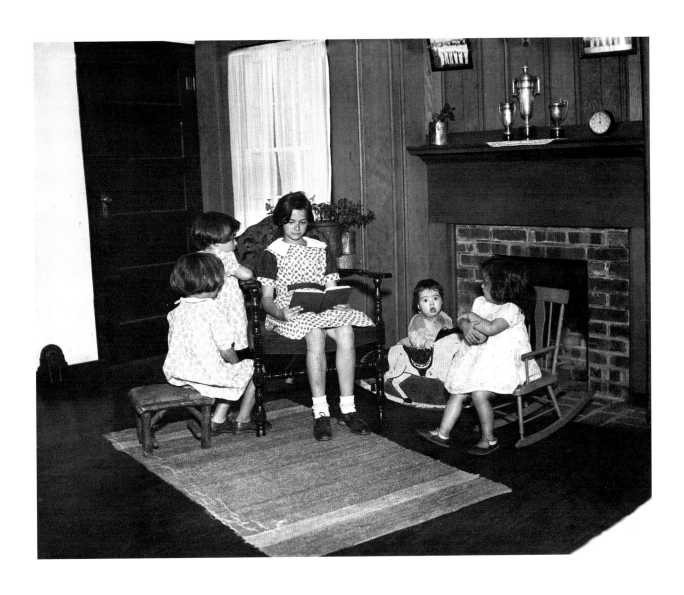

Children in new home on the Arthurdale project. Reedsville, West Virginia.
Elmer Johnson. 1935. LC-USF34-015456-C.

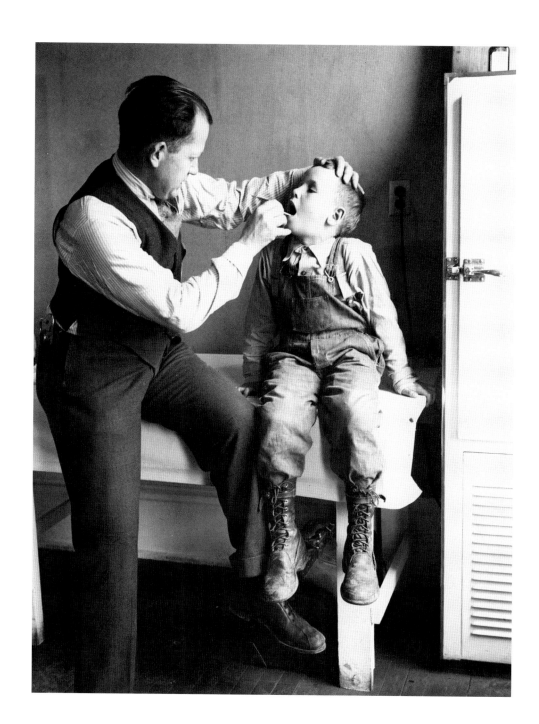

Doctor examining a
boy's throat.
Arthurdale project.
Reedsville,
West Virginia.
Elmer Johnson.
April 1935.
LC-USF34-001063-C.

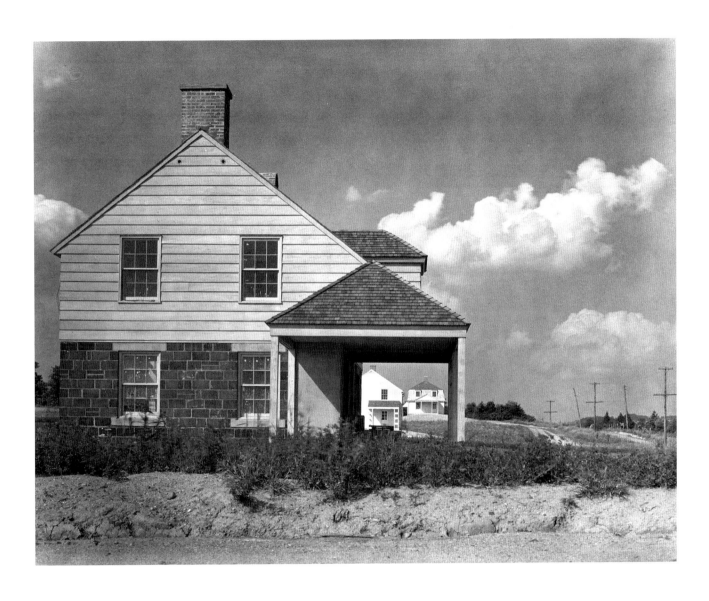

Homes. Arthurdale project. Reedsville, West Virginia. Walker Evans. June 1935. LC-USF342-000840-A.

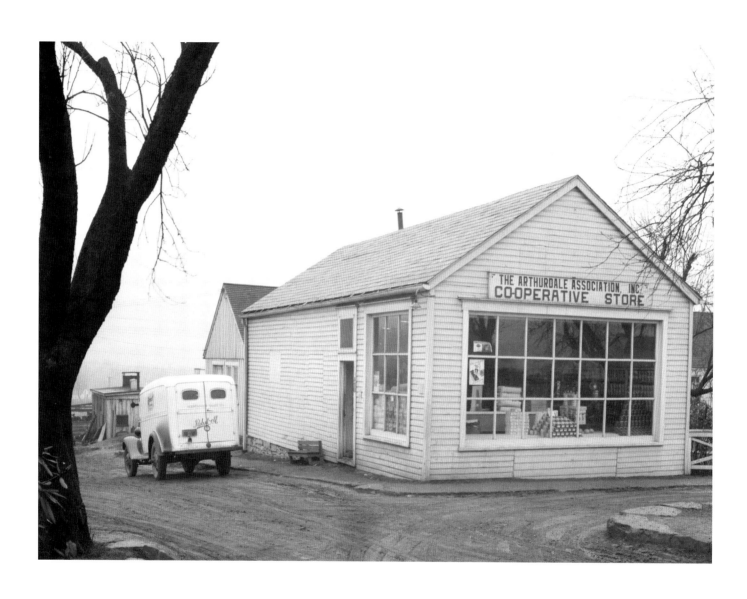

Cooperative general store at Arthurdale project. Reedsville, West Virginia.
Edwin Locke. December 1936. LC-USF34-013031-D.

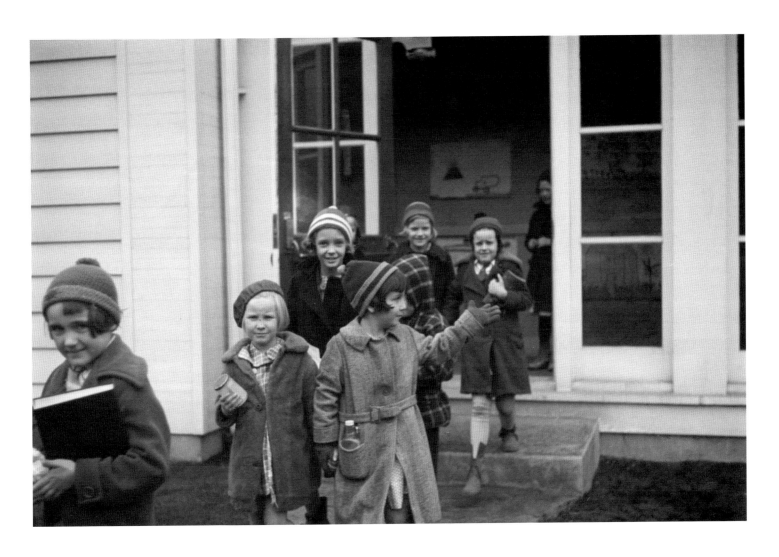

Children leaving grade school. Arthurdale project. Reedsville, West Virginia.
Edwin Locke. December 1936. LC-USF33-004166-M2.

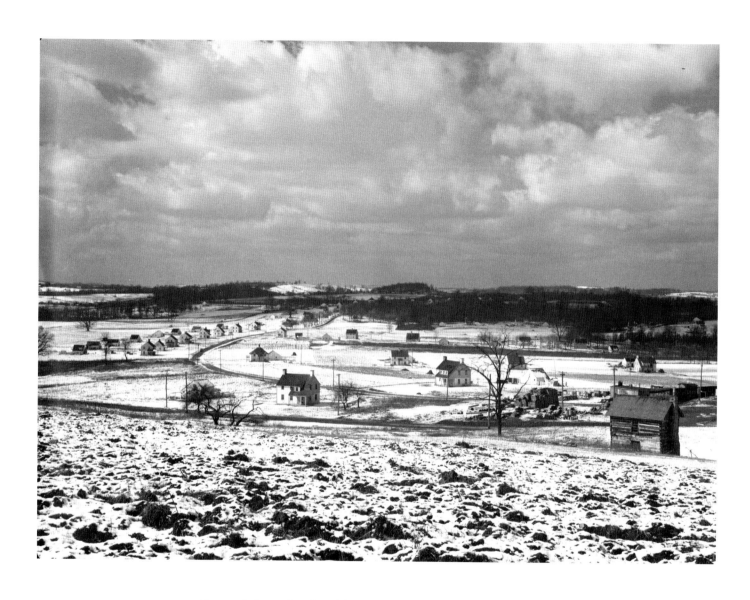

General view of Arthurdale project. Reedsville, West Virginia.
Edwin Locke. February 1937. LC-USF34-013090-D.

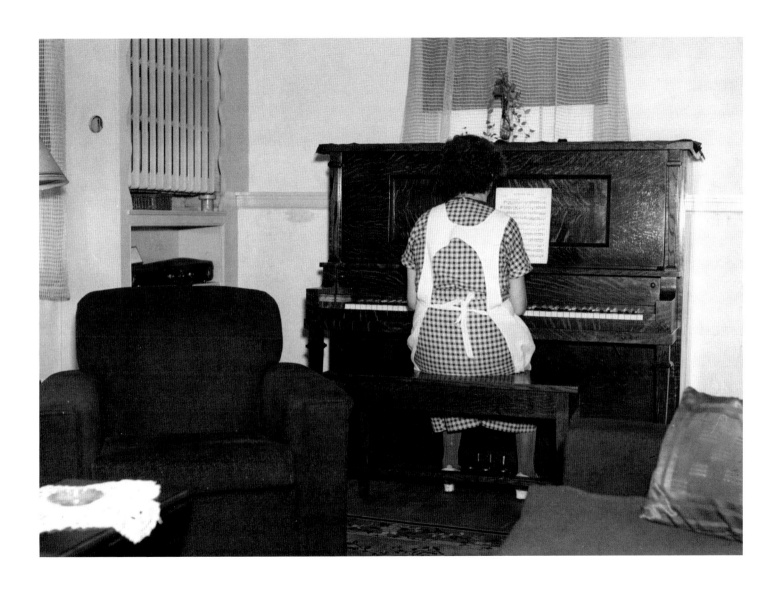

Homesteader's living room. Arthurdale project. Reedsville, West Virginia.
Edwin Locke. February 1937. LC-USF34-013103-D.

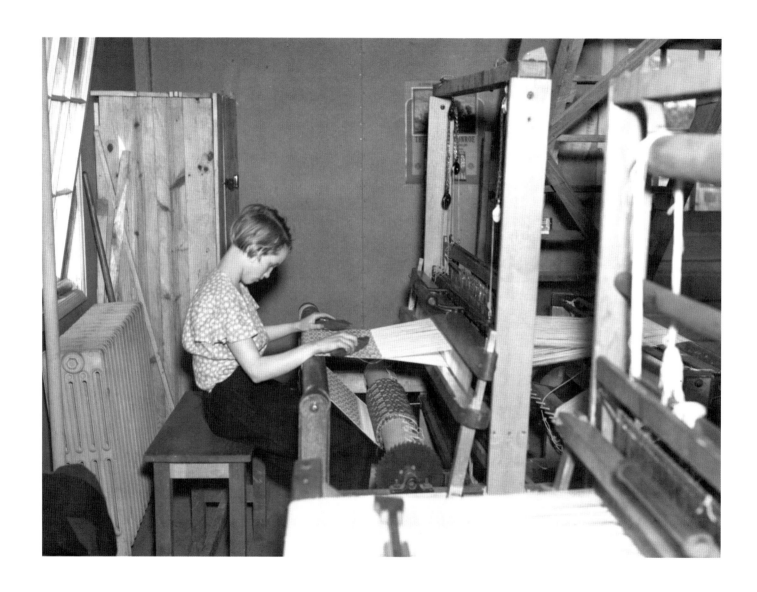

Homesteader weaving in the cooperative looms. Arthurdale project. Reedsville, West Virginia. Edwin Locke. February 1937. LC-USF34-013109-D.

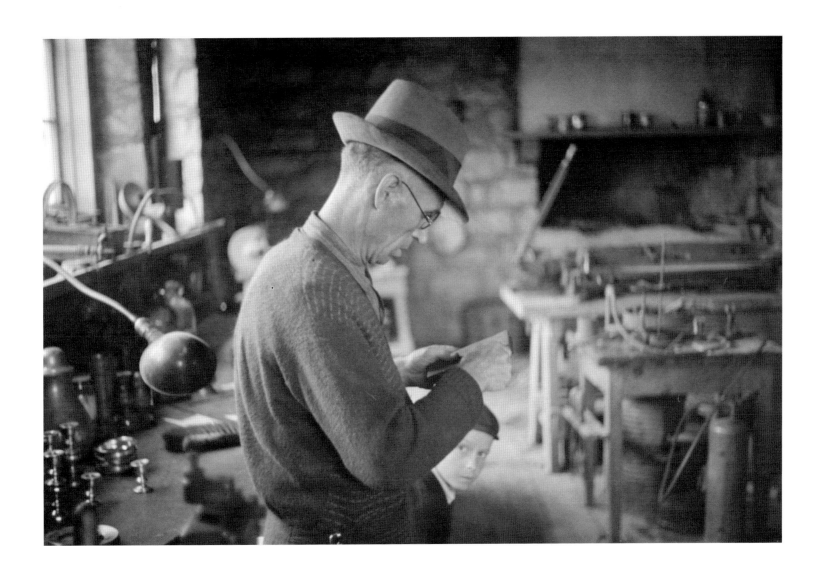

Metal shop. Arthurdale project. Reedsville, West Virginia. Ben Shahn. 1937. LC-USF33-006351-M3.

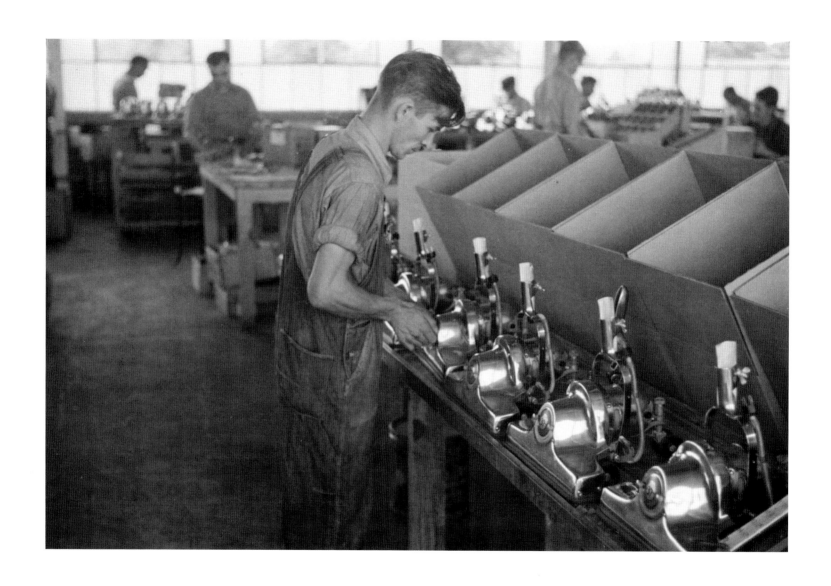

Vacuum cleaner factory. Arthurdale project. Reedsville, West Virginia. Ben Shahn. 1937. LC-USF33-006360-M2.

7

Model Communities: Eleanor

Eleanor Roosevelt,
"My Day" syndicated column,
May 16, 1938.
Eleanor Roosevelt
Papers Project.

"**WASHINGTON, SUNDAY**—I did not have space on Saturday to tell you anything about my visit to the Government homestead near Charleston, West Virginia. I had always called it 'Red House,' but discovered that the post office is 'Eleanor,' and noted with some amusement that the sign at the entrance to the homestead reads: 'Eleanor Unincorporated.'

The Legion Post met and escorted me to the stand in the park which is being developed. The Women's Auxiliary of the Post presented me with a lovely hand-woven runner which had been made in the craft shop, a basket of flowers, and a bunch of roses which one homesteader had picked in his own garden.

Except for their home gardens, their agricultural ventures are run on a cooperative basis. A tract with an overhead watering system should produce some very good early vegetables. A small nursery of trees has been planted and the purchase of a dairy farm at some little distance from the homestead looks as though it would be profitable. They need an industry and are still in an unsettled condition because a visible means of permanent employment is not yet in sight.

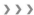

I visited several families and marveled at the work they have done in their homes. The ingenuity and loving care which has gone into the furnishing and arranging of these houses is rarely found among people who are not yet quite secure in their future. It shows courage and good morale and I feel very proud of this group of people. They have had hard times and have met them with better courage than most of us.

In the project's recently opened cooperative restaurant, the State Administrator of the National Youth Administration lunched with us. He has a tree surgery project for the boys of the homestead and a weaving project for the girls. I did not have time to see much of the work done by the Youth Administration, but Mr. Glenn S. Callaghan, the director, is full of enthusiasm. I think the praise which he gives to the young people working under him on the construction projects is really deserved.

Forty thousand young men and women between the ages of 16 and 25 have been on the program since it started and 8000 are at present participating in student aid and work programs. These young people, under expert guidance of course, have built a plant herbarium at Marshall College, water supply cisterns for rural schools, gymnasiums, community centers, youth work centers, school buildings, a museum for Negro historical records, playgrounds, athletic fields and have engaged in many more activities I cannot begin to cover. These things could not have been done except through this program and they will be of far more value to the communities than the money which has been expended.

After speaking at the dinner of the State Federation of Business and Professional Women, I took the night train back to Washington."

—*Eleanor Roosevelt*

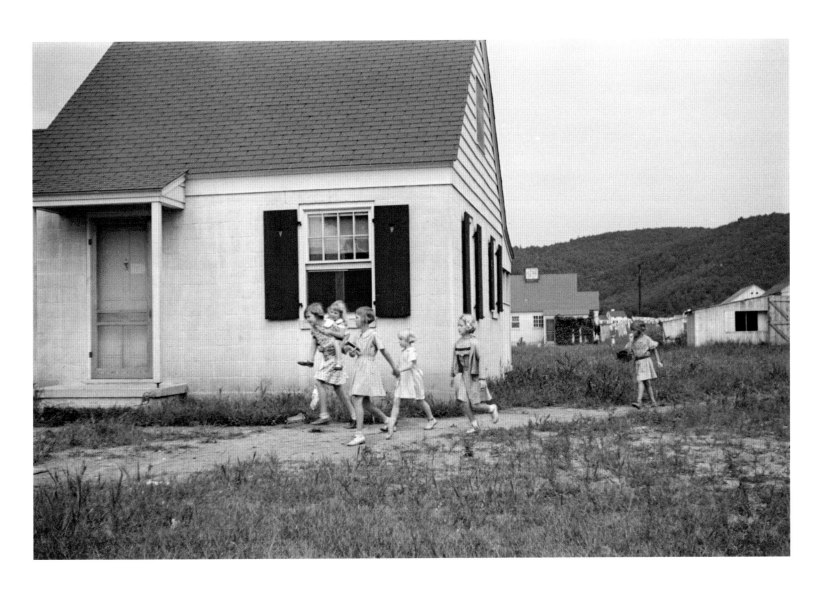

Children on their way to school. Eleanor project. Red House, West Virginia. Elmer Johnson. September 1935. LC-USF33-008002-M2.

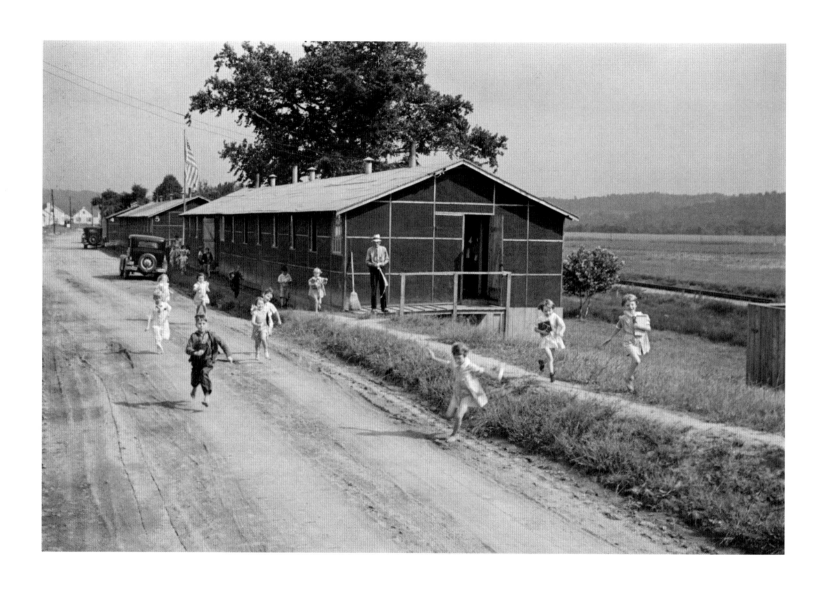

Children leaving school. Eleanor project. Red House, West Virginia. Elmer Johnson. September 1935.
LC-USF33-008019-M2.

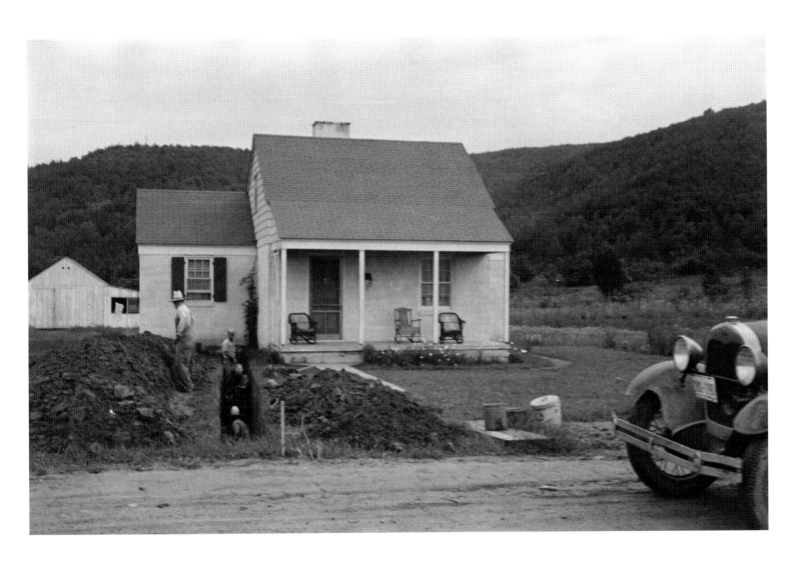

Men digging ditch. Eleanor project. Red House, West Virginia. Elmer Johnson. September 1935.
LC-USF33-008031-M3.

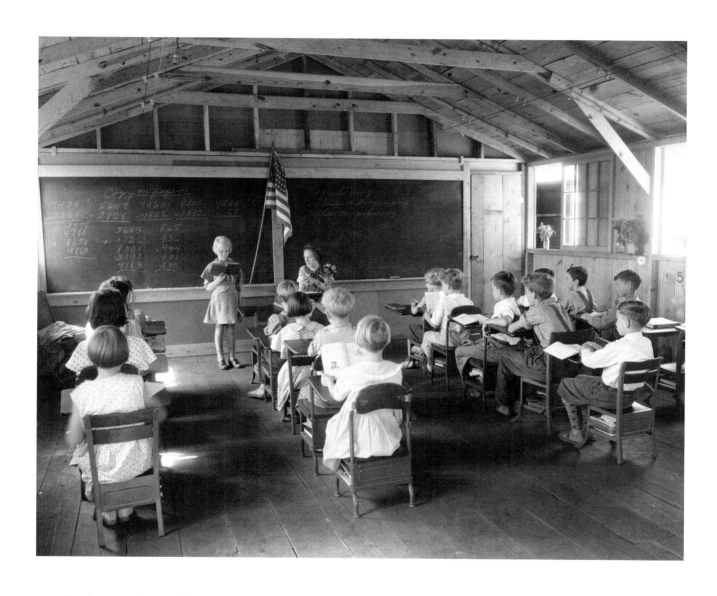

Student reading to class. Eleanor project. Red House, West Virginia. Elmer Johnson. September 1935. LC-USF34-001394-C.

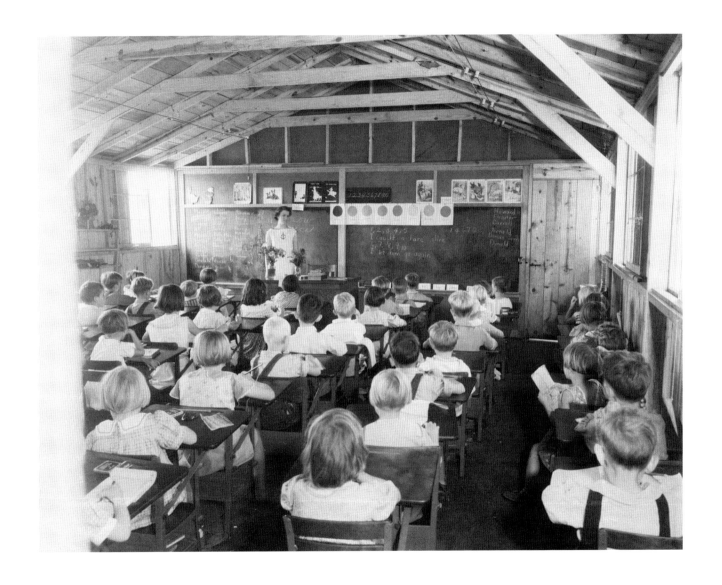

Teacher in front of classroom. Eleanor project. Red House, West Virginia. Elmer Johnson. September 1935.
LC-USF34-001399-C.

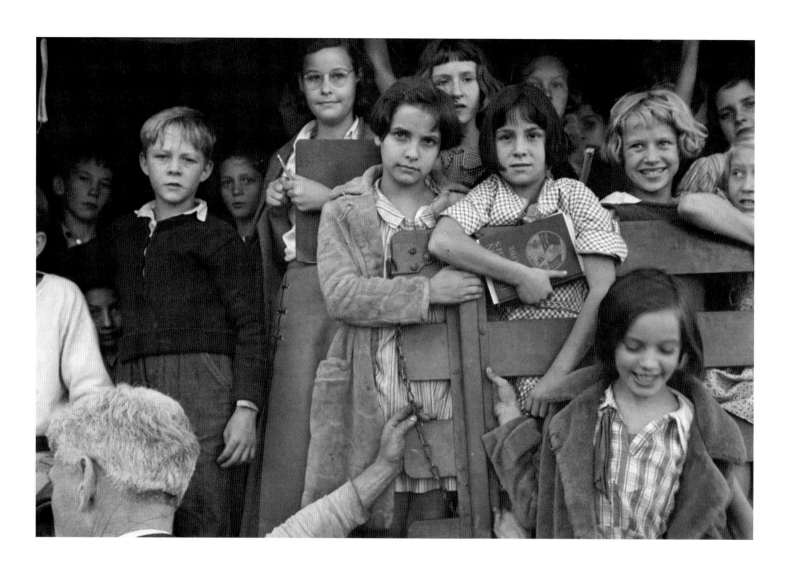

Students arriving at school. Eleanor project. Red House, West Virginia. Ben Shahn. October 1935.
LC-USF33-006146-M1.

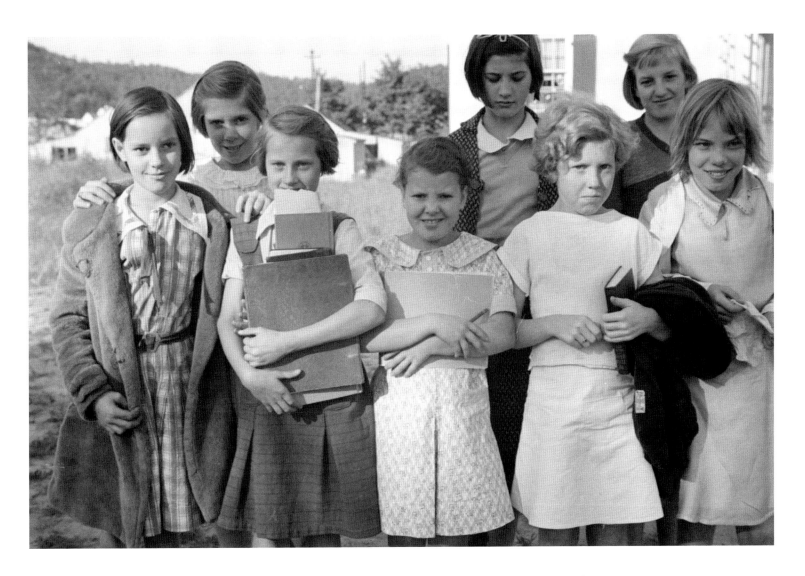

Schoolgirls. Eleanor project. Red House, West Virginia. Ben Shahn. October 1935.
LC-USF33-006147-A-M2.

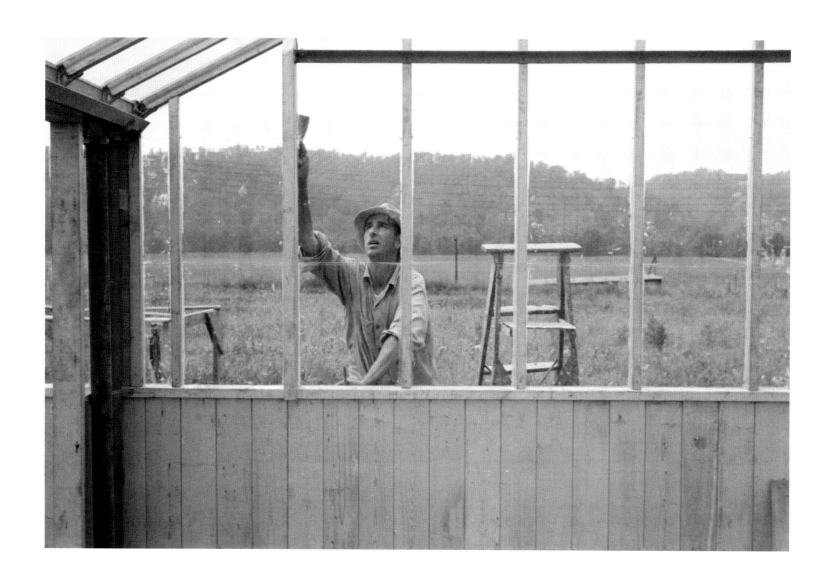

Working on greenhouse, part of Eleanor project. Red House, West Virginia. Ben Shahn. October 1935.
LC-USF33-006333-M5.

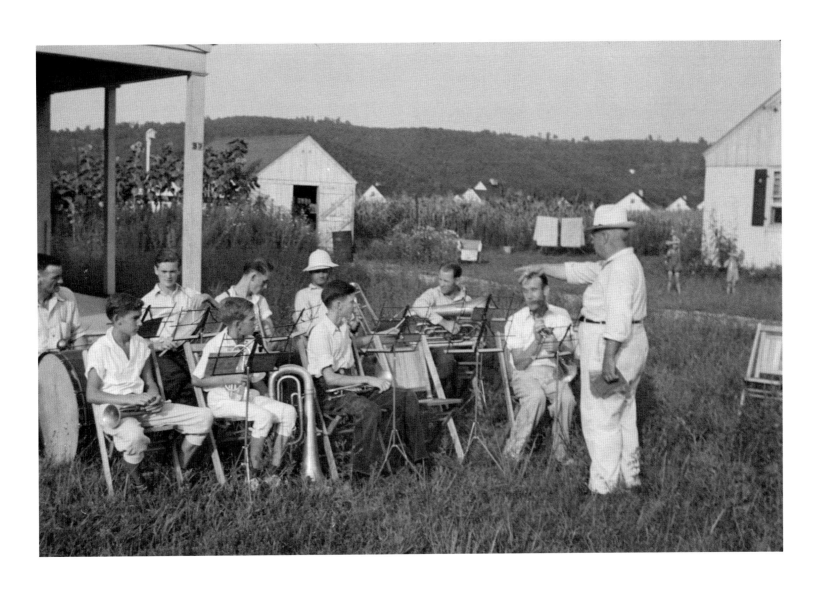

Band rehearsal. Eleanor project. Red House, West Virginia. Ben Shahn. July 1937.
LC-USF33-006340-M4.

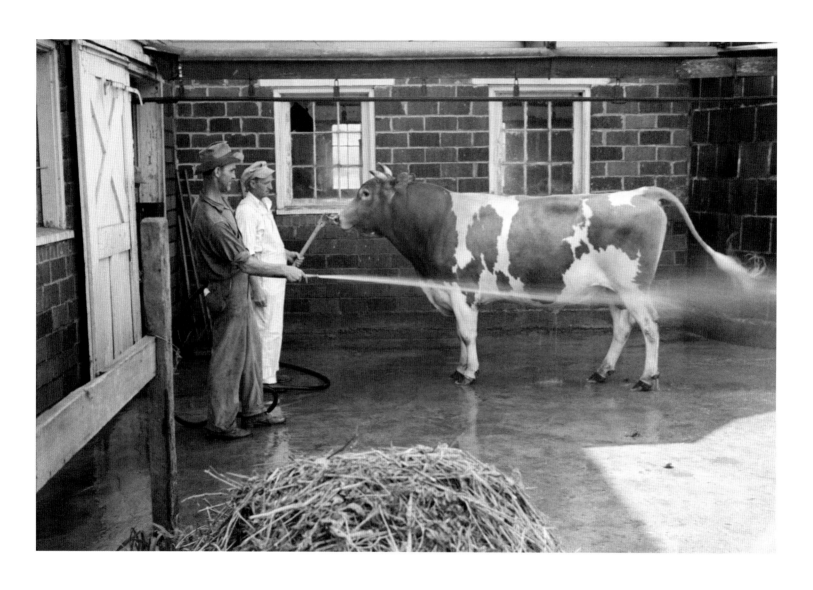

Washing a prize bull at the dairy barn. Part of Eleanor project. Red House, West Virginia. Ben Shahn. 1937.
LC-USF33-006345-M5.

Model Communities:
Tygart Valley Homesteads

Miss Marion Post
Hotel Morgan
Morgantown, West Virginia

Roy Stryker, letter to Marion Post Wolcott, September 21, 1938. Roy E. Stryker Papers, Special Collections, Ekstrom Library, University of Louisville.

"DEAR MARION:

Back in the office and the sun starts to shine just as I get back. We drove from Rutland to Washington yesterday in a continuous rainstorm, and I will bet you have been having your rains in West Virginia. Let us hope that the sun will shine very soon.

I got back and found many things stirring, one of them being a suggestion to send you west. That has been pretty well scotched for the time being. I told our friend Mr. F. that you were to have enough time to really get yourself adjusted to the type of photography which we do here. It is my feeling that a new photographer is entitled to one trip unrushed by the damned routine of project pictures. Therefore, we are letting you take more time to finish up some of the things you are finding to do. I know full well no photographer ever really gets through in any region, but at least he wants

to have a satisfied feeling of putting together at least a few of the rough edges. These jobs in the west can wait. They fiddle around with appointments and delay getting people on the payroll and then expect the photographers to make up for it when they do get on the payroll tearing around like mad people—to hell with them!

Mrs. Wakeham had a terrible time trying to keep things straightened out in my absence. Her job was to try to appease the higher ups and protect you people in the field against these damned newspaper men who want to photograph everything in three days.

I suggest that you go ahead and do the thing you are finding interesting and do not worry about getting back here in a hurry. It would seem to me that the best thing for you to do is to do the trip as you previously planned. If you get near Tygart Valley I think a day's photographing there would be worthwhile. It would mean that we could lay on the desk of the superiors a set of project pictures. Then come on in and we will get your stuff printed up and go over your pictures and make plans for your next month's work.

I am not quite sure what you want in the way of fast film for the Leica. There is nothing on the market today that would be faster than the Agfa Supreme. Anyway it takes a lot of time to get stuff and if you can possible [*sic*] get along with the Supreme that would be better.

Don't let rain, or government red tape, or newspaper bosses get you down. When you get back we will go over and kick hell out of a few of them. Better tear up this letter since I prefer to say these things directly to the person concerned."

—Roy Stryker

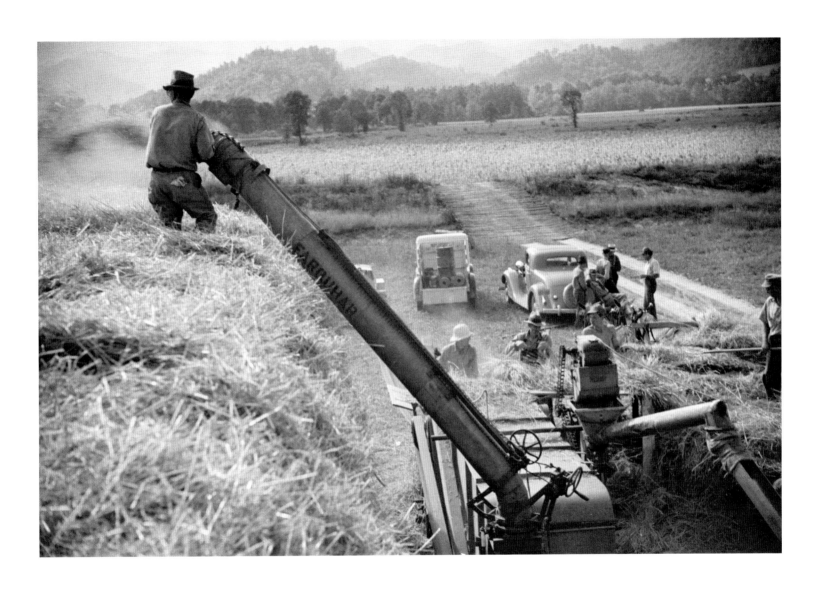

Threshing. Tygart Valley project. Dailey, West Virginia. Carl Mydans. August 1936.
LC-USF33-000722-M5.

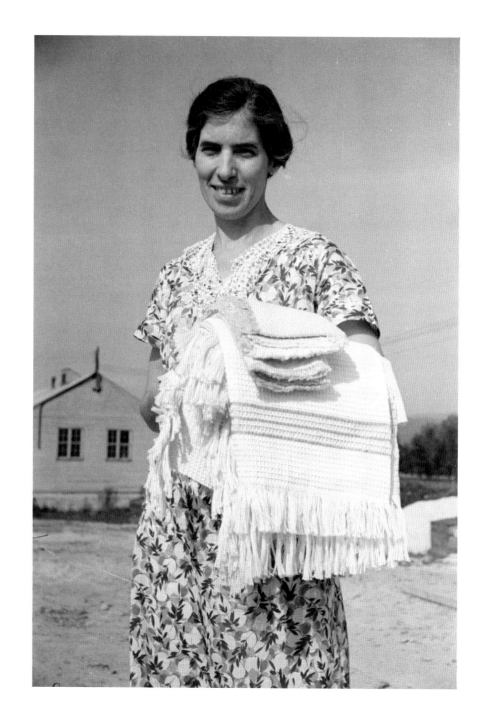

Homesteader carrying products woven at Tygart Valley project. Dailey, West Virginia. Carl Mydans. August 1936. LC-USF33-000727-M3.

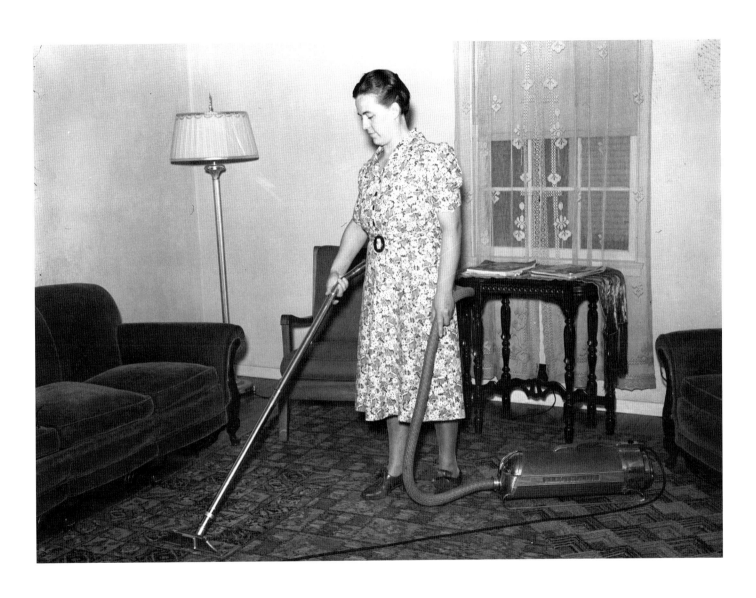

Modern household equipment reduces household drudgery. Tygart Valley project. Dailey, West Virginia. Marion Post Wolcott. September 1938. LC-USF34-050101.

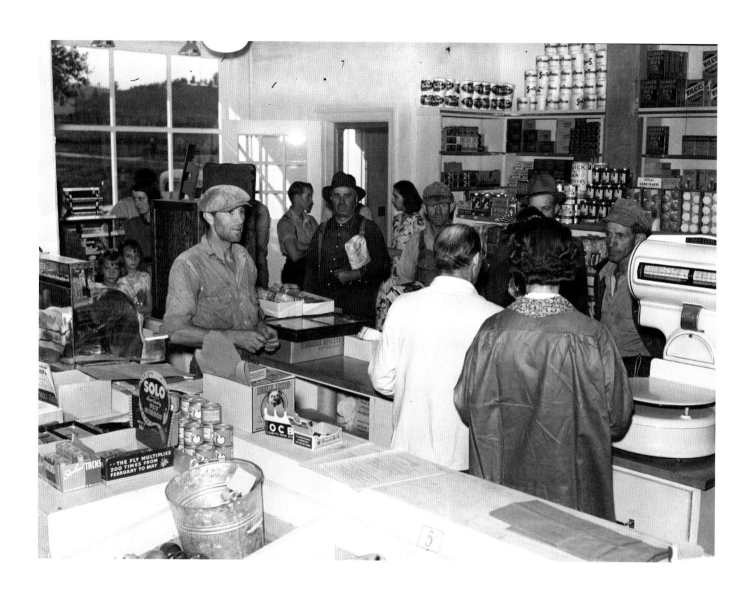

Buying groceries in community store. Tygart Valley project. Dailey, West Virginia. Marion Post Wolcott. LC-USF34-050117-D.

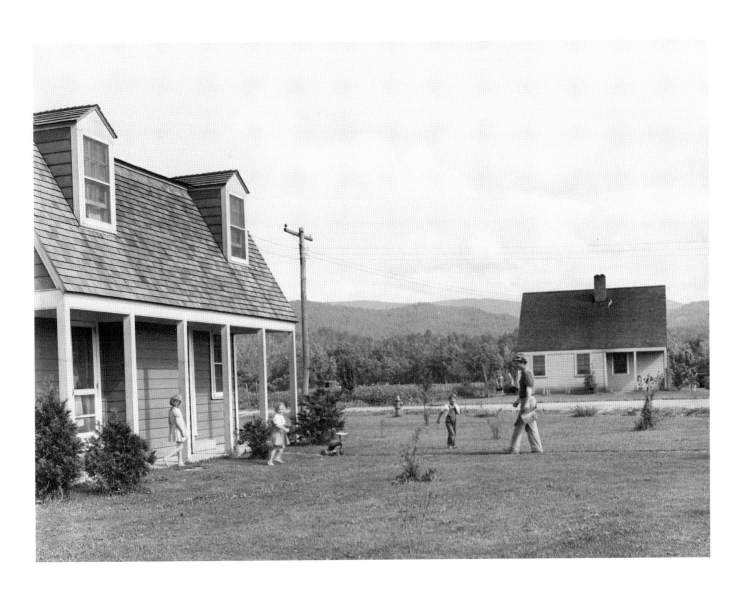

Homesteader returning from work in the lumber plant. Tygart Valley project. Dailey, West Virginia.
John Vachon. June 1939. LC-USF34-060094-D.

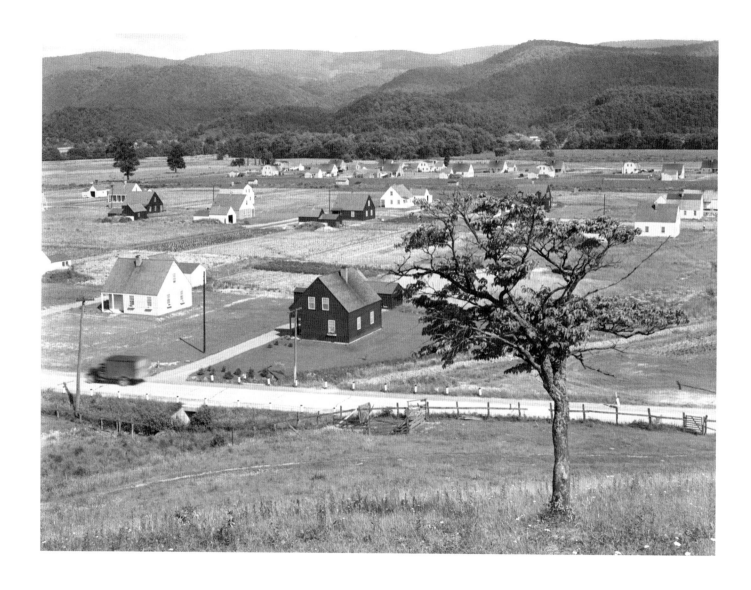

View of Tygart Valley project. Dailey, West Virginia. John Vachon. June 1939. LC-USF34-060095-D.

Recreation time at meeting of women's club. Tygart Valley project. Dailey, West Virginia.
John Vachon. June 1939. LC-USF34-060025-D.

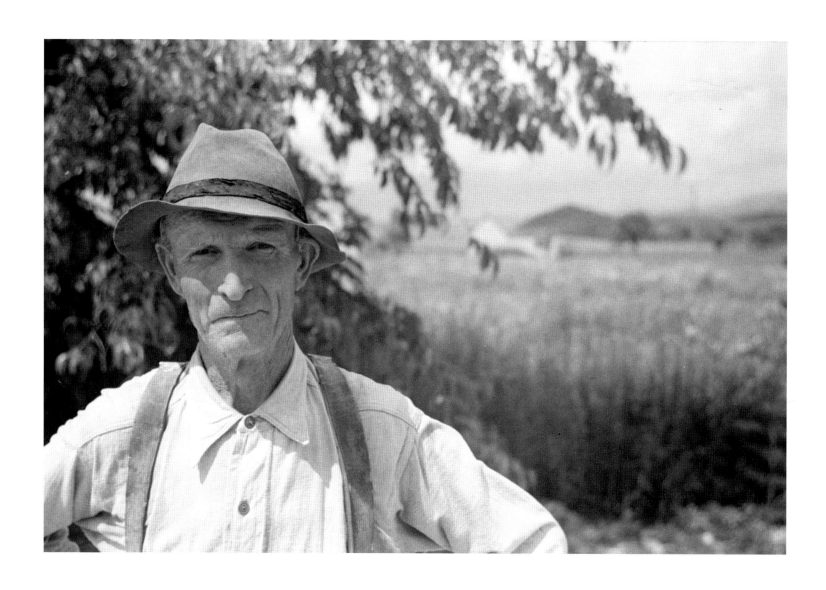

Homesteader. Tygart Valley project. Dailey, West Virginia. John Vachon. June 1939. LC-USF33-001396-M2.

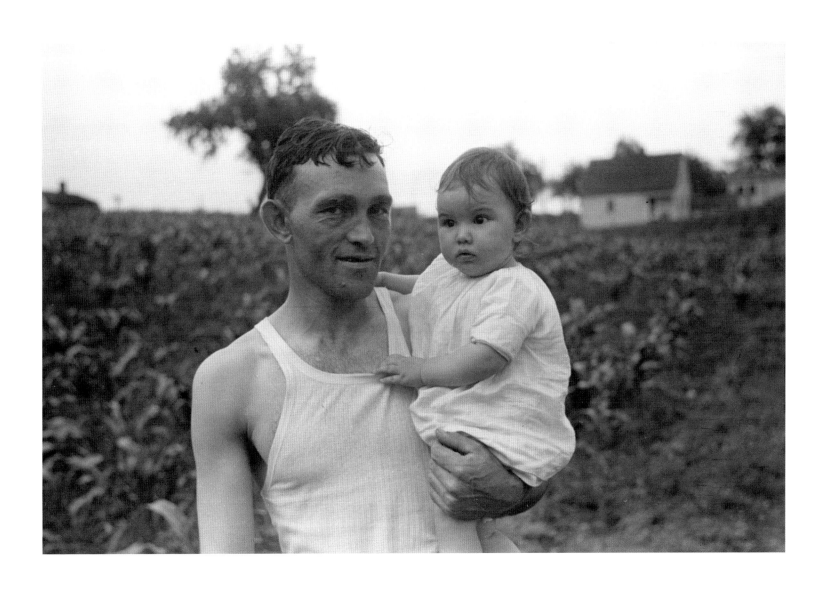

Father and daughter. Tygart Valley project. Dailey, West Virginia. John Vachon. June 1939. LC-USF33-001407-M2.

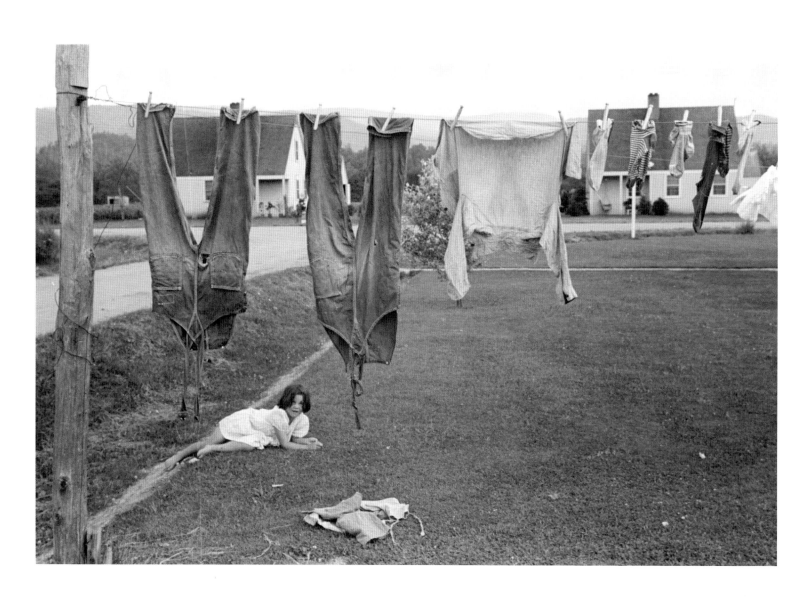

Girl in yard by clothesline. Tygart Valley project. Dailey, West Virginia. John Vachon. June 1939.
LC-USF33-001412-M1.

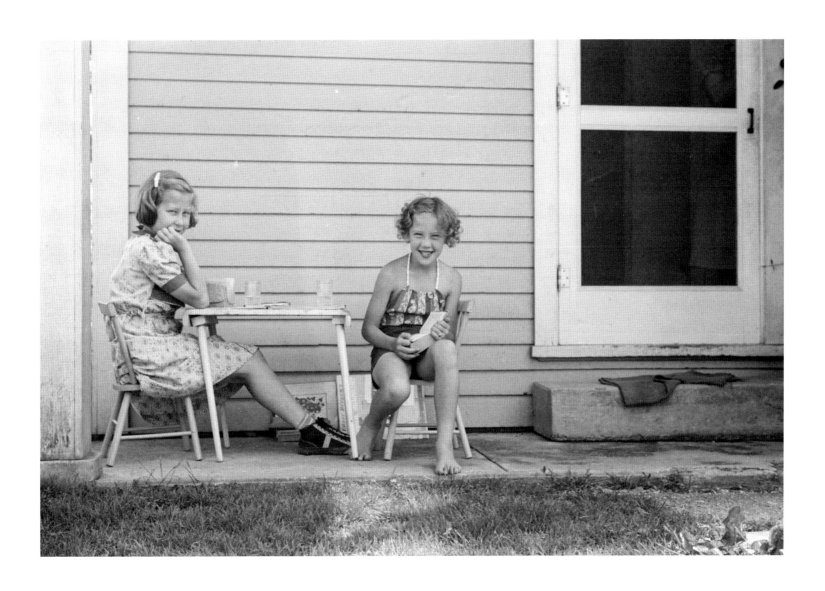

Children of homesteaders. Tygart Valley project. Dailey, West Virginia. John Vachon. June 1939.
LC-USF33-001414-M4.

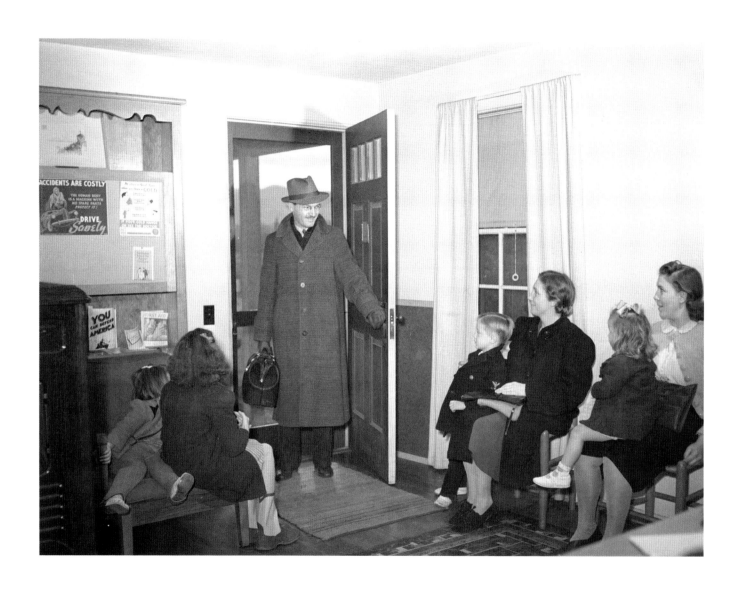

Doctor Tabor entering health center to give inoculations against measles to a group of children. Tygart Valley project. Dailey, West Virginia. Arthur Rothstein. December 1941. LC-USF34-024399-D.

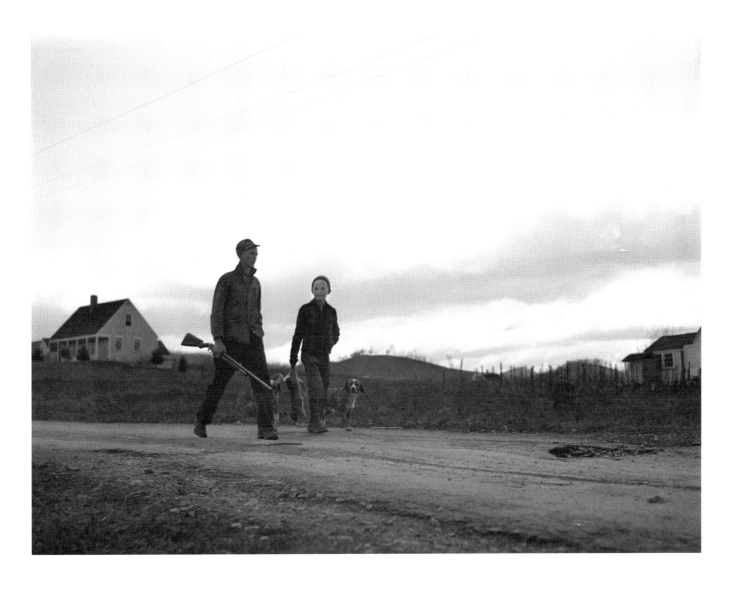

Returning from rabbit hunt. Tygart Valley project. Dailey, West Virginia. Arthur Rothstein. December 1941.
LC-USF34-024400-D.

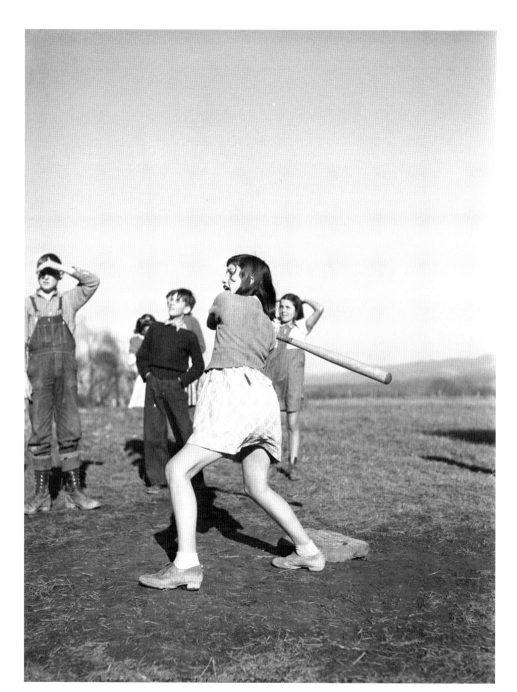

Baseball game, Homestead
School. Tygart Valley project.
Dailey, West Virginia.
Arthur Rothstein.
December 1941.
LC-USF34-024408-D.

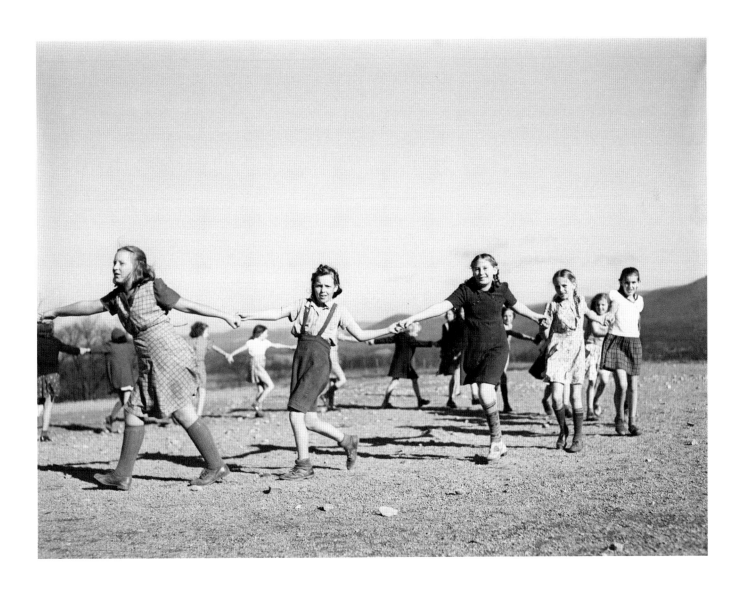

Singing games in the schoolyard, Homestead School. Tygart Valley project. Dailey, West Virginia.
Arthur Rothstein. December 1941. LC-USF34-024429-D.

Southern Coalfields: 1935

H.W. Francis,
Letter to Harry Hopkins,
Secretary of the Federal
Emergency Relief
Administration,
December 7, 1934.
Hopkins Papers,
FDR Library.

"FOR SIX DAYS I have been traveling in Logan and Mingo. I have made more than 450 miles by automobile and on foot. I have visited the 'hottest spots' in Mingo, and some described as 'pretty bad' in Logan. I have found worse living conditions and more cause for discontent than I have ever seen anywhere. But nowhere have I encountered hostility—even sullenness has been rare. On the contrary, I have been treated with kindness and met with understanding. I leave Mingo amazed at the docility and capacity for suffering of most of these people who, I had always understood, were hot-headed and temperamentally given to unreasoning revolt. I have found more common sense in the mining camps and in the dark hovels of mountain ravines than I have in the homes and offices of the controlling class. In those homes and offices I have seen more firearms than in the poor shelters of the workers and heard more threatening talk. I have talked with lawyers, doctors and merchants who admitted sitting at their windows and firing upon striking workers and who expressed their willingness and determination to do so again should occasion arise. That such occasion eventually will arise is taken for granted by many with whom I have talked.

〉 〉 〉

The mine operators themselves generally in these counties do not believe that labor troubles are over. They look forward to a breaking up of the union sooner or later and hope for a return to non-union conditions. They are opposed to unemployment insurance, old age pensions and shorter hours. They are unsympathetic to anything providing for the greater security of the worker and look upon present governmental efforts towards such security as being inspired solely by political considerations.

I visited homes, saw pay envelopes and talked with the women. Conditions are bad. Clothes and bedding are needed in many cases. There is trouble in the air. . . . The old time hostility between capital and labor seems merely to be quiescent; meantime those aligned with capital are busy shaking their heads over the 'immoderate measure of consideration being shown labor at the expense of industry.' [Mr. H_____] . . . likes to think that if the government 'would do something about helping industry' labor's difficulties would be over and relief would not be necessary. That is, of course, quite overlooking the fact that there are thousands of former coal miners in Logan and Mingo counties who could not pass the physical test requisite to employment. In fact, last Spring, when the Lake Trade was demanding greater tonnage, Island Creek and other mines in Logan imported large numbers of miners from out of the State in preference to employing those who, because of age or minor physical handicaps, are classified as 'seconds.'

No one with whom I have talked entertains the hope of any new industry ever coming to Logan. The attitude taken in the sitting rooms of Logan's 'best' people is: 'Why worry about other industry; there's enough coal in Logan to supply the entire world for a hundred years?'"

—*H.W. Francis*

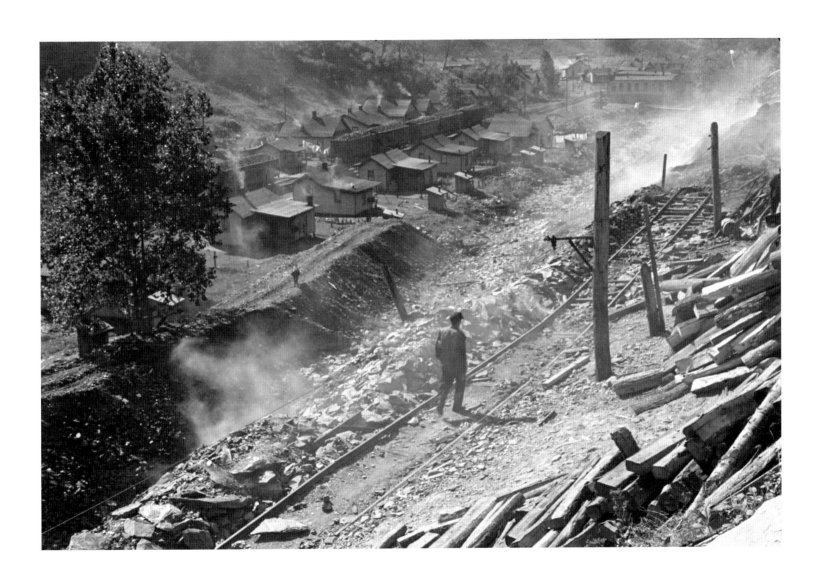

Miner walking atop slag heap. Freeze Fork, West Virginia. Ben Shahn. October 1935.
LC-USF33-006150-M2.

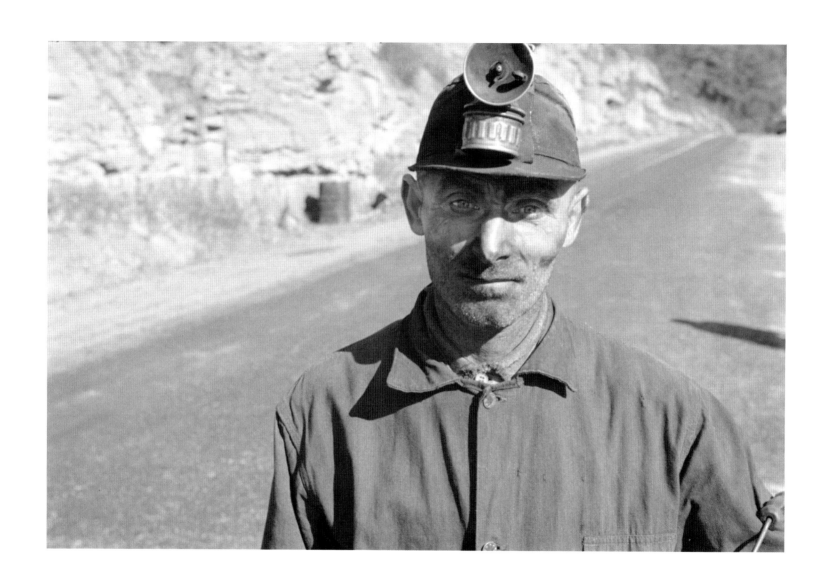

Miner on road. Freeze Fork, West Virginia. Ben Shahn. October 1935. LC-USF33-006151-M1.

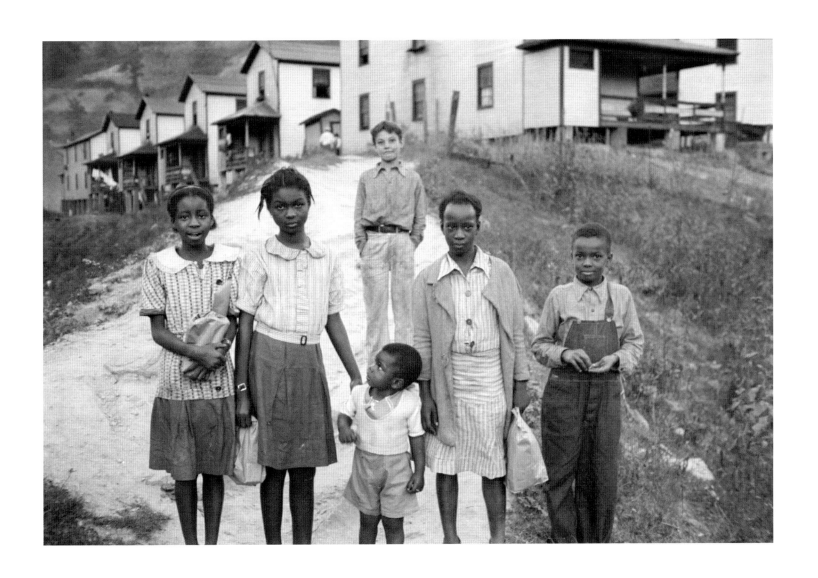

Residents of coal camp. Omar, West Virginia. Ben Shahn. October 1935. LC-USF33-006135-M5.

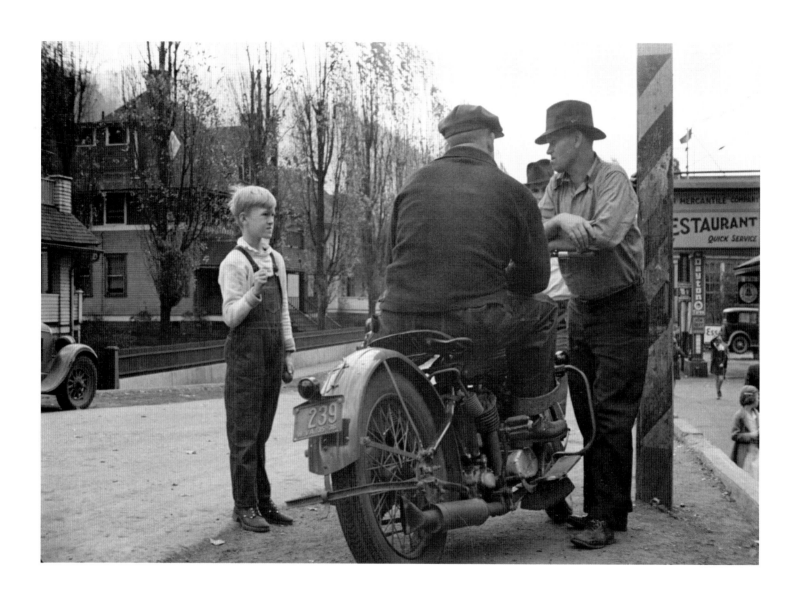

Main street. Omar, West Virginia. Ben Shahn. October 1935. LC-USF33-006189-M1.

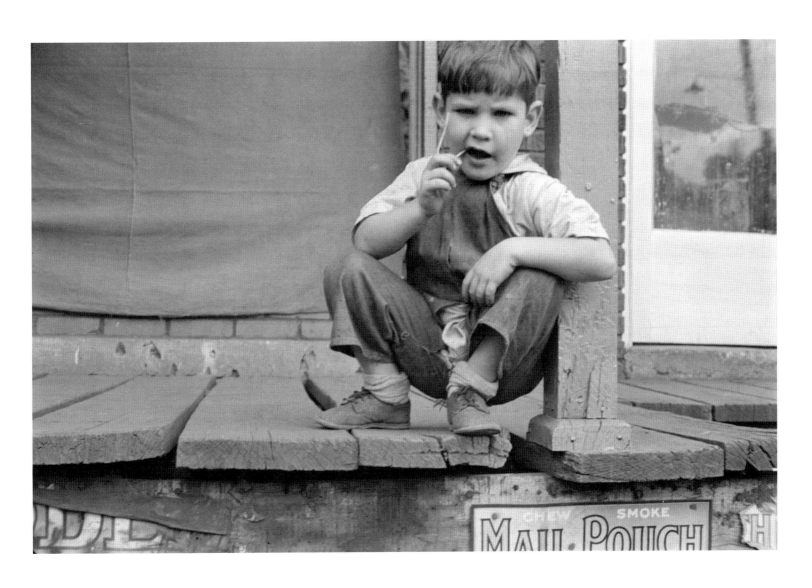

Young resident. Omar, West Virginia. Ben Shahn. October 1935. LC-USF33-006190-M1.

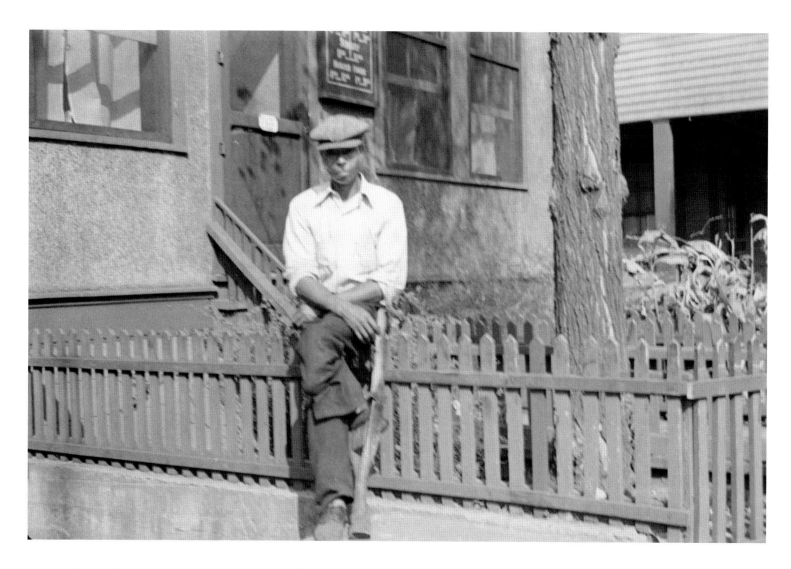

Man with one leg in front of doctor's office. Omar, West Virginia. Ben Shahn. October 1935. LC-USF33-006190-M3.

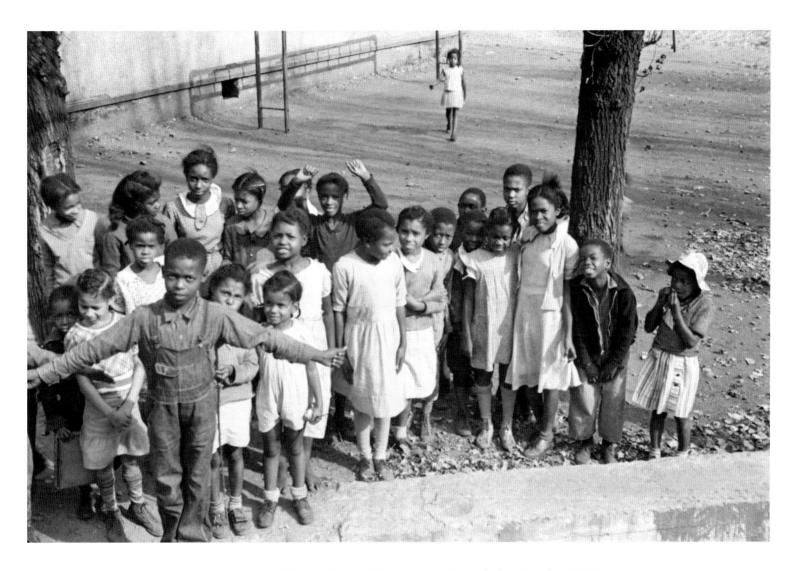

Negro schoolchildren. Omar, West Virginia. Ben Shahn. October 1935.
LC-USF33-006191-M2.

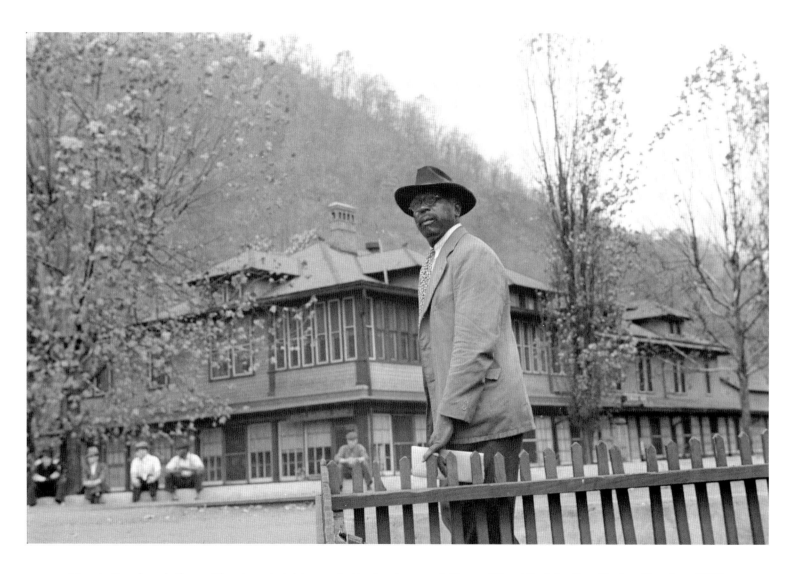

Men in Sunday clothes with miners' clubhouse in the background. Omar, West Virginia. Ben Shahn. October 1935. LC-USF33-006200-M1.

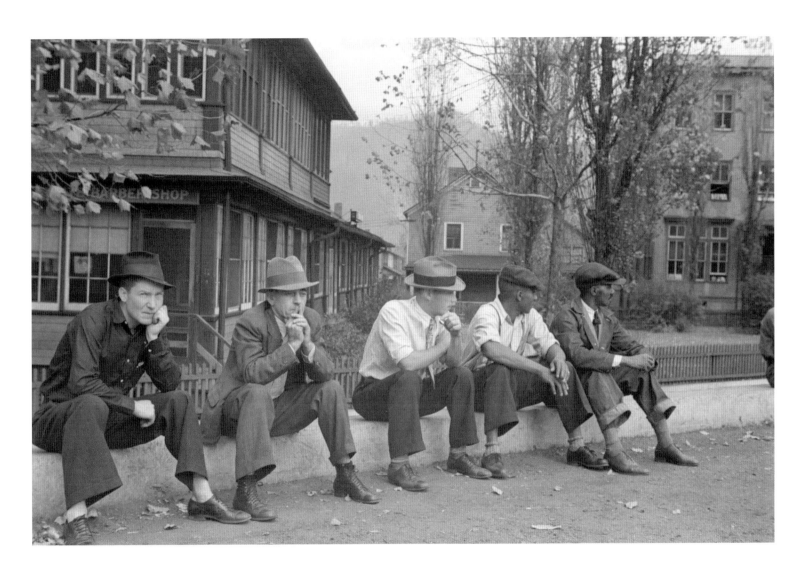

Men sitting on curb by the miners' clubhouse, Omar, West Virginia. Ben Shahn. October 1935.
LC-USF33-006202-M3.

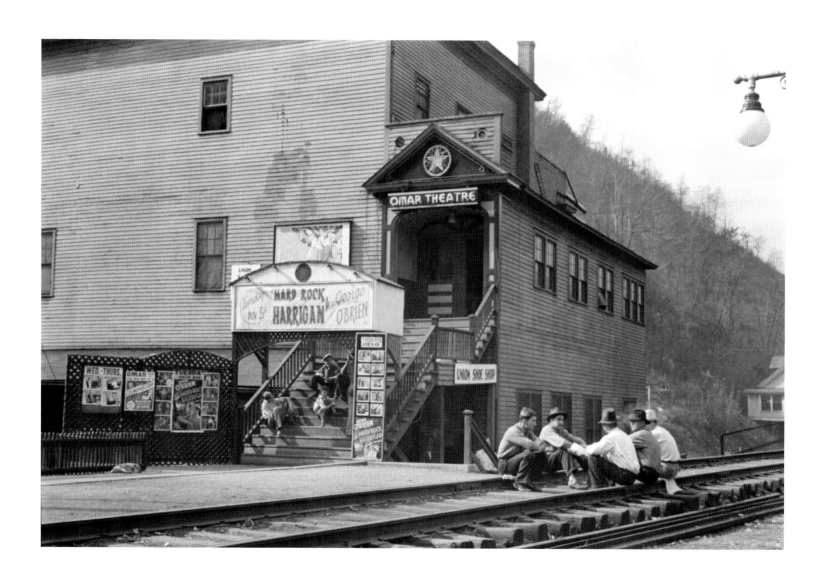

Men sitting on railroad tracks by the movie theater. Omar, West Virginia. Ben Shahn. October 1935. LC-USF33-006203-M3.

Southern Coalfields: 1938

"**THE IMPACT OF THE PHOTOS** in the file, the stimulation of the first month was terrific. . . . I was convinced that through our photographic interpretations and honest, forceful documentation of the social scene and of F.S.A.'s efforts to improve living conditions of people in many areas, that we were contributing to the education not only of the public, but also of the legislators and bureaucrats. Our pictures would be used in exhibits, large and small, in books, magazines and newspapers.

This was a unique way of working, a new approach. The time for regional research before field trips—as well as in the field. . . . Along with our political awareness and our interest in trying to make a comment, simply, and forcefully, and directly, on our national social scene, Roy widened our horizon by constantly plugging and urging us to record, to document America from the historians', sociologists', and the architects' point of view. Constantly we were asked and asking of ourselves, 'In what direction are we going; are we doing the whole job? How can we fill in the gaps, round out the file, also photograph some of the beauty, grandeur and vastness, [the] lush quality of the U.S.A.?'

Marion Post Wolcott,
undated biographical statement.
Roy E. Stryker Papers.

Finally, it was an integrated unit, supported by the knowledge that Roy was a fighter for his ideas, for our project, for the wide and varied use of the pictures, for credit lines, our re-classification and raises. His concern was not only for the group but for each of us as individuals, understanding our growing pains, personal problems, deeply involved in our development as people in our own different directions. We knew we would always be heard, our opinions respected, though not necessarily agreed with."

—*Marion Post Wolcott*

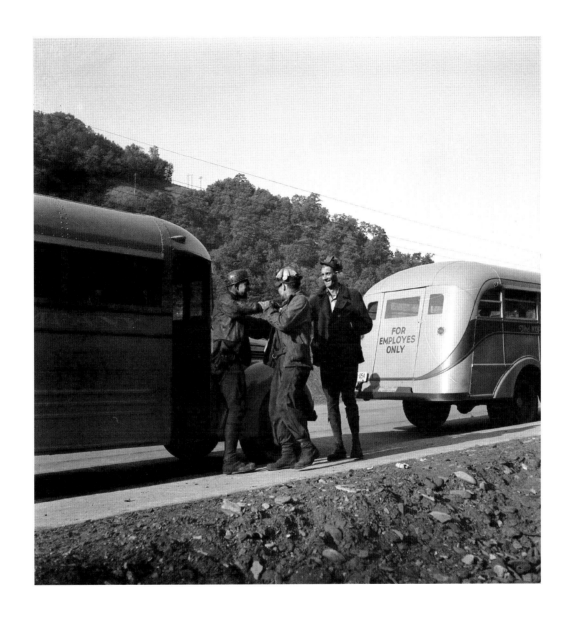

Coal miners waiting along road for bus to take them home. Between Welch and Bluefield, West Virginia. Marion Post Wolcott. September 1938. LC-USF34-050027-E.

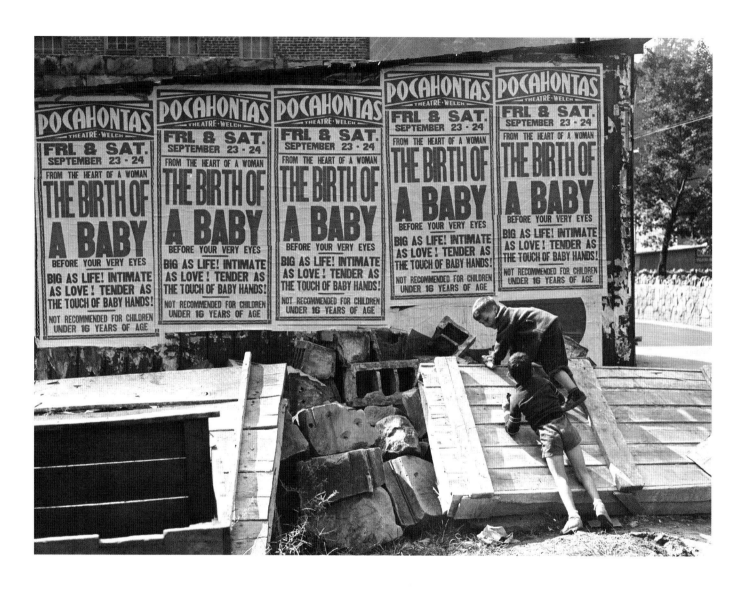

Movie advertisement on side of building. Welch, West Virginia. Marion Post Wolcott. September 1938.
LC-USF34-050084-E.

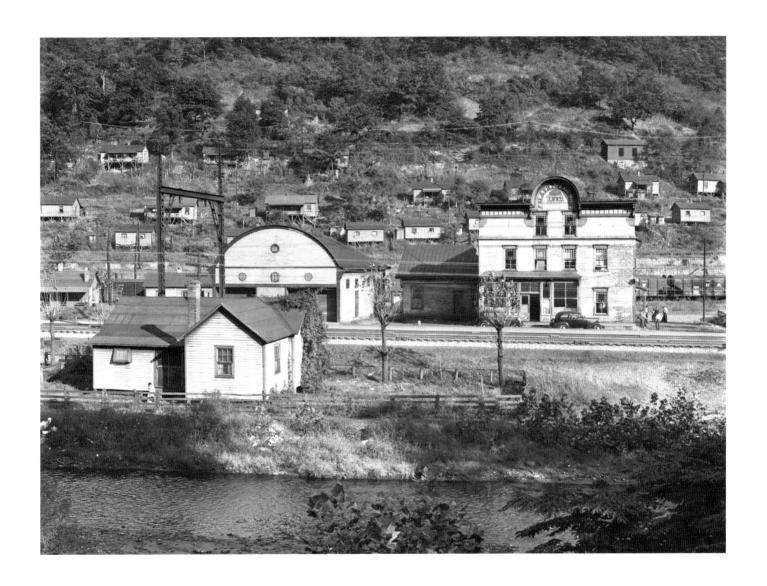

Coal mining town. Eckman, West Virginia. Marion Post Wolcott. September 1938.
LC-USF34-050086-E.

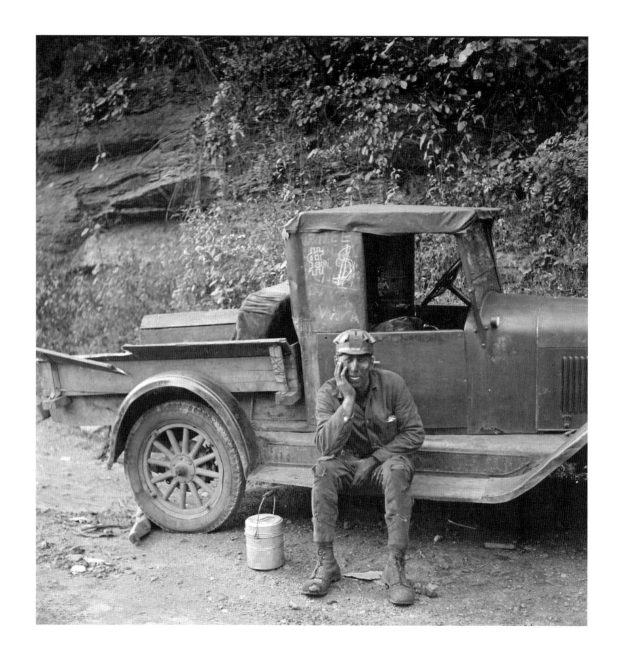

Miner waiting for ride home. Each miner pays twenty-five cents a week to owner of car. Capels, West Virginia. Marion Post Wolcott. September 1938. LC-USF34-050185-E.

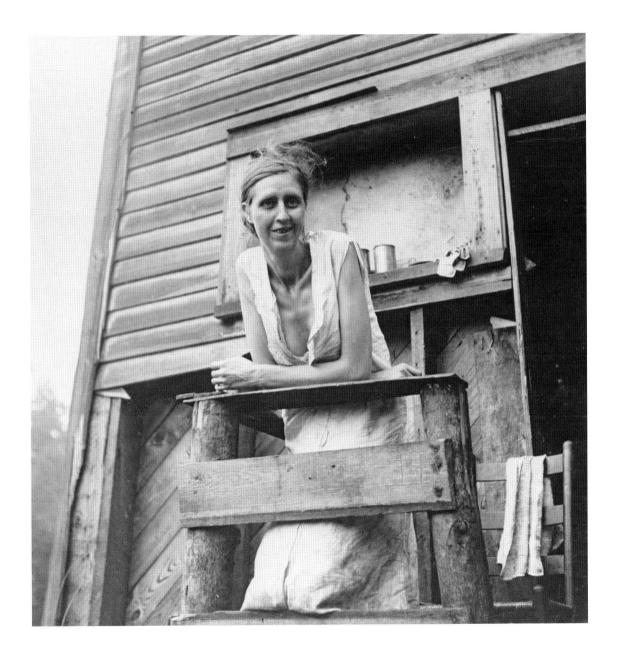

Wife of unemployed coal miner, suffering from T.B., living in old company store. Abandoned mining town. Marine, West Virginia. Marion Post Wolcott. September 1938. LC-USF34-050243-E.

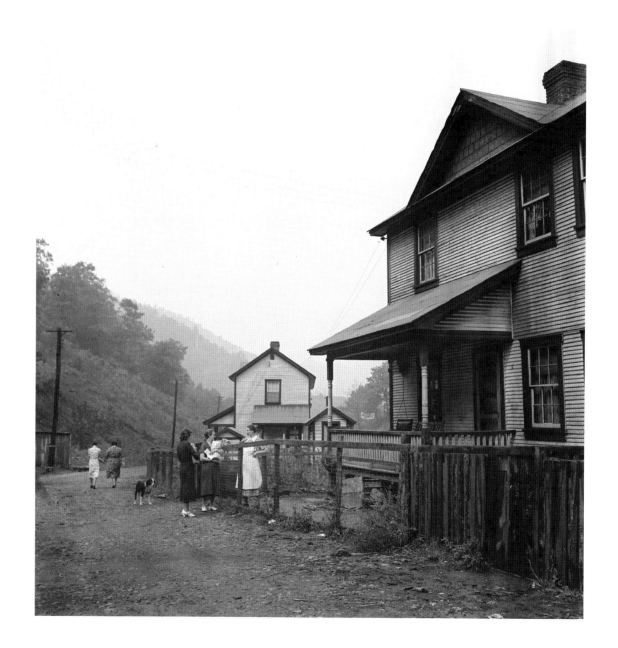

Wives of coal miners
talking over the fence.
Capels, West Virginia.
Marion Post Wolcott.
September 1938.
LC-USF34-050260-E.

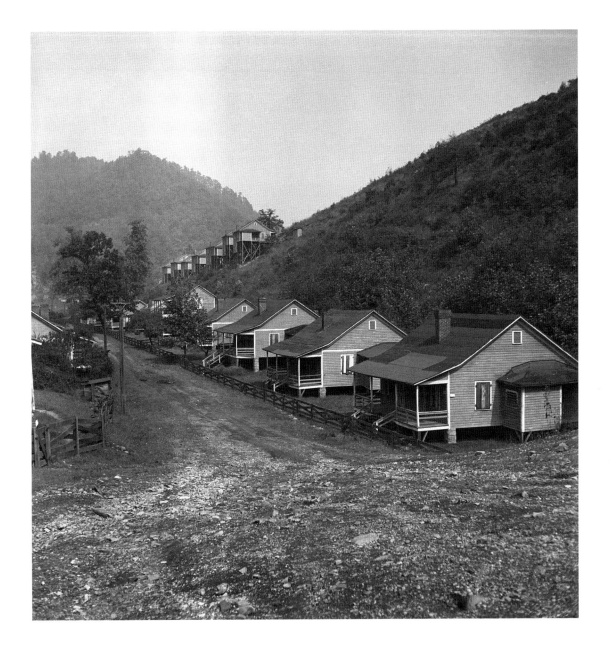

Boarded-up homes in abandoned mining town. . . . Once very nice, owned by Ford. About four years ago when an attempt to organize it was made, Ford closed it down completely rather than have it unionized. About 1000 men used to work there. They won't sell it, rent or let "squatters" live in the deserted homes that are rotting away. Twin Branch, West Virginia. Marion Post Wolcott. September 1938. LC-USF34-050274-E.

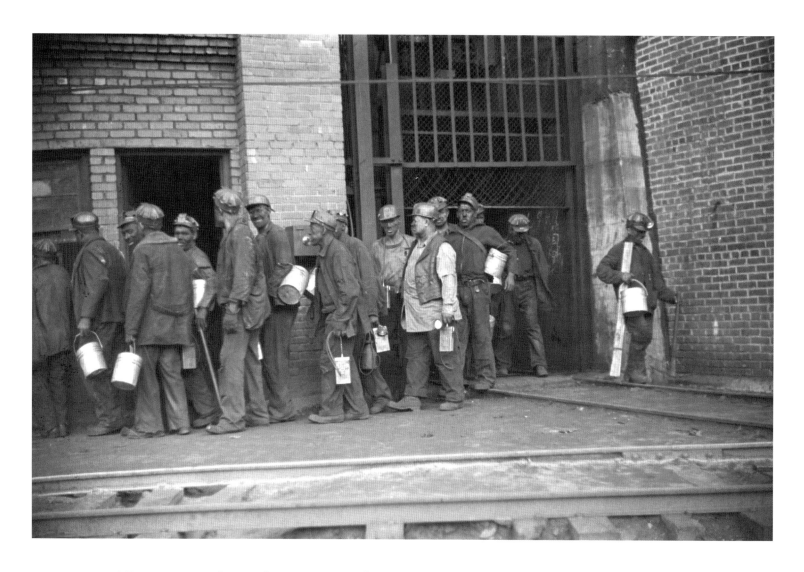

Miners turning in lamps after getting out of cage from shaft, which goes down sixty feet to tunnel, which is two miles long. Capels, West Virginia. Marion Post Wolcott. September 1938. LC-USF33-030065-M5.

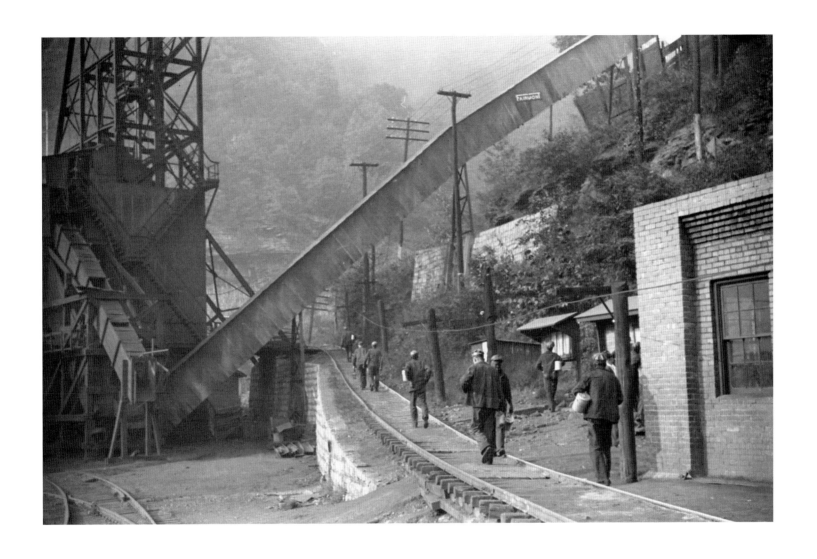

Miners starting home after work. Part of coal tipple shown at left. Capels, West Virginia. Marion Post Wolcott. September 1938. LC-USF33-030066-M4.

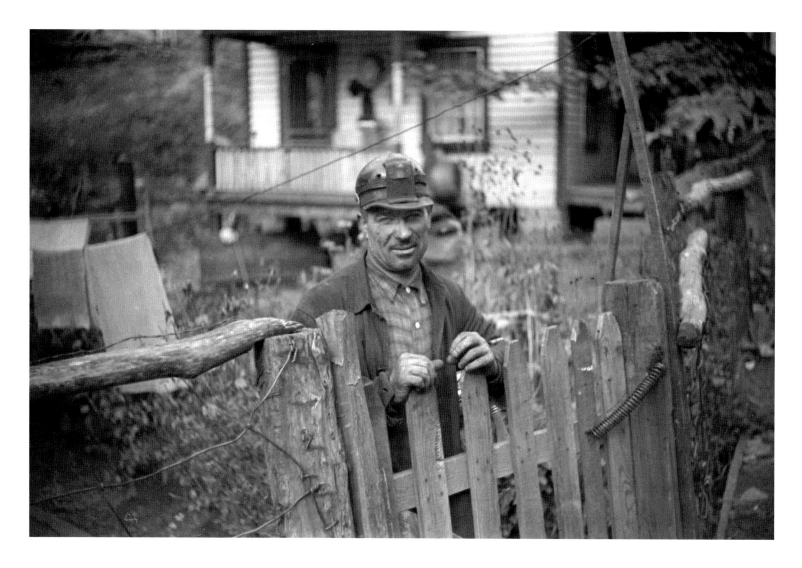

Miner (Russian). Capels, West Virginia. Marion Post Wolcott. September 1938.
LC-USF33-030077-M1.

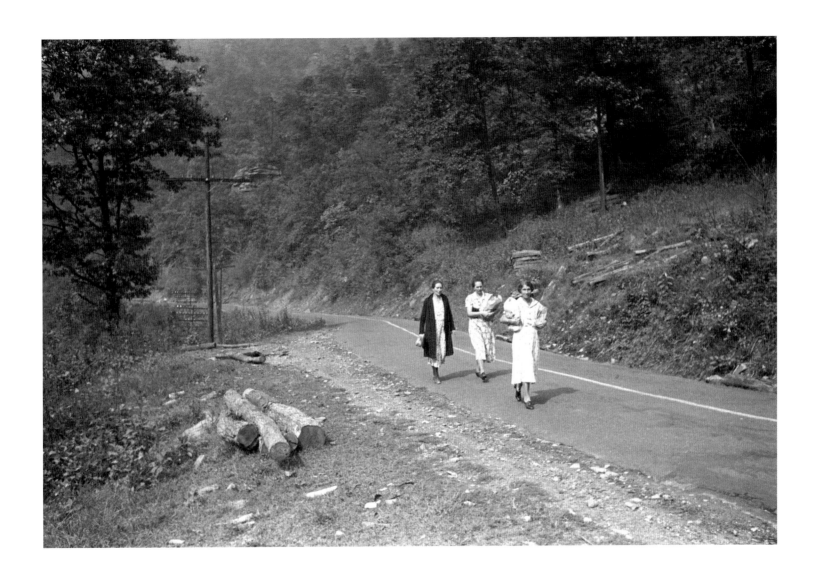

Miners' wives coming home from town with groceries on payday. Near Mohegan, West Virginia. Marion Post Wolcott. September 1938. LC-USF33-030085-M3.

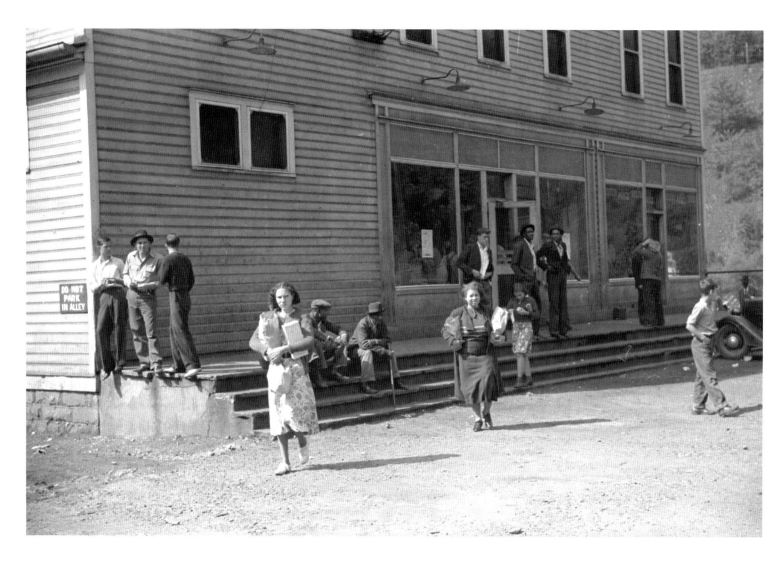

Company store, coal mining town. Capels, West Virginia. Marion Post Wolcott. September 1938. LC-USF33-030102-M1.

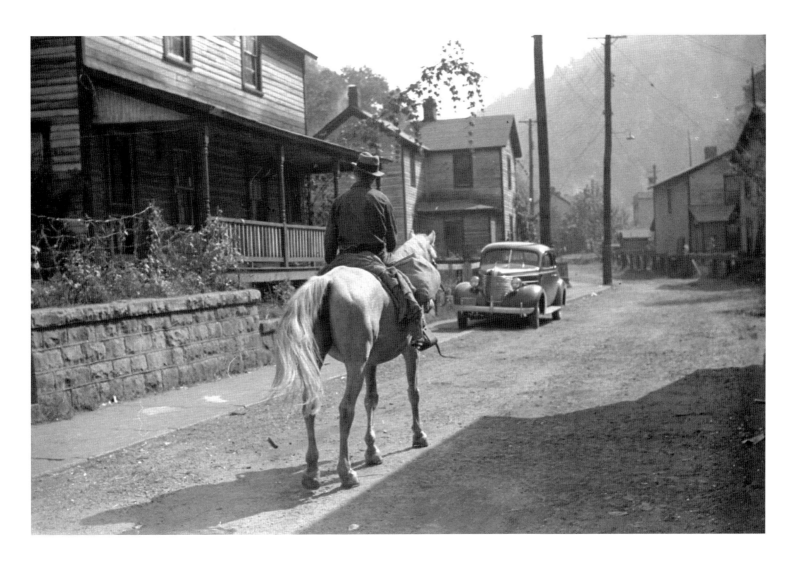

Miner taking home provisions. Capels, West Virginia. Marion Post Wolcott. September 1938.
LC-USF33-030102-M3.

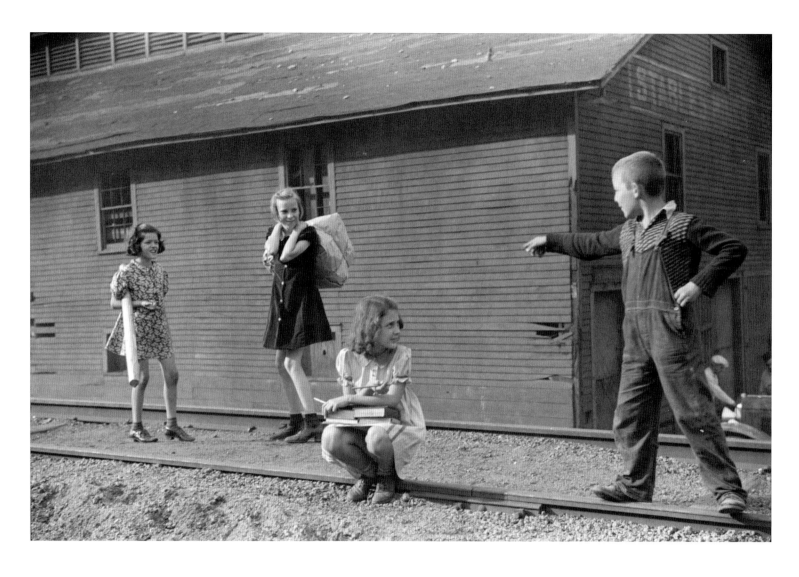

Children going home from school. Omar, West Virginia. Marion Post Wolcott. September 1938. LC-USF33-030115-M5.

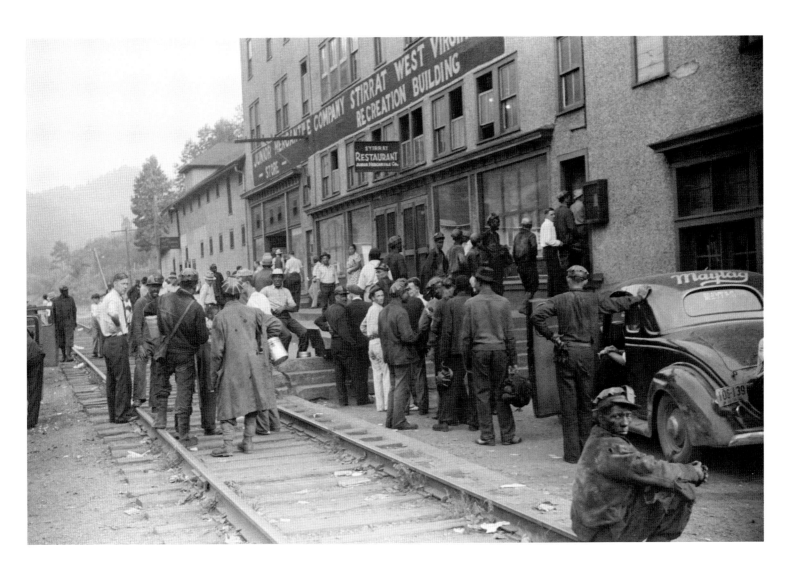

Payday, coal mining town. Stirrat, West Virginia. Marion Post Wolcott. September 1938.
LC-USF33-030117-M5.

11

Wartime Photo-Essays: Richwood and Point Pleasant

Carl Mydans,
Oral history interview,
April 29, 1964.
Archives of American Art

"I THINK THE MOST exciting thing first to me was to learn something about America. When I started out in the Farm Security Administration I came from the Eastern seaboard. I knew New England. That was my background. I guess it still is. But I lived in an isolated world; vaguely there was a great river called the Hudson, and a great bit of land at the other side of the Hudson, but I knew very little about it. Then I began to travel across the United States, and I began to see what a country it was. Perhaps of all the things that I saw, I was impressed mostly by the people. They differed in various parts of the country on the one hand, but on the other, they didn't differ at all. They dressed physically differently in various parts of the U.S.A., they earned their living sometimes in different ways. But the first awareness I had in America that Americans had something that was very American, and it didn't matter what part of the country you were in, came in those months when I made pictures for the Farm Security Administration. Years and years later, when we were involved in World War II and some people were so astonished that we could pull ourselves together with such a diverse background and go toward a national goal with such national effort, it was no surprise to me; for years before that I had learned that despite the superficial differences of Americans, and despite a history so short, we are a single people with a single purpose."

— *Carl Mydans*

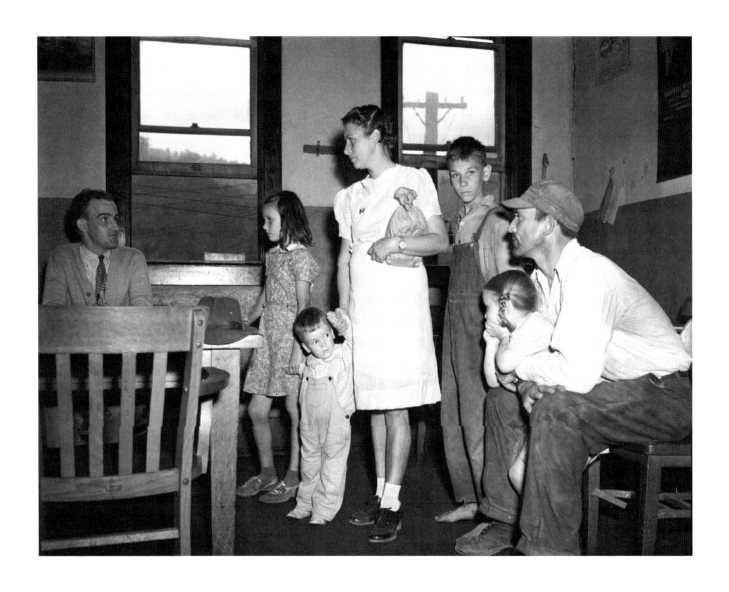

A family talking over the prospects of work with the United States employment service. Richwood, West Virginia. John Collier. September 1942. LC-USF34-083927-C.

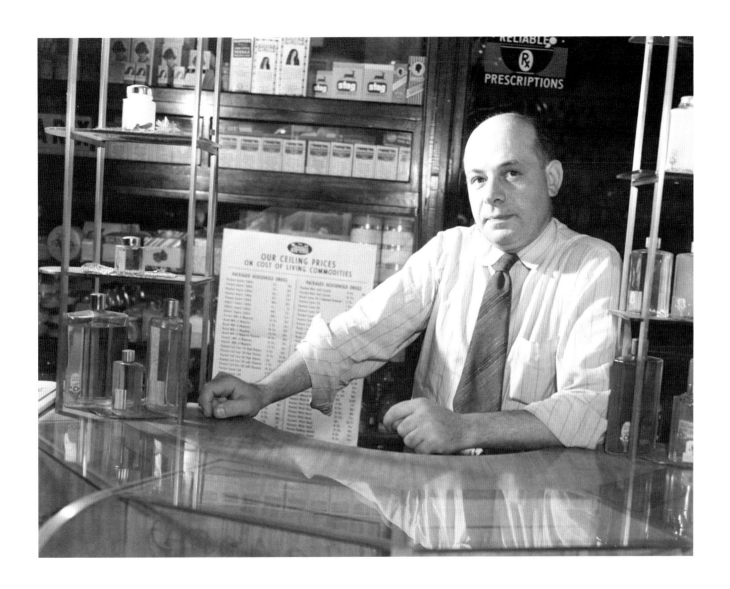

Doctor Carl Kesling, druggist, says that sending our young men to other parts of the country to work will make a better attitude toward "getting ahead." Richwood, West Virginia. John Collier. September 1942. LC-USF34-083938-C.

Mrs. Burt Marshall thinks girls should not go away to work, and that the boys should be seventeen years old, but thinks on the whole, that the government-supervised labor recruiting is good for the boys, because it helps them be good citizens and participate in the war effort. Richwood, West Virginia. John Collier. September 1942. LC-USF34-083961-C.

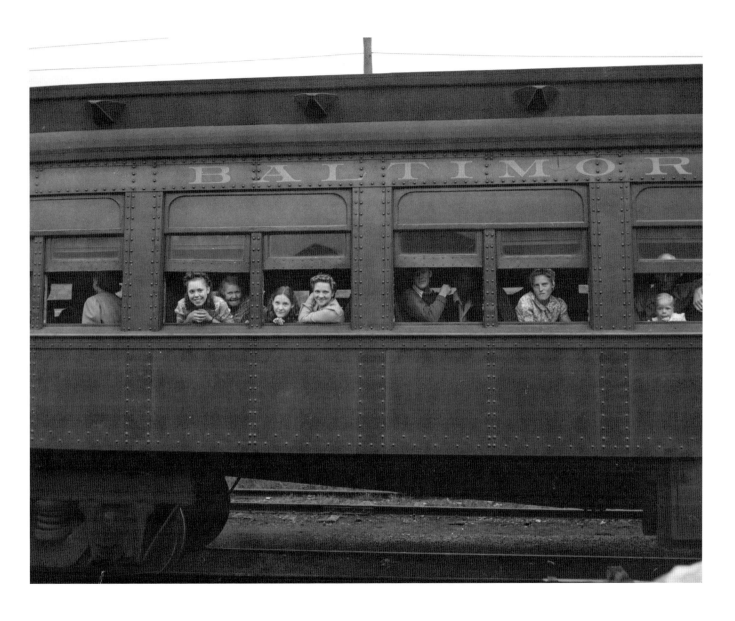

Trainload of migratory workers bound for the harvest fields in New York state. Richwood, West Virginia.
John Collier. September 1942. LC-USF34-083948-C.

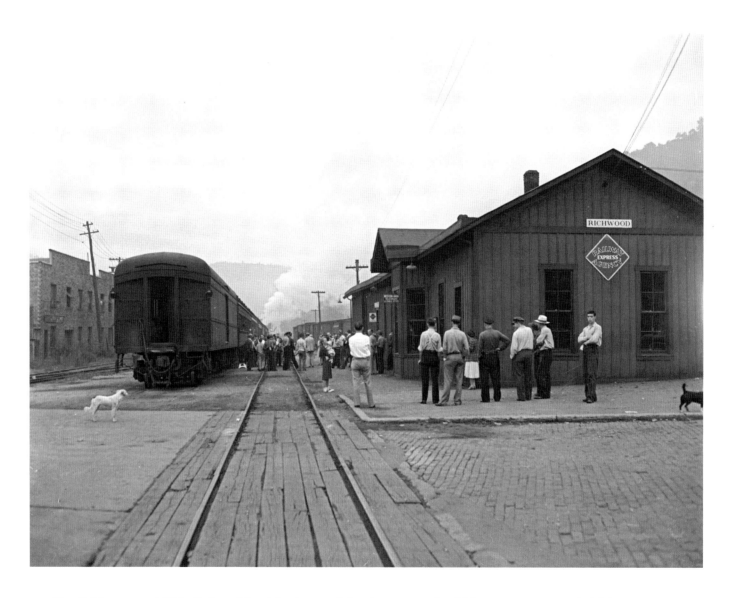

The Baltimore and Ohio Railroad furnished a special train to carry the 300 men, women and children to upper New York state, where they will work in the harvest. Richwood, West Virginia. John Collier. September 1942. LC-USF34-083975-C.

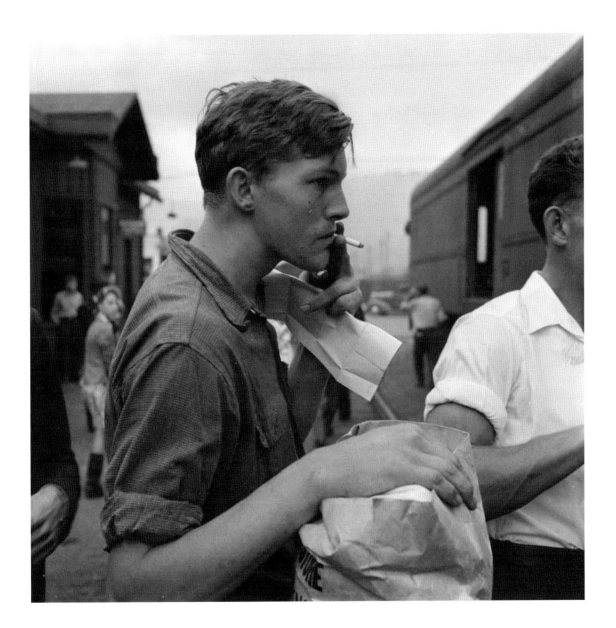

Young man boarding
train for New York
state, where he will
help with the harvest.
Richwood, West
Virginia. John Collier.
September 1942. LC-
USF34-084077-E.

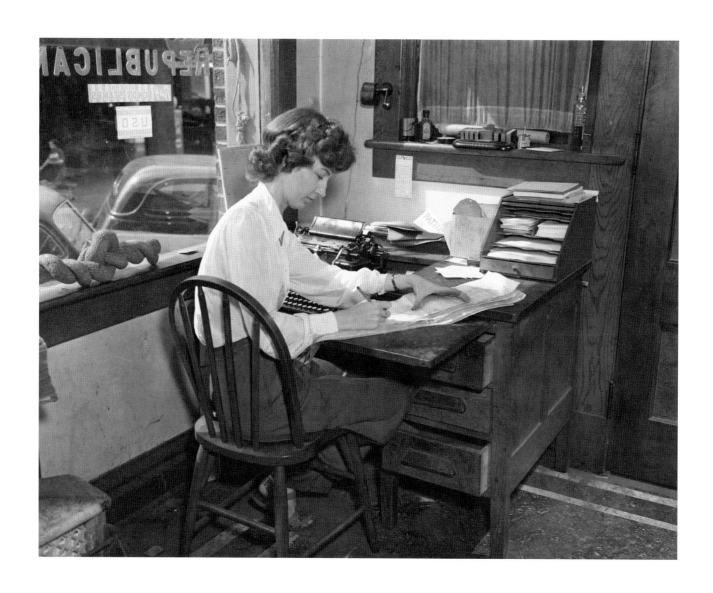

Louise Thompson, daughter of the editor of the Nicholas Republican newspaper. Richwood, West Virginia.
John Collier. September 1942. LC-USF34-084002-C.

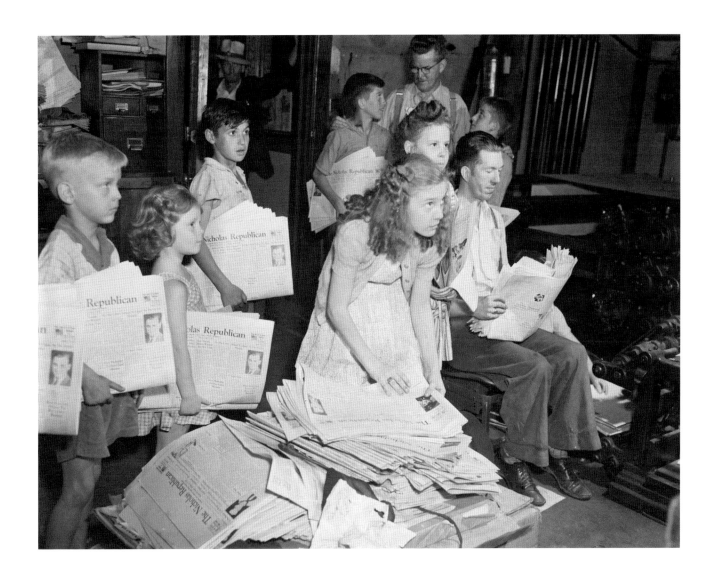

Children preparing to deliver newspapers. Richwood, West Virginia. John Collier. September 1942. LC-USF34-084024-C.

LT boats being built for the United States Army at the Marietta Manufacturing Company. Point Pleasant, West Virginia. Arthur S. Siegel. May 1943. LC-USW3-029847-E.

Man working on
U.S. Army LT-218
at the Marietta
Manufacturing
Company.
Point Pleasant,
West Virginia.
Arthur S. Siegel.
May 1943.
LC-USW3-029879-E.

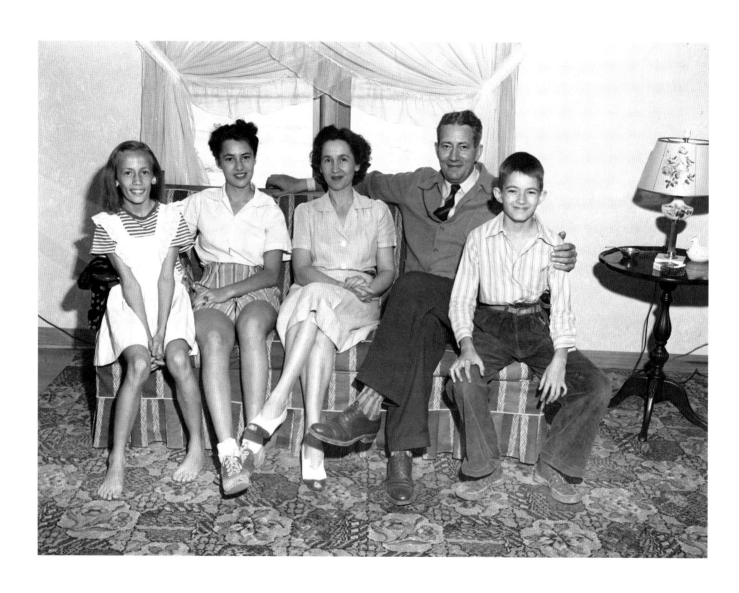

The family of Bob Fergusen, the principal of the local junior high school. Left to right: Ann, Nancy, Mrs. Mamie Fergusen, Bob and Jimmie. Point Pleasant, West Virginia. Arthur S. Siegel. May 1943. LC-USW3-029713-D.

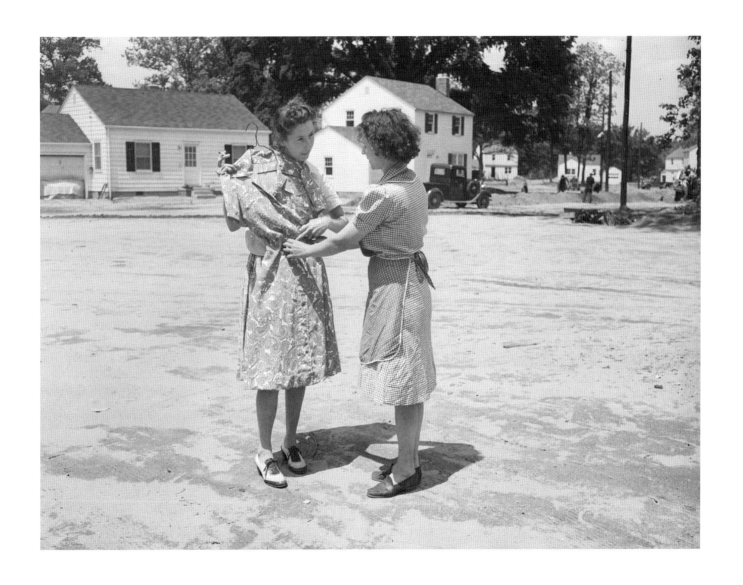

Mrs. Fergusen and a neighbor discussing a homemade dress. Point Pleasant, West Virginia. Arthur S. Siegel. May 1943. LC-USW3-029739-D.

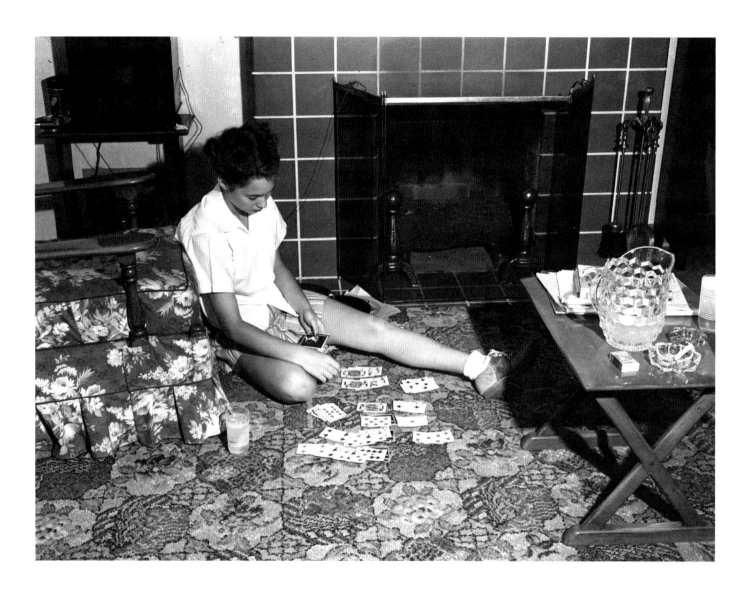

Nancy Fergusen playing a game of solitaire. The town is practically depopulated of young men. Point Pleasant, West Virginia. Arthur S. Siegel. May 1943. LC-USW3-029740-D.

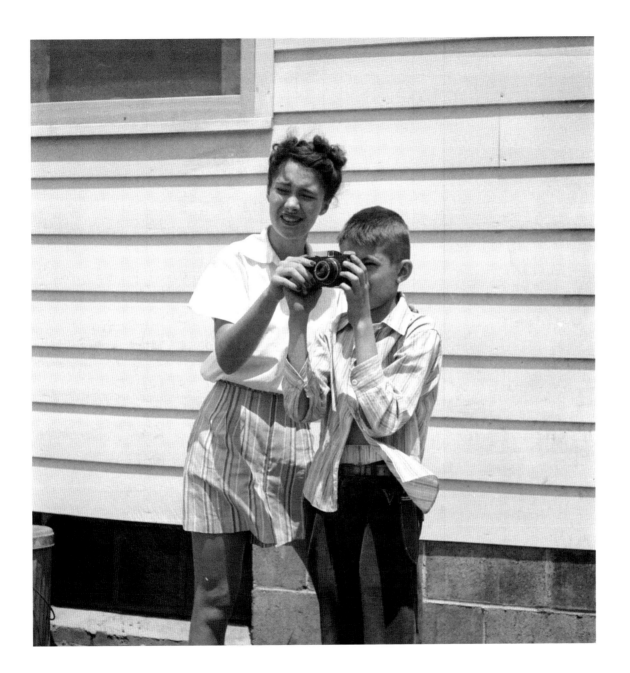

Nancy and
Jimmie Fergusen
with a camera.
Point Pleasant,
West Virginia.
Arthur S. Siegel.
May 1943.
LC-USW3-029864-E.

Pastor and inside of church.
Point Pleasant, West Virginia.
Arthur S. Siegel. May 1943.
LC-USW3-030424-D.

A West Virginia Perspective

"**FOR NEARLY EIGHT YEARS,** it was my great privilege to direct a small group of photographers working out of a grubby little government office in Washington, D.C. These gifted men and women of the Historical Section of the Farm Security Administration produced 270,000 pictures during that time. It is called a great collection now, perhaps the greatest ever assembled in the history of America. But I am not interested in adjectives, I am only interested in pictures.

And what pictures they were. I had no idea what was going to happen. I expected competence. I did not expect to be shocked at what began to come across my desk. . . . Every day was for me an education and a revelation. I could hardly wait to get to the mail in the morning."[1]

—Roy Emerson Stryker

〉〉〉

Between 1934 and 1943, ten amazing artists and photographers associated with the Farm Security Administration (FSA) Project came to West Virginia and produced unique and groundbreaking work that chronicled the impact of the Depression on rural and small town Americans. The photographs in this book are a selection from the best photographs taken during their visits to the state.

Most of these photographs include people. Photographs of people involve communication between the artist, the people photographed, and the viewer. Through these photographs the artists and subjects continue to engage viewers to this day. At the same time, contemporary viewers bring their own perspectives and interests to the images.

This essay offers a contemporary West Virginia view of this earlier work, the way it came about, and the photographers themselves. The FSA Project that sponsored and preserved these photographs extended nationwide. It included shifting crews of professional photographers who produced black and white negatives and prints, plus a small number of color photographs. Scans of these negatives are now available online through the Library of Congress at http://www.loc.gov/pictures/collection/fsa and http://memory.loc.gov/ammem/fsahtml/fahome.html.[2] Half of the forty-eight states from that time have published books or catalogs of their photographs.

The overall mission of the FSA Project was to introduce Americans to America.[3] The primary focus was to show 1) needs that arose from the Great Depression, 2) the successes of New Deal programs and policies that were designed to address these needs, and 3) the everyday life of people living in rural and small town America. Especially during the later years, the photographers also visited some of the nation's big cities.

The FSA covered all regions of the country. However, there were not enough resources to photograph in every part of every state. In West Virginia, for instance, most attention was given to the northern and southern coalfields; the subsistence homestead communities in Arthurdale, Eleanor, and Tygart Valley Homesteads; and the towns of Summersville and Richwood in Nicholas County and Point Pleasant in Mason County.

A Wide-ranging View

The back story shows that West Virginia was a full partner in the development of the FSA Project. Two major factors contributed to this partnership.

First, both President and First Lady Eleanor Roosevelt were integrally involved with West Virginia from the early years of the administration, which began in March of 1933. Their involvement was based largely on their association with Clarence Pickett, executive secretary of the American Friends Service Committee (AFSC). Pickett was a strong advocate for the citizens of the state and region and helped to develop Arthurdale, the first subsistence homestead community in the country.

Another key player at the national level was Rexford Tugwell, who took over responsibility for administering subsistence homesteads and related

programs. Tugwell also established the FSA Project and brought Roy Stryker in as its chief.

Second, the ten photographers who visited West Virginia from 1934 to 1943 were willing to learn and grow through their experiences in the state and use their gifts to produce often iconic photographs of the region and its people. This essay presents their stories in chronological order, based on the time when each photographer made his or her first visit to the state. Information from archives, publications, and websites has been mined to identify direct observations they made of their time in West Virginia. However, the availability of information varied from photographer to photographer, and additional documents may still be tucked away in boxes of letters and diaries awaiting further exploration.

The ten photographers discussed here represent an impressive range of reputations and roles. Elmer "Ted" Johnson was a government photographer with elementary technical training who was available to take photographs requested for President and Mrs. Roosevelt before there was an organized FSA Project. Walker Evans and Ben Shahn are both giants in the history of art who had already established themselves when they began doing government work. Arthur Rothstein, Carl Mydans, and John Vachon built on their FSA experiences to become pioneering photo-journalists for the new pictorial magazines, *Life* and *Look*. Edwin Locke primarily provided administrative support before moving on to a variety of different jobs.

Marion Post Wolcott came to the FSA Project with strong recommendations from well-known photo–graphers and did stellar work. She then turned to a

career at her home and farms and later accompanied her husband on his overseas assignments before being brought to prominence in the 1970s and 1980s, in part due to the attention of the women's movement. In less than three weeks in West Virginia in September 1938, she produced over one-third of the photographs of the state that were a part of the FSA Project. John Collier, who grew up among artists in California and New Mexico, later contributed to the use of photography in cultural anthropology. Arthur Siegel became a leader in experimental fine art photography and worked as an academic from his base in Chicago.

The Roosevelts and Clarence Pickett: Friends of the State

President and Mrs. Roosevelt and Clarence Pickett provided the most direct link between West Virginia and the development of the photographs represented in this book. A number of themes and interrelationships feed into this part of the story. This section of the essay focuses on the period between 1930 and the summer of 1935, which was a precursor to the establishment of the FSA Project. It concludes with a profile of Roy Stryker, the first and only chief of the FSA Project.

As Thomas described in the opening essay, many coal miners lived in dire conditions that developed during the 1920s, before the 1929 stock market crash and the beginning of the Great Depression. Herbert Hoover, who was president from early March 1929 through early March 1933, was a Quaker who had a background in providing food relief to European

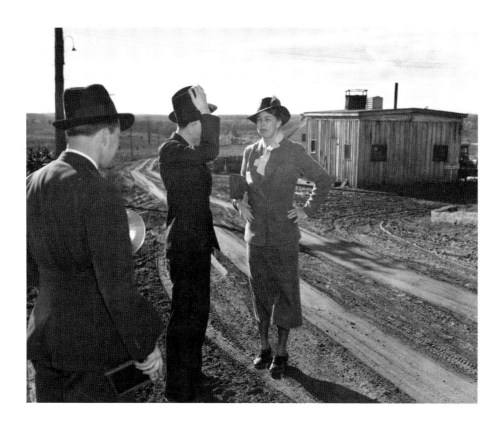

Clockwise from above: Eleanor Roosevelt Visits Arthurdale, West Virginia. West Virginia and Regional History Collection (WVRHC) No. 005263; President Franklin D. Roosevelt Listens to Homesteader M.L. Perkins. Arthurdale, West Virginia. May 27, 1938. WVRHC No. 005274; Carolyn Pickett, Clarence Pickett, Rachel Pickett, Nancy Cook, Eleanor Roosevelt, and Lilly Pickett. Chester County, Pennsylvania. April 25, 1935. AFSC Archives.

countries during and after World War I. The prevailing philosophy during his presidency was that conditions were going to get better by supporting and investing in business and industry; the federal government did not have a major role in providing relief to its own citizens.[4]

However, conditions became worse, not better. After the Wall Street crash in October 1929, while President Hoover was assuring visitors in Washington that the depression was over, Governor Roosevelt was considering a variety of plans designed to salvage its victims.[5] As governor of New York, Franklin Delano Roosevelt worked with Frances Perkins, whom he named as industrial commissioner and a member of his Cabinet, to develop unemployment insurance. Roosevelt also established a new agency, the Temporary Emergency Relief Administration, through which Harry Hopkins, a social worker, developed and administered relief programs for New York.[6]

In 1932, both before and after the November presidential election that Roosevelt won, he sought out people who had direct knowledge of what was happening elsewhere in the country and could give him suggestions for national programs and policies. Clarence Pickett was one of the people Franklin and Eleanor Roosevelt brought in for discussions.[7] Clarence Pickett (1884–1965) had been executive secretary of the AFSC, an organization sponsored by the Quakers, for about two years when his board received and accepted an appeal from the Hoover administration on behalf of the Council of Social Agencies in Morgantown. Professors at West Virginia University and other local leaders, including clergy, had asked for help from the United States Children's Bureau, which appealed to the AFSC to get involved in feeding the children of Appalachia.[8] Between September 1, 1931, and August 31, 1932, the AFSC provided relief in 563 communities in 41 counties in Pennsylvania, West Virginia, Maryland, Kentucky, Illinois, and Tennessee. Within West Virginia, 15,223 children, in 377 schools and 17 counties, received over one million meals. This represented 32.9 percent of the children enrolled in these schools. The counties served were Barbour, Boone, Brooke, Fayette, Kanawha, Logan, Marion, McDowell, Mineral, Mingo, Monongalia, Ohio, Preston, Raleigh, Randolph, Taylor, and Tucker.[9]

Approximately half of the twenty-four schools served in Monongalia County were in the vicinity of Scotts Run, which was across the river from Morgantown.[10] Pickett deployed field representatives to the county and made several trips there himself in support of such local initiatives as bread-baking, community gardening, and a crafts cooperative. As he noted in his autobiography, "Although this was looked upon primarily as a relief undertaking, those of us who had had experience in such enterprises knew from the beginning that it could never be kept fully within the bounds of relief. With half a million miners facing bewildering and often tragic insecurity, it was inevitable that we should become concerned about long-time solutions as well as emergency measures."[11]

The AFSC also began to see some small successes, including, in January 1933, the founding of the Mountaineer Craftsmen's Co-operative Association. This Association helped to build on the AFSC

initiatives to teach miners and their families to make functional crafts and established an outlet for marketing and selling their products.[12]

The direct administration by the AFSC of the program to feed children in the coalfields was intended to be short term. Pickett reported that, by 1933, the organization had closed out this part of its work. He was gratified that groups ranging from local mine operators to the United Mine Workers of America invested in providing health and welfare services. He also welcomed the new assumption of federal responsibility initiated by the Roosevelt administration.[13]

Pickett became involved early on with the Roosevelts' interests in expanding the federal role. During the period between the 1932 election and the inauguration, Pickett stayed a night at the Roosevelt home in Hyde Park and met the next morning with the president-elect and Mrs. Roosevelt to share his thoughts about what could be done for miners, such as those in Scotts Run. Pickett told them about the long-term needs for such programs as vocational reeducation and subsistence living that the AFSC was already piloting.[14]

In January 1933, Pickett appeared before a committee of the United States Senate and advocated with the chairmen for rehabilitation funds to keep people permanently off of relief.[15] As part of legislation passed during the first One Hundred Days of the Roosevelt administration, $25 million was allocated for a program of subsistence homesteading. One of the problems this legislation was intended to alleviate was described as follows: "'Stranded' industrial population

groups. Particularly in the extractive industries, thousands of people have been left without an adequate source of employment and future livelihood because of the decline of a particular industry or its relocation elsewhere. It has been estimated that there are at least 200,000 bituminous coal miners, for example, who have little or no prospect of future employment, partly because of improved mining machinery and methods, in some cases because of age, but largely because of exhaustion or closing of particular mines."[16]

On August 22, 1933, Secretary of the Interior Harold Ickes appointed Pickett as chief of the section on Stranded Mining and Industrial Populations. He reported to Milburn L. Wilson, director of the Division of Subsistence Homesteads. While Pickett spent most of his time in his new position, he was also able to bring in help so that he could maintain and cover his responsibilities with the AFSC.[17]

Pickett's biographer, Lawrence McK. Miller, described the support for Pickett's new government program as a three-legged stool: the existing AFSC initiatives in the coalfields, the federal financial support, and the personal interest and involvement of Eleanor Roosevelt.[18] Pickett helped to facilitate Mrs. Roosevelt's visit to Scotts Run in the late summer of 1933, and played a major role in the establishment of the first subsistence homestead community.

Lorena Hickok met the Roosevelts through her work as a reporter for the Associated Press, for whom she covered the 1932 presidential campaign and the early months of the presidency. After leaving this job she became a senior field investigator for Harry

Hopkins. Hopkins had moved from New York to become Secretary of the Federal Emergency Relief Administration (FERA). In planning her first visit to the field, Hickok checked in with Pickett, who advised her to start in the coalfields in southwestern Pennsylvania and northern West Virginia.

Pickett's brother-in-law, Errol Peckham, who worked for the AFSC, escorted Hickok around Scotts Run. Hickok was so horrified by what she saw that she immediately sent an impassioned report to Hopkins and Mrs. Roosevelt. Mrs. Roosevelt responded by driving over to see the community for herself.[19]

Mrs. Roosevelt was able to remain fairly anonymous at the beginning of her tenure as First Lady. She refused Secret Service coverage and drove her own car. As she wrote in her 1949 memoir, "I had not been photographed often enough then to be recognized so with one of the social workers I was able to spend a whole day going about the area near Morgantown, West Virginia, without anyone's discovering who I was or that I was even remotely connected with the government." This helped her to gain insight into the lives of the residents.[20] Mrs. Roosevelt also wrote, "I liked the Quaker people I met, Clarence Pickett particularly, and I liked the theory of trying to put people to work to help themselves."[21]

Pickett and local citizens in Morgantown had already determined that a subsistence homestead community would be a possible solution to address the needs of at least some of the stranded miners. Originally there were two main concepts for homesteads: one was farming cooperatives and the other was new suburban communities for unemployed urban workers and their families. Pickett's advocacy for communities for stranded miners and other workers helped to develop a third concept of homesteads to address the needs of this population.[22]

After visiting Scotts Run, Mrs. Roosevelt supported the establishment of a subsistence homestead community for residents in the coal camps there. She wanted to move quickly because of the glaring needs of the miners and her concerns that they might turn to communism or become violent because their conditions were so dire. She also wanted a tangible demonstration that gave hope to people in similar circumstances. Resettlement could showcase and build on the strengths and abilities of the miners and their families once they moved to new, supportive surroundings.[23]

The interested citizens from Morgantown had already identified a possible location for the homestead in Reedsville, Preston County, within an hour's drive from Scotts Run. This model community was named Arthurdale after an owner of the property. The land was purchased in October 1933, and construction began shortly afterward. The principal decisions regarding the component parts of this new community were in the hands of a Projects Committee consisting of Wilson, Howe (Louis Howe, the president's closest advisor), Pickett, and Mrs. Roosevelt.[24] Mrs. Roosevelt advocated for what she considered to be basic American standards, including indoor plumbing and electricity. She became involved in details, such as selecting the models of refrigerators for the houses.[25]

Mrs. Roosevelt donated personal funds for the Arthurdale project. "In 1934 Pickett set up an Eleanor

Roosevelt Transit Fund Account, to which she sent her earnings from radio broadcasts, speeches, and articles. . . . For example, in 1934 she received $18,000 from six fifteen-minute radio broadcasts under commercial sponsorship, and all of these earnings went to Arthurdale—the handicraft center, the community school, and the health clinic."[26] She also recruited associates to make donations. One of the most prominent was Bernard Baruch, an industrialist, philanthropist, and power broker, who provided major support for the school.[27]

Mrs. Roosevelt influenced the direction of the community but did not control it. She was not happy with all of the decisions, particularly related to the choice of residents. She had envisioned making the community available to any qualified citizens from Scotts Run. In the end the community was limited to native-born whites based on the belief that this would allow it to fit in better with the surrounding area.

In his autobiography Pickett wrote: "The problem was not 'the Negro' but the tensions that were intensifying around the question [of admissions of Negroes to the homesteads]."[28] Mrs. Roosevelt asked him to convene a meeting of black leaders at the White House so that she could better understand the issues related to race.

The meeting with eight black leaders, which included Mordecai Johnson, a pastor at Charleston's First Baptist Church before going on to become the first African-American president of Howard University, was held on January 26, 1934. President Roosevelt joined the group briefly toward the end.[29] "That White House meeting heralded a new moment in civil rights

policies . . . ER promised to make every effort to ensure black participation in all federal work and relief programs. She would fight for equal education funding and opportunity. ER assured the leaders that her door was always open, her heart with them."[30]

As First Lady, Mrs. Roosevelt went on to devote her energy, sometimes against considerable opposition, to a wide range of civil rights issues.[31] She also continued to build relationships with those who remained in Scotts Run, including black and immigrant residents. Her visits to Arthurdale over the next several years generally included visits to Scotts Run.

Mrs. Roosevelt supported the building of a new black high school in Monongalia County; she attended its dedication on May 28, 1938, before joining President Roosevelt for his speech at the high school graduation in Arthurdale.[32] In 1942, she arranged for the high school's choir to tour in the eastern United States. The tour included a visit to the White House, where the choir performed for the president and First Lady and their guests.[33]

In the rush to develop the model at Arthurdale and establish a prototype for communities nationally, mistakes were made that led to cost overruns and expensive experiments. Arthurdale received national media attention and became a household word for what was good or bad about the New Deal. Mrs. Roosevelt, in particular, was harshly criticized for her involvement.[34]

The administration went on the offensive in the face of this criticism. Mrs. Roosevelt wrote about the merits of subsistence homesteads.[35] She also arranged for an exhibit of photographs showing

the progress of construction at Arthurdale and the other initial communities. The exhibit was held in Washington, D.C., at the Department of Commerce, on April 24, 1934. Her guests at the White House that day included Pickett and his wife, Lilly, who came to lunch, and two of his West Virginia field representatives, who came for tea. At five o'clock in the afternoon President Roosevelt attended the exhibit and made a speech that was broadcast on the radio. Mrs. Roosevelt also spoke in the first joint broadcast ever made by a president and First Lady. The audience included Cabinet members and members of Congress.[36]

President Roosevelt began his speech by saying, "This particular subject that we are here today to talk about and to visualize happens to be one of my own pet children." He described situations all across the country where workers were brought in to provide labor for industries that later declined, for whatever reason, and left them and their families stranded in their communities. He dedicated himself to planning and experimentation to find the best solution for these populations. He also said that even though some experiments might be more successful than others, the country could learn from any failures and profit in the long term. He projected that the costs of investing in families and children who would eventually become self-sufficient would work out to be less than the costs of providing lifelong relief.[37]

Pickett's government responsibilities extended to four subsistence homesteads for stranded communities. Two of these—Arthurdale and Tygart Valley Homesteads—were in West Virginia. As executive secretary of the AFSC, he voiced concerns about international affairs and disarmament and was able to utilize his access to President and Mrs. Roosevelt to present the faith-based views of his organization. On April 25, 1934—immediately following the exhibit of subsistence homestead photographs—Pickett and his wife began a trip to Europe to assess conditions there. He combined explorations of European subsistence homesteads with business related to assistance to refugees— they were primarily from Germany, where Hitler had assumed power in 1933.[38]

On June 15, 1934, after returning to the United States, Pickett had a private dinner with President and Mrs. Roosevelt. Earlier in the day he had presented some concerns to the First Lady that she thought the president might benefit from hearing directly. The subjects ranged from international affairs to operations of the New Deal subsistence homesteads. Pickett had particular concerns about the fact that several different agencies within the government were involved with establishing homesteads. For example, within West Virginia a third community, Eleanor, was built under the auspices of Harry Hopkins at FERA.[39] President Roosevelt shared this concern and said that he was working on plans to address the structural issues.

Pickett was in and out of the White House during the Roosevelt presidency over 150 times, in addition to the many activities that he and Mrs. Roosevelt undertook together outside of Washington, D.C.[40] Although Pickett gradually eased himself out of his administrative position with the government,

he remained involved with the homesteads as a consultant. He worked with the AFSC to develop its own model community, Penn-Craft, in the coalfields of southwestern Pennsylvania, with less restrictions and greater self-governance than in the government's projects.[41]

In December 1947, the AFSC and its British counterpart were awarded the Nobel Peace Prize for their humanitarian work with refugees in Europe and around the world. Pickett's own contribution to public service comes through clearly in the last paragraph of his autobiography: "To live in that state of tension which enables us to be at the same time critic and friend of government, to study its workings sufficiently to be able to help religious insight become political action, remains part of our duty and call. And withal and beyond all, to maintain an abiding faith in the power of good to overcome evil, to live in that way of loving service for which we all most deeply yearn: nothing less than this kind of energetic commitment of our whole lives can satisfy the inner sanctuary of the human spirit."[42]

In her "My Day" column on January 1, 1953, Mrs. Roosevelt described a visit to Pickett and his wife at their home near Philadelphia. She wrote, "It had been some time since I had been in the Quaker atmosphere and I found it a very pleasant experience again. There is a gentle sobriety about how the Quakers conduct their affairs, and yet this gentleness makes them no less firm in their statements and beliefs."[43]

It is interesting to contemplate how Pickett and his association with the Roosevelts may have affected the course of history, including the development of the subsistence homesteads that began in West Virginia. The homesteads, in turn, led directly to the use of photography as a silent witness to what Mrs. Roosevelt later referred to as "the belief in the dignity of man and the value of the human individual." She continued, "This is the basic difference; this is what we of the West really fight for. True, we have not succeeded as yet even in the U.S. in giving it to all our citizens. But we strive for it and we believe in it, and someday we will achieve it."[44]

Rexford Tugwell (1891–1979): A Descriptive Economist

Rexford Tugwell taught economics at Columbia University from 1920 to 1932. In 1932, he was recruited by a fellow professor, Raymond Moley, to be an initial member of the Roosevelt brain trust.[45] This was one of the avenues created by then-Governor Roosevelt to help develop national policies for use in his presidential campaign and potential service as president.[46]

When Roosevelt became president he appointed Tugwell to be assistant secretary to Henry Wallace, secretary of agriculture.[47] Tugwell continued to have access to the president and to offer his ideas. He was outspoken and willing to enter into tough battles, including attempting to bring changes to the old guard in the Department of Agriculture.[48]

Tugwell was labeled a radical, based in part on a trip that he had made to Russia in the late 1920s to study model communities there. He was also regarded with suspicion because he tried to strengthen the

Pure Food and Drug Act of 1906 to provide more protections for consumers. This initiative contributed to attacks by newspapers that were dependent on advertising for patent medicines. He volunteered to leave the administration because of his concern that he was a liability to the president.[49]

On April 30, 1935, President Roosevelt signed an executive order to consolidate administration of all the subsistence homestead communities and other programs designed primarily to help the rural poor, under a new agency called the Resettlement Administration (RA).[50] Roosevelt showed his continued confidence in Tugwell's abilities by naming him as the RA administrator. Tugwell reported directly to Roosevelt while simultaneously serving as undersecretary to Wallace.[51]

Tugwell had reservations about the viability of the four subsistence homestead communities that were designed to serve stranded miners and their families. Nonetheless, out of loyalty to the president, he did his best to make them all work.[52]

Tugwell was determined to provide information to the media and the public that would build support for the president's programs. He created an Information Division to serve this function. Within this division he established the Historical Section and recruited Roy Stryker to serve as its chief.

As Stryker remembered it, "in '35 Tugwell suggested, 'Why don't you come on down [to Washington, D.C.]?' About this time the Resettlement Administration was aborning. It was a glint in the papas' eyes, the two papas being Tugwell and the President."[53] Stryker also said that Tugwell's directions to him were in "a very simple statement. . . . He said that we are going to have a lot of trouble. The press isn't going to be kind to us. We are going to have to turn to new devices, the movie, and the still picture and other things, and he said our problem is to try to tell the rest of the world that there is a lower third, that they are human beings like the rest of us. Their shoes are a bit shabbier and their clothes are a little bit more holey and worn, but they are human beings. That was our job."[54]

In a conversation with William Stott, author of *Documentary Expression and Thirties America*, Tugwell included Stryker as an originator of the FSA Project. In a footnote Stott wrote: "The idea of the unit, Tugwell says, 'was mine and Stryker's, and we wanted to make as complete a record as we could of an agonizing interlude in American life.'"[55]

At the end of 1936, Tugwell left the administration.[56] Stryker and the FSA Project were well enough established to continue without his protection. The president's support from the beginning was crucial to its programs and goals.

Roy E. Stryker (1893–1975): Father of the FSA Project

Roy Stryker was perfect for the job that Tugwell assigned him. Born and raised in Colorado, he had gone to college in mining engineering, worked on a cattle ranch, and served in the infantry in France in non-combat zones during and after World War I. Stryker then moved to New York City to study at Columbia University. He did postgraduate work under

Tugwell and served with him as a graduate assistant and instructor.[57]

One of Tugwell's early interests at Columbia University had been to help develop and promote the Contemporary Civilization core course that was required for all students. As part of his work he involved Stryker and Thomas Monro in putting together a book, *American Economic Life and the Means of Its Improvement*, for use in the course. Stryker's primary responsibility was to provide the visuals to illustrate the text. He worked with Lewis Hine, a pioneer of documentary photography who had photographed children at work in West Virginia and elsewhere in the early 1900s, and chose 76 of Hine's photographs to be included in a total of 188 in the book. Other sources included government agencies, businesses and organizations, and stock photographers.[58] According to Stott, this was the first book about American society with pictures on virtually every page.[59]

Following this project, Stryker initiated a wide variety of field trips and activities to help his students gain firsthand experience with problems and issues in New York City. He also wrote a field manual for use by others who taught the core course. In looking back at his own early work he said, "I guess I was a natural product. I was a person who very easily took Tugwell's admonitions to make economics descriptive to start with. . . . He was always emphasizing descriptive economics. . . . Long before this [FSA] project developed I was busy making charts, hunting up old advertisements, running a bulletin board."[60]

During the summer of 1934, Tugwell hired Stryker to work for the Agricultural Adjustment Administration in Washington, D.C., to illustrate concepts related to agricultural economics. This assignment evolved into a project to develop a pictorial sourcebook. When Stryker returned to Columbia University, for the 1934–35 school year, he enlisted Arthur Rothstein, a student in his senior year, to help find visuals for this project. Rothstein was an amateur photographer who established the first camera club at the school and did work for student publications. A group of twenty students worked with the project through the National Youth Administration. Stryker used his Christmas vacation to go back on the federal payroll to help move the project along. However, the sourcebook was never published.[61]

Stryker gave up on attempting to get a doctorate and moved to Washington in July 1935 to head up the Historical Section. He totally dedicated himself to the task at hand. Arthur Rothstein was the first photographer he hired directly. Stryker assessed the organizational dynamics and realized that he needed to include under his own direction any photography that was going on throughout the RA. He brought Elmer "Ted" Johnson and Carl Mydans in from other RA units. Stryker arranged to include Walker Evans's contract work and later to hire him on staff. He used photographs taken by Ben Shahn during an orientation tour through West Virginia to the Deep South for the RA's Special Skills Division.[62]

Stryker also learned of the photography of rural conditions that Dorothea Lange had been doing in the West; he worked out a way for her to join the staff from her home base in California. She did not photograph in West Virginia—possibly the closest she came was a

trip through Washington, Pennsylvania, on her way to Washington, D.C.—but her early commitment to social issues and the high quality of her photography helped to shape the project.[63]

In a 1971 interview, Evans said, in effect, that at first Stryker didn't know what he was doing and relied on him and Shahn for advice and direction.[64] Possibly this assertion had some validity from a New York art world point of view. Stryker certainly respected the achievements of both Evans and Shahn and was willing to learn from them as he went along. As Stryker himself observed later, "Honestly, I think as far as I am concerned the unorthodox people [Evans, Shahn, and Lange] were educating me. Don't ever overlook the fact that I came in there very green, a very green guy avaricious for a lot of pictures and excited for the kind of material I had looked for."[65]

At the same time, Stryker was extraordinarily well prepared to make the most of the situation in which he found himself. Going back to his contribution to *American Economic Life* and his other projects with Tugwell, he was accustomed to combining photographs with other visuals to illustrate cultural, historic, and economic concepts. His time in Washington, in the summer of 1934, would have given him good exposure to some of the workings of the New Deal. He would also have had the benefit of the intervening year, when he was back at Columbia University, to think about and process what he had experienced.

As noted earlier, Stryker had the backing of both Tugwell and President Roosevelt. In a 1965 interview with Richard Doud, Tugwell said: "Stryker felt that he was very vulnerable, because he had people out taking

Roy E. Stryker. Probably in Washington, D.C. Russell Lee. August 1938. LC-USF33-011585-M5.

pictures, and taking lots of pictures too." . . . [they had] "one great protection—the President. If we got into any particular criticism, all I had to do was go and tell the President, 'You are going to hear something bad.' He would laugh."[66]

Stryker had an excellent sense of what was required to be a "good bureaucrat."[67] He was protective

of his program and his staff. He was flexible in his thinking and in how he worked with people. He had principles and standards that he was willing to fight for and defend.

Stryker also brought his skills as a teacher and insisted that the photographers who worked for him develop an extensive background knowledge of the region and the subject that they were going out to photograph. He served as a mentor in helping staff to further their skills and experience and encouraged them in seeking out new opportunities. Stryker knew how to match people up with the work that needed to be done. Carl Mydans later characterized Stryker as "an inspired educator" with "the unusual quality among educators of being able to transfer his enthusiasm to others."[68]

Stryker fought for the photographers to get credits when their work was published or exhibited. In the 1952 discussion with Stryker and other photographers, Rothstein noted, "there was a great deal of recognition in that project, and I think that is very important to a photographer. Every photographer likes to feel that the work that he is doing is recognized, recognized perhaps by publication somewhere, recognized through use or recognized because it serves some useful purpose, or recognized because somebody in a supervisory capacity says, 'That is a fine job. You did a wonderful job.' And Roy was always doing that." FSA photographer John Vachon added, "A large part of the population became aware of what you were taking pictures for."[69]

Part of Stryker's role was to coordinate the photographers' trips with the requests from the RA regional staff. He forecast trends and anticipated where the next needs for photographs might be. In some situations he supported the photographers in exposing injustices such as the forced removal of tenants from their farms or the misuse of power by local officials.

Stryker's protectiveness of his staff could sometimes appear to be paternalistic. In one exchange of letters with Marion Post Wolcott, he expressed concern about her wearing pants during her travels in the South. She responded that she couldn't find skirts with the pockets she needed for her equipment and that she was careful to be as unobtrusive as possible in her choice of trousers.[70]

Stryker's use of a hole punch to edit out negatives was resisted by some of the photographers, while others adopted this practice for their own use. At least one of the photographers suspected that toward the later years there were so many photographs coming in that Stryker couldn't keep up with them and didn't really know what he had.

In retrospect it is hard to imagine anyone else getting the kind of results that Stryker was able to accomplish through his staff. He managed to steer his program through two major reorganizations—from the RA to the Farm Security Administration, under the Department of Agriculture, at the beginning of 1937; and from the FSA to the Office of War Information (OWI), in 1942. He survived a major downsizing, in early 1938, and he came back to add new staff and a new lab to his program.

In the process of moving the FSA Project through these various reorganizations, Stryker worked for many different bosses. Some of these bosses were

more supportive and understanding of the project than others. However, Stryker was able to protect the integrity of the project and stay true to his vision due in part to his knowledge that he had the support of the president and in part to his own skills in navigating the federal bureaucracy.

Toward the end of Stryker's tenure he brought in Paul Vanderbilt to reorganize the files of photographs so that they would be more accessible. Before leaving his government position when his work was phased out during World War II, Stryker arranged for the FSA photographs and negatives to be housed permanently at the Library of Congress. This may have been one of his greatest legacies as an educator, as the Library of Congress has continued to open up and encourage their use.

Stryker went on to establish comprehensive visual files for private corporations, including Standard Oil of New Jersey and Jones and Loughlin Steel. He also did similar work for the City of Pittsburgh. Some of the former FSA photographers continued to work with him in these new projects.

John Collier, one of the last photographers hired by Stryker, later summarized the strengths of his leadership as follows: "His approach to social documentation was virile and straightforward. He owed no allegiance to any esthetic front but was consumed with the traditions of America and the vitality of rural culture. His enthusiasm for the American scene created a unique opportunity for the FSA photographers—the opportunity to go forth and find the American earth, to record its life just as they felt it should be recorded."[71]

One of the basic tenets of good administration is that managers work through other people. Stryker's mastery as the sole director of the FSA Project led to the production and preservation of the photographs of West Virginia in this book and of those in the national project as a whole.

THE PHOTOGRAPHERS

Elmer "Ted" Johnson: The first New Deal photographer in West Virginia

As an employee of the Division of Subsistence Homesteads of the Department of the Interior, Johnson took at least one photograph of Arthurdale, in February 1934, that was the earliest of the photographs of West Virginia and possibly the earliest of any of the photographs that were included in the FSA Project. It is likely that he was a key photographer who provided the photographs for Mrs. Roosevelt's 1934 exhibit on subsistence homesteads. The dates of some of Johnson's other photographs show that he returned to West Virginia to photograph at Arthurdale later in 1934, in 1935, and in 1936, and that he photographed the subsistence homestead at Eleanor in 1935.

Only a couple of paragraphs about Johnson and his work have been published. He lacked a high school education, trained at Bliss Technical School, and worked for an unnamed newspaper in Washington, D.C.[72] However, his photographs of Arthurdale show that he was technically competent as a photographer, and they are important documents depicting the initial

site; the first style of houses, including exterior and interior scenes; and photographs of daily life.[73]

The one surviving photograph that Johnson took in Scotts Run appeared to be posed. It showed conditions that were somewhat better than those shown in many of the photographs taken there by other New Deal photographers (page 49). A very formal photograph of children in their living room at Arthurdale (page 91) was also attributed to him. Although these photographs were not of the same family, they may have been intended to show a before and after comparison of life in the two communities.

Johnson did not appear to have the education or artistic background of the other photographers in this book. What he did have, which was unique to him, was the full attention and support of President Roosevelt and the First Lady and other national leaders, who were interested in seeing photographs of the first subsistence homesteads. This would have inspired any photographer to do his or her best work.

According to Robert L. Reid, "When the small photographic unit in the Division of Subsistence Homesteads was transferred to [Roy] Stryker's office in the summer of 1935, Johnson became one of the FSA's first photographers. In the fall he was appointed head of the Photographic Lab, a position he held until he left the agency in 1937."[74] Further information has not been located about Johnson's life after leaving the agency.

In Stryker's own correspondence he made several references to Johnson's work in the lab. For example, when Lange expressed concerns about the handling of her films, Stryker reassured her that Johnson would do a good job with them.[75] Stryker's interviews and papers do not refer to Johnson as one of his photographers. However, Johnson continued to visit West Virginia, and his photographs were added to the FSA Project file, after Stryker took over. Johnson was also listed as one of the FSA photographers in the catalog for a College Art Association exhibit, in 1936.[76]

Walker Evans (1903–1975) and Ben Shahn (1898–1969): Setting the bar high

Even before Stryker assumed his position, John Franklin Carter, Tugwell's director of the Information Division, authorized a contract in June 1935 with Walker Evans, an accomplished fine art photographer. Evans was sent to take photographs of Arthurdale and then received word to travel back East by way of another new subsistence homestead project, Westmoreland Estates, in southwestern Pennsylvania.[77]

Tugwell and Carter also supported the hiring in September 1935 of a professional artist, Ben Shahn, by Adrian Dornbush, who was chief of the new Special Skills Division. Shahn was immediately sent on tour through the South, territory that was new to him. This trip took him through West Virginia, where he used his camera to document what he saw.

By the time Evans returned from his trip, Stryker was on board in his job as chief of the Historical Section. The first photographer on the new Resettlement Administration payroll was Carl Mydans, who had been working for Suburban Resettlement. Stryker's first direct hire was Rothstein, who had just graduated from Columbia University.[78]

Stryker interviewed Evans, used his photographs in starting what was to become the FSA Project, and hired him on as staff. He also reviewed photographs from Shahn's trip and included them as part of the Project.[79]

Walker Evans and Ben Shahn were in many ways as different as night and day. Yet there were enough similarities between them and their experiences that they may be discussed in relationship to each other. In some ways they were a breed apart from their fellow photographers because they were established professional artists before, during, and after their time working for the government. This gave them a unique influence on the FSA Project as a whole. They were also friends and colleagues, at least for a time, and were in a position to influence each other.

Shahn was the elder of the two by five years. He was born in Lithuania and emigrated with his family to New York City when he was eight years old. There were craftspeople on both sides of his family, and he began to draw at an early age. When he was eleven, he was taken out of public school and apprenticed to a lithographer. By the age of nineteen, he was a journeyman, belonged to a union, and was able to support himself through his craft.[80]

Evans was born in St. Louis and lived with his family near Chicago and in Toledo, Ohio, and New York City. He graduated from the Phillips Andover Academy in Massachusetts. As a student he was primarily interested in literature.[81]

Both Shahn and Evans tried college but dropped out before they finished. Shahn used his earnings to pay for night classes at New York University and the

City College of New York. He also took courses at the National Academy of Design and the Art Students League. He explored a career in marine biology and studied for two summers at the Woods Hole Marine Biological Laboratory in Massachusetts.[82]

Evans spent a year at Williams College in Massachusetts. He worked for three years at odd jobs, including the New York Stock Exchange and the New York Public Library, before living in Europe for two years. He studied at The Sorbonne in Paris, where he focused on literature. He observed the active literary scene; at one point he was offered an introduction to James Joyce in a bookstore but left instead because he was afraid to meet him. Evans aspired to be a great writer until he realized that this was not his calling. He began using a camera, mainly to take snapshots.[83]

Shahn first went to Paris in 1925. He also attended The Sorbonne, where he studied French, and the Academie de la Grande Chaumère, where he studied art. He returned to New York City to earn more money and then stayed abroad again, until 1929. By the end of his two trips, he had visited France, Spain, Italy, Holland, and North Africa.

As a developing artist, Shahn studied and assessed both current and historical artistic styles. One of his early role models was Giotto, whose work he had first seen at the Metropolitan Museum of Art when he visited there as a child. According to Bernarda Bryson Shahn, "He thought deeply about Giotto, the simplicity and the humanity that had made him so great. He said, 'I often longed to have lived in a time such as Giotto's, when the world was moved by some event as profound as the Crucifixion, when

artists could put all their feelings into paint without fear of triviality."[84]

By the time Shahn returned to America, he realized that he was not bound by anyone else's work. Although he made a few more forays into European styles, as exemplified by paintings that reflected Cezanne's influence, he became determined to trust and express his own vision in all of the various forms he used for his art.[85]

After Evans came back to New York City in 1928, he immersed himself in photography. He mastered the technical aspects of the equipment and processing. Two of his role models were Paul Strand and Eugene Atget. Evans particularly admired a photograph by Strand that showed a blind woman on the street. He saw Atget's work when his friend Berenice Abbott first brought photographic plates and prints back from Paris after Atget's death. "Atget's love for the visibly timeworn, the naïve, and the popular chimed with Evans's own passion for the discarded object and the unpretentious art of the people . . . here was a technique that Evans had already gone far toward mastering, an approach that was self-guided, and a subject—the present shape of a great civilization—that was sufficiently important, large, and amorphous to challenge his ambition."[86] Like Shahn, Evans had his own way of seeing, and he dedicated himself to pursuing this approach.

Shahn and Evans became acquainted in New York City. Shahn had a house and studio in Truro, on Cape Cod, where Evans visited. Shahn painted at least two portraits of Evans at Truro, and Evans took photographs there. They held a joint exhibit of their work in a

Walker Evans, 1926-30. The Metropolitan Museum of Art, Walker Evans Archive, 1994 (1994.251.143).

neighbor's barn. "Shahn's influence on Evans was considerable, although his character and personality—energetic, fearless, and principled—probably had a greater impact than his art."[87]

Evans rented rooms from Shahn in New York City and the two of them, along with a third artist, shared a studio nearby. Both of them had commissions and gallery shows, and each developed a small following. Shahn's series of paintings protesting the execution of two Italian anarchists, Sacco and Vanzetti, received widespread attention. His work was included in major museum shows, including exhibits at the Museum of Modern Art (MoMA) and the Whitney Museum of American Art.

In the early 1930s, Evans worked on a book about Cuba and became interested in photographing the southern United States. He was the first photographer to have a solo exhibition at MoMA, in 1933, when he exhibited photographs of nineteenth-century houses alongside of the first retrospective exhibition of the works of Edward Hopper.[88] In the spring of 1935, he exhibited photographs at the Julien Levy Gallery, in New York City, with Henri Cartier-Bresson and Manual Alvarez Bravo, two other future masters of twentieth-century photography.[89] He also photographed sculptures in MoMA's exhibit of African Negro Art.[90]

Shahn learned about mural painting through working with the Mexican artist, Diego Rivera. In the first years of the Roosevelt administration, Shahn had mixed experiences in designing murals for two New Deal Programs, the Public Works of Art Project (PWAP) and FERA. In both cases the projects he worked on were initially accepted by the sponsors and then ultimately rejected by the New York Municipal Art Commission.[91]

Evans had mixed feelings toward government support. When he was first being considered for a job with the RA, in the spring of 1935, he drafted a memorandum where he specified what he would and would not do. Evans wrote he would "never make photographic statements for the government or do photographic chores for gov or anyone in gov, no matter how powerful—this is pure record not propaganda. The value and, if you like, even the propaganda value for the government lies in the record itself which in the long run will prove an intelligent and farsighted thing to have done. NO POLITICS whatever."[92]

Nonetheless, Evans accepted a contract with the RA, which took him to West Virginia between June 27 and July 10, 1935. During his time in West Virginia he photographed in Arthurdale, along the roads he traveled, and in Morgantown and Scotts Run, which interested him more than the subsistence homestead community. Before he left the area he received a letter and telegram directing him to photograph another project, in Westmoreland, Pennsylvania. While there Evans went down into a mine, which he referred to in his diary as "cold and terrifying."[93]

On July 15, Evans met with Roy Stryker, who had just begun his job with the RA the previous week. They met again, on August 30, and Evans was hired as full-time staff for the RA by the end of September.[94]

Evans worked with the RA through the beginning of 1937, with a leave of absence during the summer of 1936. During the leave he took photographs of three tenant families in Alabama that, in 1941, were combined with the writings of his friend, James Agee, in the book, *Let Us Now Praise Famous Men*. In late 1936, he traveled through West Virginia again and took a few more photographs of Arthurdale; it also appears

that he was with Edwin Locke when they returned through Arthurdale in early 1937, after photographing the Great Flood in the Mississippi basin.

Stryker had to downsize his staff in the spring of 1937 and decided to let Evans go because he was the least productive in terms of the number of photographs. Stryker later acknowledged that his relationship with Evans had become uneasy and difficult and was another major factor in his decision. At the same time, he acknowledged Evans's influence: "Walker had a great effect on me, he showed me pictures he had, and we walked and talked, and he . . . tried to tell me why he saw things. . . . Walker won't believe that I would say this about him, but, by God, he gave me a piece of education that had terrific impact and to this day I love Walker's pictures."[95]

While still in New York City, Shahn had started to use a Leica camera as a short-hand way of making sketches of street life for his paintings. By the time he made his trip to West Virginia and the Deep South, "He respected the camera, and did not set out to use it as a prop for painting; each picture that he took was valued for its own qualities as document or image. But during this time he referred to his photographs constantly; they were his final authority, and in the process of photographing he learned a new way of seeing."[96]

Shahn generally followed the route through West Virginia that Evans had taken a couple of months earlier. Like Evans, he was more interested in where the residents of Arthurdale came from than in Arthurdale itself.[97] He spent some time in Morgantown and around Scotts Run.

He then went south through the state and visited the subsistence homestead at Eleanor.[98] He traveled through Kanawha County, where he took photographs at Hernshaw, and then went down into Logan County. He was in the coal company headquarters town of Omar on a Sunday and Monday: one photograph was labeled "Sunday Morning" and several showed men in dress suits, while in others children were leaving school and laundry hung on clotheslines. He went to some of the surrounding areas, including Freeze Fork, and photographed the train yards in Williamson before crossing into Kentucky and traveling down through the Deep South.

Shahn was not a technical photographer, and the labs sometimes had trouble salvaging his prints. He was also philosophically opposed to using a flash, because he felt that it altered the environment for people indoors. But Stryker saw Shahn's photographs and wanted to use the best of them. Critical elements that Shahn contributed were his impeccable artistry in terms of composition, his insight into the situations he chose to photograph, and his humanity in portraying the people in these situations. Looking back from the perspective of the 1960s, Stryker said that Shahn produced "some of the most exciting . . . interesting human documents in the whole file."[99]

Shahn was able to provide an early and ongoing influence as the FSA Project developed.[100] He worked for the RA through 1938.[101]

Major museums throughout the world continued to exhibit Evans's and Shahn's work both during their lifetimes and since that time. Evans's West Virginia photographs have been included in many of his exhibits.

For his 1938 solo exhibit at MoMA, he also produced a book, *American Photographs*. Both the exhibit and book included three of his photographs from West Virginia.

Shahn made several paintings that were based directly on photographs taken in West Virginia. The best known of these is "Scotts Run, West Virginia." A documentary that was made in 2001 showed how he took elements of three of his photographs and incorporated them into this one painting.[102] Other paintings replicate scenes or details from his photographs of Omar, Westover, and Williamson. Shahn was clearly deeply affected by the time he spent in the coalfields, as demonstrated in a series of illustrations regarding a coal mining disaster in Pennsylvania that he produced for a *Harper's* magazine article in 1948.[103]

From 1945 to 1965 Evans worked as an assistant editor for *Fortune* magazine, with a good deal of freedom to develop his own projects. After leaving Fortune, he became a professor of graphic design at Yale University, where he enjoyed sharing in the learning process with younger generations of photographers.[104]

Shahn also had later experiences with academia. In 1956–57, he presented a lecture series at Harvard University that was published as a book, *The Shape of Content*.[105] He also lectured and taught at other schools and colleges.

Evans is recognized as one of the greatest photographers ever. As described by Peter Galassi, elements of Evans's work that have affected other photographers and artists include the historical dimension; the car culture; street portraits of strangers; domestic interiors; signs and advertising;

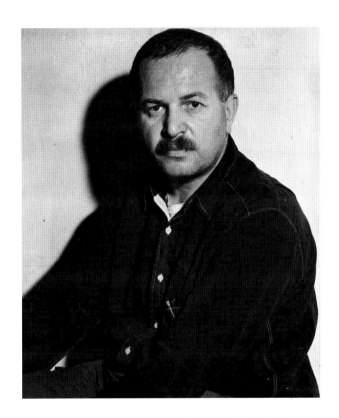

Ben Shahn. New York, New York. December 12, 1938 (AP Photo/Charles Kenneth Lucas)

the movies; a frontal style; and intimate portraits, some also of strangers.[106]

Evans pointed to the elements of transcendence and vision that constitute the greatness of his photographs: "The photographer, the artist, 'takes' a picture: symbolically he lifts an object or a combination of objects, and in so doing he makes a claim for that object or that composition, and a claim for his act of seeing in the first place. The claim is that he has

rendered his object in some way transcendent, and that in each instance his vision has penetrating validity."[107]

Ben Shahn is no longer a household name in the same way that Walker Evans is. However, he also stayed true to his vision and created a prolific body of work, including a series of publications where he combined painting and words.

At the core of Shahn's work was his commitment to humanity. In a 1954 article he wrote: "I find that my own array of values—at least the conscious ones—rotate around the central concept of man as the source of all value. Thus whatever institutions and activities have the avowed purpose of broadening man's life, enriching his experience and his self-awareness are particularly dear to me."[108] Shahn undoubtedly contributed to the infusion of this value throughout the FSA Project.

The photographs of Evans and Shahn continue to be published and exhibited in a variety of contexts. Viewers of the West Virginia photographs are greatly enriched by having the benefit of the time that each of them spent in the state. When Stryker and others refer to the early influence that each of them had on the FSA Project as a whole, they are referring in part to the photographs that Evans and Shahn took in West Virginia.

Arthur Rothstein (1915–1985): An FSA mainstay

Arthur Rothstein was the first photographer Stryker himself selected for the FSA Project. Rothstein was born and raised in New York City and graduated from Columbia University with a major in physics and chemistry.

There are stories that the professional artists, Evans and Shahn, may have considered Rothstein to be a lightweight compared to themselves. Rothstein was willing to learn what he could from working with them to develop his own approach and skills: "Now these men were a little farther advanced in their field—they already had reputations. Ben was a well-known artist at that time and Walker Evans was an accomplished photographer with a very definite sense of style. Both of them contributed a great deal to my own development as a photographer in those days, because they had very definite approaches, and it was not just a question of making a picture, but making a picture that had meaning. They made me very aware of the elements that go into photography—that go beyond just the content of the picture—the elements of style, of individual approach, of being able to see clearly, being able to visualize ideas, and I'm quite sure that these two people did more for my development as a photographer than any two photographers that I could think of at that particular stage."[109]

Rothstein was dedicated and productive. Due in part to his long tenure, he had a considerable influence on the shaping of the FSA Project. He also served as a resource to the project's later photographers.

The Library of Congress (LOC) file includes photographs that Rothstein took in West Virginia in 1936, 1938, 1939, 1940, and 1941. Several of these photographs show road trips when he was driving across the state on his way to somewhere else. He may have been conscious of trying to capture additional views of the state that had not been covered by others. Unfortunately, the letters between Rothstein and Stryker did not include reflections on his time in West Virginia.

Rothstein's most extensive series in West Virginia was taken in December 1941 at Tygart Valley Homesteads. It is not known as of this writing whether this was before or after Pearl Harbor. Although Rothstein had left the FSA Project in 1940 to work at *Look* magazine, he made several trips for Stryker's division, including this one, in 1941–42.

The images of daily life at Tygart Valley Homesteads are insightful and positive, with no signs of the impending war that would absorb Rothstein along with the rest of the country. One photograph shows a rare view of a father and son returning home from hunting rabbits (page 127). This series also includes a photograph of a girl at bat in a mixed-gender baseball game (page 128) and schoolgirls in a circle game (page 129).

Rothstein appears to have been the kind of person who worked well behind the scenes, day in and day out, and contributed to the common goals. He was one of two photographers—the other was Russell Lee—who had the longest service with Stryker and who may have had the broadest view of what he was trying to do. They would have been of immeasurable value in helping to support him and keep the vision.

Between 1943 and 1946, Rothstein served as a photography officer for the United States Signal Corps in China, Burma, and India. In 1946, he was chief photographer for the United Nations Relief and Rehabilitation Administration in China. After returning to the United States he went on to be the director of photography for *Look* and later for *Parade* magazine. Rothstein's books included subjects such as photojournalism, color photography, and documentary photography. He also served as an adjunct

Arthur Rothstein. July 1938. LC-USF33-002825-M2.

faculty member at Columbia University and Syracuse University.[110]

Carl Mydans (1907–2004): Journalist turned photographer

Carl Mydans worked in the Resettlement Division of the RA before transferring into the Historical Section when Stryker consolidated the photographic functions. He visited West Virginia in July and August 1936 and was the first FSA photographer to contribute photographs of Tygart Valley Homesteads.

Carl Mydans. Washington, D.C. Self portrait. ca. 1935. LC-USZ62-120968.

Mydans was born in Boston and grew up in Medford, Massachusetts. While he was in high school he had a job in the boatyards. He considered three

professions—shipbuilder, surgeon, and journalist—and decided to pursue journalism. He graduated from the School of Journalism at Boston University and worked for three years in New York City at The American Banker, where he reported Wall Street and banking news. [111]

In New York City Mydans used the camera for fun. He also used it for photographs that he needed in his freelance writing and did a considerable amount of work in the darkroom. He took a course in photography at the Brooklyn Institute of Arts and Sciences.

Mydans benefited from two men who were major influences in his professional life. One of these was Bob Cheney, a boatbuilder, "who taught me how to use my hands, and he would often stop me and say, 'stand back and look at it, and if you think you've done a good job, that's it. If you don't think you've done a good job, then go back and redo it or do it better next time.' Those are words that I have never forgotten, and whenever I have looked at a picture or looked at a possibility of a picture that I am going to make I often hear his words. Will what I take meet my expectations? He didn't say *his* expectations, he said meet *my* expectations. It was one of the most profound things that ever was said to me."[112]

The other influence was Roy Stryker. Mydans recalled, "He would sometimes pick up a picture that I made and look at it. He was an intense, visual historian. And he would say 'I like that picture but that lamppost there in the foreground, I don't like that. Don't tell me that it was there. I don't want to know anything about a picture that isn't right. I want you to make a picture that is right.'" [113]

Mydans's 1936 photographs of Tygart Valley Homesteads demonstrated his direct and engaging approach to his work (page 115 and page 116). He considered his experience with the FSA Project to be a very important part of his own development.

Mydans left the FSA Project in November 1936 to join *Life* as its first issue was being published. He was the first of several of the FSA photographers to carry his gifts and skills into one of the new pictorial magazines, *Life* and *Look*. These magazines, in turn, had an influence on the later stages of the FSA Project.

At *Life* Mydans did feature photography and then went on to become a highly recognized war photographer. Mydans's memoir, *More Than Meets the Eye*, is an absorbing well-written account that focused mainly on his wartime experiences, including the time that he and his wife, also a *Life* employee, were interned by the Japanese. He also described in detail the circumstances that led to his taking a famous photograph of General Douglas MacArthur reclaiming the Philippines.[114]

According to Mydans's obituary in the *New York Times*, August 18, 2004, "His ability to tell a story through a single face would distinguish his career."

Edwin Locke: Passing through

In April 1936 Stryker hired Edwin Locke to serve as his assistant. Locke was a graduate of New York University and also attended the New School for Social Research, where he studied physics, mathematics, and literature. He had paid his tuition by working a variety

Edwin Locke. LC-USZ62-121075

of jobs, including messenger, seaman, and salesman. Prior to working for the federal government, where he started, in 1935, as an assistant clerk, he spent six years as a clerk for the New York Edison Company and volunteered with a magazine.[115]

Locke was primarily a writer, but he also traveled for the FSA Project as a photographer. He visited West Virginia in December 1936 and February 1937. On his December trip he stopped in Kempton, Maryland, which straddled the border with West Virginia, and then went on to Arthurdale and Tygart Valley Homesteads.

On the February trip Locke and Evans went to Arkansas and Tennessee to photograph the Great Flood and stopped in Arthurdale on their way home. Locke's work included photographs of residents going about their lives (page 97 and page 98).

Locke stayed with the FSA Project until late 1937, when he and his wife visited Ireland. In a January 1938 letter to Locke, Stryker discussed possible changes in his organization. Evidently Locke maintained a good relationship with Pare Lorentz, an RA filmmaker, that he used to the advantage of Stryker's division. Stryker noted: "Pare is certainly in good spirits and certainly is acting in a very friendly manner. For this, I am sure, I owe you a great deal of thanks." Stryker continued by commenting, "The news of Spain and China depresses me no end. Also internal situations seem to grow more muddled as the days go by, and I don't know who in the hell can get us out of the wilderness." He also offered to get money to Locke if he had an emergency on his trip to Ireland.[116]

In March 1938, Stryker wrote the following recommendation letter for Locke: "During the two years in which he was associated with me as my assistant I feel that I had ample opportunity to judge his virtues and weaknesses. I found him to be a person of excellent judgment. No matter how long the hours

or what the pressure, he carried his share of the work cheerfully and intelligently. He is a clean cut, forthright fellow, honest and fair at all times in his dealings with his associates."[117]

When Locke came back from Ireland he did some work for Lorentz. He held a number of different jobs and made several unsuccessful attempts to rejoin the FSA Project. He and Stryker had a long correspondence throughout this time. Locke later worked with Stryker on projects for Standard Oil of New Jersey.

Marion Post Wolcott (1910–1990): A unique contribution

Because of federal funding cutbacks, the spring of 1938 was a low point for the FSA project. Stryker lamented in his letters that he was down to two photographers and could not replace others as they left. Then in July 1938 there was a resurgence in spending. Stryker rejoiced that he was able to hire two new photographers and build a new photographic laboratory.

The first of these two new photographers was Marion Post Wolcott. At the time she was a single woman, Marion Post. After she married, in 1941, her married name was used retroactively in all references to her and her work.[118]

Post Wolcott had been in a position to view at close hand the conditions of different levels of society in the country. She grew up in Montclair, New Jersey, across from New York City. Her father was a homeopathic physician. When her parents divorced, she and her sister, Helen, went to a progressive

boarding school in Greenwich, Connecticut. Marion also spent time in Greenwich Village with her mother. After studying early childhood education at the New School for Social Research and at New York University, Marion followed her sister to Europe in 1932. There she studied dance in Paris and child psychology at the University of Vienna.

By then Helen Post was a serious photographer. Post Wolcott bought her first camera, a Rolleiflex, and took photography lessons in Austria. Both of the sisters witnessed the early rise of Hitler. They had Jewish friends whose lives were in jeopardy. As conditions worsened the administrator of a trust from their father forced them to return to the United States.

Post Wolcott gained additional experience in the use of the camera while supporting herself with a teaching job in an experimental school.[119] She moved to New York City, where she began to do freelance photography. She became acquainted with Ralph Steiner and Paul Strand, and she worked with them and with Elia Kazan on the film, *People of the Cumberlands*.[120]

In 1937, Post Wolcott took a job with the *Philadelphia Evening Bulletin*, where she was the only woman photographer. In the beginning she had to stake out her ground among her male colleagues, who challenged her by such actions as using rough language and spitting in her developer. After a year and a half of assignments that focused on the society sections of the paper, she decided to leave to seek more meaningful work where she could better contribute to improving conditions in the country.[121]

Post Wolcott learned about the FSA project and decided to apply for a job there. Strand wrote in a reference letter to Stryker that "It gives me pleasure to give this note of introduction to Marion Post because I know her work well. She is a young photographer of considerable experience who has made a number of very good photographs on social themes in the South and elsewhere. . . . I feel that if you have any place for a conscientious and talented photographer, you will do well to give her an opportunity."[122] Stryker hired her despite his misgivings about sending a young attractive single woman to travel alone through the South.[123]

Post Wolcott spent several weeks in Washington studying what were by then extensive photographic files. She was on three months' probation and needed to prove what she could do. She drove to West Virginia for a trial tour.

Approximately one-third of the FSA photographs of West Virginia were taken by Post Wolcott. Although she traveled in the footsteps of her predecessors, she brought a new and original style and sensibility to her work. Her photographs were on the one hand clear and straightforward, and on the other intimate and domestic. Post Wolcott took time to gain entry into communities and homes. She would offer to help with dinner, change diapers, and generally be useful to a family before taking up the camera to photograph their lives.

F. Jack Hurley wrote that with one photograph (page 75), Post Wolcott cemented her tenure with the FSA Project.[124] This photograph showed from the back a young girl who was toiling to carry a kerosene can as she

Marion Post Wolcott. Pine Mountain, Kentucky. Marie Turner. August 1940. LC-USF34-055917-E.

walked on a path between coal camp houses and coal trains, with a coal mine tipple in the distance. Times were supposed to be better, and Post Wolcott's primary charge was to show the successes. At the same time, her photographs show that she was unable to ignore the challenging conditions and, in some instances, vestiges of abject poverty, that she encountered.

Post Wolcott also photographed a few fine country houses and farms, life in Arthurdale and Tygart Valley Homesteads, miners entering and leaving the mines, and children returning from school to their homes in High Collar, the section of Omar

for professional staff. The bulk of her work focused on the unique characteristics of everyday life in the coal camps of Scotts Run and along the Davy Road in McDowell County.

Like Shahn, Post Wolcott had an interest in diversity. Many of the captions for her photographs refer to race and ethnicity. One of the best sequences of her photographs, which showed African American families at home in Scotts Run, was unfortunately marred by a large white spot in the lower left-hand corner of each print.

According to Nicholas Natanson, the photographers collectively achieved a range and depth of coverage of African American life that was rare in government or private photography. Post Wolcott, Evans, Shahn, and Lange were leaders in contributing photographs of blacks to the FSA file. West Virginia was one of four upper South states where the percentage of photographs with black people in them exceeded the percentage of blacks in the population as a whole.[125]

The selection of Post Wolcott's photographs in this book includes at least two that may be viewed as reinforcing negative stereotypes of the state. Both of these have been widely published. In the first of these (page 149), a woman's strong fighting spirit comes through despite her desperate circumstances.

The second photograph (page 21), which shows two dirty-faced children on a bed with dolls hanging from the ceiling above them, may be seen as a grotesque but strong and moving statement of young lives foreshortened by circumstances beyond their control. Other photographs in this series showed the children's young mother with a third child—a

toddler—in a chaotic environment that appeared to be overwhelming.

The series with the second photograph was taken in Charleston, where Post Wolcott focused mainly on the houseboat culture on the Elk River and the lower-income sections of the city and its environs, along with a small series of the Union Carbide chemical plant. It appears that she was mainly passing through on her way to the southern coalfields, where her coverage was balanced by showing a team of men and boys making molasses, women in ironed cotton dresses and high-heeled shoes carrying groceries home from the store and meeting over a fence, and relaxed and genial miners talking among themselves and greeting her from their front yards.

The only firsthand report on the trip to West Virginia was a telegram that Post Wolcott sent to Stryker on September 27, 1938, as follows:

ARRIVED WELCH YESTERDAY AFTERNOON FOGGY RAINY ALL TODAY REMAINING THIS TERRITORY FRIDAY SATURDAY IN HOPES BETTER WEATHR WONDERFL MATERIAL HERE. NEED AT LEAST ONE GOOD DAY ADDRESS HOTEL CARTER RETURN SUNDAY BE IN OFFICE MONDAY. MARION.[126]

In response to a request for any further writings from West Virginia that might be in Post Wolcott's personal files, her daughter wrote that "Because it was her first trip, 1938, difficult and overwhelming, I don't think there was time for much commentary other than in the great many captions she had to write at night."[127] Post Wolcott's captions were among the most detailed in the collection of West Virginia photographs.

Post Wolcott brought tremendous insight and energy to her work in West Virginia. She recognized and celebrated the spirit of the people she photographed as they went about their daily lives. She also left a comprehensive and enduring record of high-quality photographs.

In 1939, following her West Virginia trip, Post Wolcott proposed to Stryker that she spend time in Florida photographing the life of wealthy townspeople as a marked contrast to the people who were working in the fields.[128] She eventually did this project and another similar series of the rich in northern Virginia. Of all of the photographers Post Wolcott may have been one of the most sensitive to these issues based on her experiences as a teacher of both rich and poor children and as a photographer of Philadelphia society who was also involved with photographing and filming in rural Depression-era Appalachia and the Deep South.[129]

Post Wolcott was a consistent and loyal contributor to the FSA Project during the years that she served with it. She was almost constantly on the road and produced an enormous body of work that is still being mined for books and exhibits. She left the project in 1942 after marrying Lee Wolcott, a widower with two young children. They had two children together and she retired from professional photography to stay at home with the four children and help to manage a series of family farms while her husband did public work.[130]

During the 1970s and 1980s, Post Wolcott was rediscovered and honored as a pioneering woman

John Vachon. 1942. LC-USF341-014695-C.

photographer. She attended and spoke at forums, gave a few interviews, and, in her last years, worked with F. Jack Hurley on his biography of her. She also produced new photographs of cultures where she and her husband visited and lived after raising their children. She received a number of awards, and, shortly before her passing, retrospective exhibitions of her work

were held at the Art Institute of Chicago and the International Center of Photography.[131] New exhibits and publications of her photographs continue into the twenty-first century.

John Vachon (1914–1975): Understanding West Virginia

John Vachon was born and raised in St. Paul, Minnesota. He went to public schools and graduated from St. Thomas College in his home state. He moved to Washington, D.C., to do graduate work in English at Catholic University, which he left in pursuit of government work.[132] He saw himself as a writer, but he was willing to take whatever job he could find.

Stryker hired Vachon in 1936 to be a messenger. He then reassigned Vachon to organize the growing photographic file. In the process of working with the photographs, Vachon became very familiar with them and with what each photographer was doing. He took an interest in photography and wanted to try it himself. He began by taking a camera to photograph in Washington. Then Stryker sent him out to the Midwest and eventually promoted him to a position as a photographer.[133]

Vachon admired the other photographers, particularly Evans, and at first was very imitative of them. At one point he found a scene that Evans had photographed in Atlanta and tried to replicate the image. In Omaha, Nebraska, he had a kind of awakening to his own view of things. From this experience he was able to move forward and develop his own eye.

Vachon visited West Virginia in June 1939 and January 1942. On his first trip he did an extensive series of photographs of Tygart Valley Homesteads and the nearby town of Elkins. At Tygart Valley Homesteads he showed a very settled and mainstream kind of lifestyle, with women at a club meeting and young girls playing tea on a back stoop (page 121 and page 125). The people in the photographs seem to have been very comfortable with his presence.

Vachon also made some edgier photographs. His photograph of a girl on the lawn with a clothesline in the foreground seems to be prescient of Andrew Wyeth's famous painting, *Christina's World* (page 126), although that work was not completed until 1948.

Vachon's photographs of Elkins were also very interesting. His views of the streets were fairly standard (pages 23–24). More unusual places included a poolroom, hotel lobbies, and his hotel room. He also shot a small series that focused on the railroad.

During Vachon's 1942 trip, he crossed the state, apparently on Route 50, through Romney, Grafton, Clarksburg, and Parkersburg, before going into Ohio. In a diary entry from Romney, dated January 24, 1942, he referred to West Virginia as "The gaunt brooding state of the U.S."[134]

In an entry the next day—this one from Clarksburg—Vachon documented the look of poverty that continued in some parts of the state during the earliest days of the war: "Today I crossed a hundred miles of earth rump in West Virginia. Down in the cracks between brown hills the dirty towns string along. Unpainted, smoke blackened,

inadequate—these are poor towns. The look of poverty has fallen on the people's houses, the movie theatres, the hotels and stores. It has fallen on the cut hills that surround the towns, and on the people's faces. It will take many years of prosperity security and easy access to the good things to erase all of that look of poverty. Then perhaps the heritage of these thin hard straight eyed West Virginia people will bring forth a new American culture. They are the strangest of all American people, these West Virginians."[135]

Vachon's diary entry from Clarksburg went on to show his rapport with people he met in the state: "I drove two high school age girls ten miles out of Grafton today. They were dressed in poor worn bright colored clothes, holes in their silk stockings, and lipstick on their mouths. They talked of Johnny, Huck, Hiram & Sleepy, boys they know. And of the chocolate meringue pie eating contest which the boys had engaged in last night at a church party. They said to each other several times 'Golly aren't we having a lot of fun!' and giggled and laughed when they said it, each understanding the other."[136]

Although Vachon did not elaborate on his statement about the strangeness of West Virginians, it appears that he understood the close relationships that people had with each other and valued this inner spirit, regardless of outward appearances. His photograph of a window full of new shoes in Clarksburg (page 46) not only is a direct descendant of Atget's and Evans's photographs of storefronts, but it also points to a careful approach to wartime prosperity.

Vachon left the FSA Project in 1943 to work with Stryker on the Standard Oil of New Jersey Project. He

was drafted to serve in the United States Army Signal Corps, and then rejoined Stryker. He went on to work for Rothstein at *Look*, where he did feature stories. Following this Vachon did freelance work in New York and received a Guggenheim Fellowship to photograph in North Dakota.[137]

John Collier, Jr. (1913–1992): Child of the New Deal and its artists

By the time the last two photographers visited West Virginia, the FSA had been moved under the OWI and the country was on a war footing. Resources were carefully targeted to further the home front support for the war. *Life* and *Look* magazines were well established and provided a model for photojournalism that may have influenced the structure of at least some of the FSA assignments.

John Collier was a child of both the recent history of photography and of the New Deal. He was born in New York and grew up in the San Francisco Bay Area and in Taos, New Mexico. He was influenced by family friends like Dorothea Lange and Paul Strand; he worked in Strand's old darkroom in New Mexico during his time there. His father, John Collier, Sr., was appointed by President Roosevelt to be the commissioner of Indian Affairs during a period when the agency was shifting from a paternalistic to a more democratic model.[138]

As a child Collier was hurt in an accident and had problems with hearing and with learning in a normal schoolroom. His family nurtured his artistic talents and he viewed himself primarily as a painter; one of

John Collier, Jr. ca 1943. LC-USZ62-120967.

his influences was Maynard Dixon, the prominent Western painter who was also Lange's first husband. He studied at the California School of Fine Arts and worked as a photographer in San Francisco before Stryker hired him.[139]

Collier's assignment in West Virginia was to document the progression of events related to the recruitment of citizens of Nicholas County to help with the apple harvest in upstate New York. His series of photographs showed his skills in entering into a community, establishing relationships, and looking at all sides of a story. He also used extensive captions for townspeople to express their views of the events taking place. Collier rode the train with the West Virginians as they traveled to New York, where he photographed them as they settled into migrant worker camps and worked in the fields.

It is interesting now to look back at these photographs in the context of wartime. Collier showed roles for women on the home front—raising children, helping to run a newspaper, and working in shops. A very proud-looking little girl stood straight and tall in the group of children getting ready to sell newspapers (page 169). Collier also showed teenage boys who were not yet old enough to go to war, but who would be soon, before the war was over. In the photographs they seemed to be serious beyond their years as they prepared for what the future might bring. They had likely already seen older brothers and neighbors go into the service.

What endures, in the photographs included here and in the many others taken as part of the series, is the great respect that Collier demonstrated as he explored the nuances of people's lives and actually joined in with them as they left home to serve their country by helping with the harvest in New York State. He combined the assignment-oriented aspects of photojournalism with an open-ended exploration into many different dynamics that affected the community and its citizens.

Collier went into the Merchant Marine until Stryker was able to get "me a berth on a wartime project at the Standard Oil, so I got permission from my draft board to go to the Arctic to photograph oil operations."[140] According to the foreword to his book, *Visual Anthropology*, he "spent four roving years recording the role of petroleum as an agent of change, from the arctic to the tropics. This experience brought him to the challenge of cultural significance in photographic imagery." Collier also worked for two

years on an FSA-type project in Columbia, which he credited with leading him into anthropology. His collaboration with an Ecuadorean anthropologist resulted in a book, *The Awakening Valley*, about the combining of photography and ethnography.[141]

Collier served as an anthropology research assistant at Cornell University and eventually lectured at Stanford University, the University of California at Berkeley, and the California School of Fine Arts. He taught in the anthropology department of San Francisco State University, where he was named a full professor.[142]

From the perspective of 1965, Collier made a prophetic comment about the way that the FSA photographs are now used. He said: "the richness of the file is the fact that it is very non-objective. Sure, you find miles of canned fruit in the file, it's true, everybody took the turn at government projects but they tend to be pedestrian and you have two levels of important data, in the file. Something's on the firing line right in the middle of a dust storm and the Okie camps, or you find highly non-objective records of what was going on in America at that time, usually faced in the other direction from the government project. This, of course, insured a kind of eternal value to the file, because it gave the file a massive art content which would otherwise have been utterly missing."[143]

Because of the great insights of the photographers, and their interrelationships with the people they met, even the photographs of the subsistence homestead projects in West Virginia express this kind of eternal value referred to by Collier. After leaving West Virginia and the FSA Project, Collier spent the rest of his

life exploring and teaching others about the uses of photography in the study of culture.

Arthur Siegel (1913–1978): Documenting the home front

Arthur Siegel was the last of the FSA photographers to visit West Virginia. He was also one of the last to be hired by Stryker. Like Collier, he entered the project when it was in more of a photojournalistic mode. In his 1965 interview, Collier also suggested that Siegel would be a good resource for the interviewer, Richard Doud, to talk with: "He never worked for Farm Security; he worked for Roy, though, at the Office of War Information. And he knows all the photographers involved and he's an extremely intelligent and alert person."[144]

Siegel was born in Detroit and studied at the University of Michigan and Wayne State University, where he also taught photography. He studied photography at what became a program of the Illinois Institute of Technology in Chicago.

It appears from his photographs that Siegel spent at least some time on a riverboat when he visited Charleston in 1943. He photographed the State Capitol, the South Side Bridge, and the chemical factories west of Charleston from his vantage point on the river.

He visited Mason County, where he photographed a large farm, the Marietta Boatworks, members of the Coast Guard, and a family who lived in Point Pleasant. His overall theme in these photographs was the contributions to the war of those on the home front.

Siegel brought a poignancy to his photographs as he showed how daily life continued while the nation

Arthur Siegel. Chicago History Museum. ICHi-15770; Photographer—Arthur Siegel

was at war. There was the prosperity on the farm and in the small town as the wartime economy helped to lift the nation out from under the Great Depression. At the same time there were sacrifices, like using horses to plow to save gas and tending a backyard victory garden. Close-ups of the workers building the landing craft, views of the river valley from the cemetery hill, and images of a minister in his ornate church all pointed to the life and death issues that were affecting everyone in the country, even those in what might otherwise be a pastoral setting.

In a fitting coda to the final work of the photographers who visited West Virginia, Siegel showed a

young boy holding a camera, as if to pass the torch to a future generation (page 175). His scenes of everyday life also reflected the kinds of "American" standards that had become more prevalent not only in West Virginia but across the country.

Siegel's freelance photography was published in magazines, including *Life*, *Time*, *Fortune*, and *Sports Illustrated*. Siegel worked with the United States Air Corps during the war. He also worked with Stryker again after they both moved to the private sector. He returned to his alma mater in Chicago to serve as a teacher and administrator in the photography department, from 1946 to 1949, and again, from the mid-1960s until the end of his life. During the intervening years Siegel did freelance work, including experimenting with color photography. His pictures were included in exhibitions at The Art Institute of Chicago, the Museum of Modern Art, and other major museums. In addition to writing a number of articles, he edited and took photographs for the book, *Chicago's Famous Buildings*.[145]

Although Siegel was a creative and versatile photographer, he saw himself primarily as an educator. He offered this wisdom: "Photographs are made through work, thought, and technique, and the secrets are in the head and heart, not in the technical data."[146]

The Legacy of the West Virginia Photographs

The legacy of the West Virginia photographs has three primary components: 1) documenting the memories and stories of West Virginians about earlier times; 2)

demonstrating and contributing to the rich artistic culture of the state; and 3) inspiring current and future artists to look closely at their surroundings in creating fine art in all media.

Memories, Stories, and Perceptions

With relationship to the first component, many West Virginians grew up among images of poverty that did not represent what they heard from their parents and grandparents nor reflect what they saw around them. Deprivation and suffering have always affected some citizens and have often been hidden from those who lived under better circumstances even in the same county. As President Roosevelt recognized in his speeches, stranded industrial communities existed not only in West Virginia but in urban and rural areas throughout the country.

It is beyond the scope of this book to explore why, especially in the past fifty years, the state became a poster child for a culture of poverty. Unfortunately, the media have focused on poverty and exaggerated backwoods-type images as representative of West Virginia. These images have left terrible scars on a number of people who have grown up in the state. They also continue to bring harm though the perceptions that some outsiders have formed of the state and its citizens.

Yet, how many longtime residents of the state have warm and positive feelings about their upbringing? One of the phrases most commonly heard by the author when the state's elders talk about the Great Depression is: "We didn't know that we were poor, because everyone around us lived just like we did."

These elders also remember—through stories or family albums, or firsthand—how hardworking men and women dressed up to go to church or to the store, even if they were walking along unpaved rural roads. They remember growing or hunting for and preserving almost all of their own food, making what they needed, and creating their own entertainment. The photographs in this book offer professional fine art photographs in support of these memories, snapshots, and stories.

West Virginia and the Arts

Some West Virginians across generations may be unaware of the rich culture of their state because of the dominance of the negative stories and images that they have heard and seen over the past five decades. John Cuthbert has illustrated how visual artists were in step with national trends and developments dating back prior to the Civil War and statehood. He wrote about world-famous artists and photographers who came to the state for inspiration and material as well as about those who were native to the state and made their reputations beyond its borders.[147]

Within the visual arts, the state played an integral role in the development of photography. Arthur Rothstein's list of pioneers in documentary photography included Frances Benjamin Johnston (1864–1952), who was born in Grafton; and Mathew Brady (1822–1896) and Lewis Wickes Hine (1874–1940), who photographed in the state.[148] In 1925 Hine was recruited by Roy Stryker to provide the bulk of the photographs for *American Economic Life*. Although Stryker declined to hire Hine to work on the FSA

Project, he later wrote that Hine "did years ago what we are now trying to do."[149]

The West Virginian who had the closest relationship to the FSA Project was Pare Lorentz (1905–1992), who was born in Harrison County and grew up in Upshur County. After graduating from West Virginia University, Lorentz worked in New York as a film critic for a variety of magazines. While working for *Vanity Fair*, he noticed that the magazine's images contrasted with scenes that he viewed on his visits back home. He wrote in his memoir: "Practically all the pictures in my magazine were of people, and some of them were used in a comic manner. I never saw anything of the main streets of little towns with big signs, 'Store For Rent,' and no shots of rusting coal cars and idle tipples and smokeless smokestacks along the roads I drove on my way back to West Virginia to visit my people."[150] In an attempt to present a broader view, Lorentz combined photographs culled from a variety of sources with brief newsreel-type statements into a book, *The Roosevelt Year*, which told a strong graphic story of the first year of the Roosevelt administration.[151]

In 1935 Rexford Tugwell hired Lorentz to make films for the Resettlement Administration. Lorentz worked closely with Stryker and the FSA photographers on his film projects. Lorentz's first two films, *The Plow That Broke the Plains* and *The River*, brought the Depression's realities and New Deal programs to national audiences. When *The River* won a prize at the 1938 Venice Film Festival, President Roosevelt established the United States Film Service, with Lorentz as the director.[152]

West Virginia was and is integrated into the artistic life of the nation. References to the state as a cultural wasteland have always been unfounded. The creative life of the state is not limited to the wonderful indigenous culture of old-time music and folk art. With relationship to music, the West Virginia Music Hall of Fame celebrates the contributions of West Virginians in a wide variety of musical traditions, such as blues, classical, country, jazz, polka, and rock. A comparable range and diversity is characteristic of all of the arts represented in the state: architecture, dance, film, literature, theater, and the visual arts.

A Source of Inspiration

The early work in West Virginia by Walker Evans and Ben Shahn resulted in their photographs being shared with ever-wider audiences. In the beginning, when Stryker first appropriated their photographs for the FSA Project, the images of West Virginia were disproportionately represented in the FSA file. As more photographers were brought in and the size of the overall file grew, these early photographs became a smaller piece of the overall pie. Yet, many of the first photographs were used over and over, in a variety of venues that included the nation's great museums, and became recognizable as icons of the FSA Project.

In viewing the FSA photographs as a source of inspiration, it is important to recognize that some of them elicited strong feelings, pro and con, when they were first published and exhibited. At a 1938 exhibit in New York City, viewers' comments ranged from praise for the photographs and the New Deal administration, to criticisms of President Roosevelt, to

denial that the conditions in the photographs actually existed.[153]

Governor Homer Adams Holt of West Virginia had problems with some of the photographs that were selected for a state guidebook that he opposed. He said that a photograph by Shahn (page 108) "would suggest that children in West Virginia 'were herded to school like livestock going to market.'" He also objected to two photographs by Post Wolcott. With relation to one, of a Mexican miner and his young daughter (page 68), "he believed it misleading to show a picture of a Mexican miner, because there were few Mexicans in West Virginia, 'a state proud of its Anglo-Saxon heritage.'" With reference to the other (page 70), "A. . . . picture of a coal miner on his knees before a tin tub washing his hair 'filled the Governor with indignation,' for he believed it would suggest that West Virginians were without the benefits of modern plumbing." After a change in state administrations the book was published with two of these three photographs.[154]

The FSA photographs are now freely available through the Internet. The Library of Congress website refers to 164,000 black and white negatives and about 1,600 color photographs in its collection.[155] Many of these are scans of negatives that have never been printed.

The Prints and Photographs Division of the Library of Congress has undertaken a re-scanning of FSA photographs so that anyone may download and use high-resolution images at no cost. One of the goals of this book is to facilitate access to all of the photographs that were taken in West Virginia and to

promote and support local initiatives to publish and exhibit them.

Many individual photographs in this book, and other photographs that were taken in West Virginia as part of the FSA Project but that were not included here because of space limitations, have established a life of their own. This book does not provide a comprehensive indexing of the individual photographs and the publications and exhibits in which they have appeared. Some of this information has been referenced in the stories of the individual photographers.

Modern technology allows for photography that is less expensive and easier to access than ever before. The bottom line still remains the same: What is to be included in the photograph?

On a recent trip to follow the trail of Marion Post Wolcott in the southern coalfields, this author gained greater insight into the kinds of choices that she made. How do you show the hopeful spirit and energy of people who are doing the best they can in a less than perfect world? Do you show the fine old homes, which existed then as they do now? Do you show the new improvements, which may not be as interesting to photograph? What are the optimum light and composition for producing a work of fine art that transcends the time and place of its creation? How do you create a meaningful connection between what you see and experience and the future unknown viewers of the photograph?

The photographers represented in this book resolved these questions based on their understanding of their assignment and their respect for the people and culture they encountered. In the process they established a fine art mirror in which West Virginians can see themselves and show the world the great spirit of the state and its people. This is a solid and expansive legacy on which photographers and others in the arts may continue to build far into the future.

Notes

1. Roy Emerson Stryker and Nancy Wood. *In This Proud Land: America 1935-1943 as Seen in the FSA Photographs* (Greenwich, Connecticut: New York Graphic Society Ltd., 1973), 7.

2. Library of Congress, Prints and Photographs Division, http://www.loc.gov/pictures/collection/fsa and http://memory.loc.gov/ammem/fsahtml/fahome.html. All websites referenced in footnotes were accessed between June 2010 and March 2012.

3. Stryker and Wood, *In This Proud Land*, 9.

4. Jean Edward Smith, *FDR* (New York: Random House Trade Paperbacks, 2008), 24–42, 141, 250.

5. Arthur M. Schlesinger, Jr., *The Age of Roosevelt: The Crisis of the Old Order, 1919-1933* (Boston: Houghton Mifflin Company and Cambridge: The Riverside Press, 1957), 391–92.

6. Smith, *FDR*, 242, 251.

7. Lawrence McK. Miller, *Witness for Humanity: A Biography of Clarence E. Pickett* (Wallingford, Pennsylvania: Pendle Hill Publications, 1999), 129–30.

8. Clarence Pickett, *For More Than Bread* (Boston: Little, 1953), 26.

9. "Report of the Child Relief Work in the Bituminous Coal Fields, September 1, 1931, to August 31, 1932," American Friends Service Committee.

10. Ibid., 27.

11. Pickett, *For More Than Bread*, 26–27.

12. Ibid., 35.

13. Ibid., 36–40.

14. Miller, *Witness for Humanity*, 129.

15. Ibid., 130.

16. "General Information Concerning the Purposes and Policies of the Division of Subsistence Homesteads—Circular No. 1" (Washington: United States Department of the Interior, Division of Subsistence Homesteads, November 15, 1933), 2.

17. Miller, *Witness for Humanity*, 131.

18. Ibid., 132–33.

19. Ibid., 133–34.

20. Eleanor Roosevelt, *This I Remember* (New York: Harper and Brothers, 1949), 126.

21. Ibid., 127.

22. Paul K. Conkin, *Tomorrow a New World: The New Deal Community Program* (New York: Da Capo Press, 1976), 81, republished from first edition (Ithaca: Cornell University Press, 1959), and Jerry Bruce Thomas, *An Appalachian New Deal: West Virginia in the Great Depression* (Morgantown: West Virginia University Press, 2010), 168–69.

23. Joseph P. Lash, *Eleanor and Franklin: The Story of Their Relationship, Based on Eleanor Roosevelt's Private Papers* (New York: New American Library, 1973), 521–27.

24. Miller, *Witness for Humanity*, 134.

25. Lash, *Eleanor and Franklin*, 526 and 530–31.

26. Miller, *Witness for Humanity*, 136.

27. Lash, *Eleanor and Franklin*, 536–39.

28. Pickett, *For More Than Bread*, 48–49.

29. Ibid.

30. Blanche Wiesen Cook, *Eleanor Roosevelt: Volume Two—1933-1938* (New York: Viking, 1999), 153.

31. Ibid., 177–89.

32. Eleanor Roosevelt, "My Day," May 28, 1938, Eleanor Roosevelt Papers Project, George Washington University, http://www.gwu.edu/. Excerpts of the president's speech are quoted at the beginning of Chapter 1 of this book.

33. Interviews by the author with Sarah Boyd Little, a member of the choir. Little's sister, Willa Boyd Gibson, was photographed by Walker Evans in July 1935 (page 54).

34. Miller, *Witness for Humanity*, 135.

35. Eleanor Roosevelt, "Subsistence Farmsteads," *Forum 91* (April 1934), 199–201; also in nationally syndicated "My Day" columns, which began on December 31, 1935.

36. FDR Usher's Log, April 24, 1934, Pare Lorentz Film Center, Franklin D. Roosevelt Presidential Library and Museum, http://www.fdrlibrary.marist.edu/daybyday/daylog/april-24th-1934/. The website also links to a photograph of President Roosevelt at Griffith Stadium for a Boston Red Sox-Washington Senators game on the same day, at http://www.fdrlibrary.marist.edu/daybyday/resource/april-1934-5/.

37. Franklin Delano Roosevelt, "FDR's remarks following Home Subsistence Auditorium," April 24, 1934, Franklin D. Roosevelt Presidential Library and Museum, print copy provided to author.

38. Pickett, *For More Than Bread*, Chapter Three.

39. Clarence Pickett, Letter dated June 18, 1934, with attached notes, to Dr. M. L. Wilson, American Friends Service Committee archives, via email from Donald Davis, Archivist.

40. Miller, *Witness for Humanity*, 144.

41. Pickett, *For More Than Bread*, Chapter Four.

42. Ibid., 420.

43. Eleanor Roosevelt, "My Day," January 1, 1953.

44. Ibid., October 17, 1960.

45. Smith, *FDR*, 262.

46. Bernard Sternsher, *Rexford Tugwell and the New Deal* (New Brunswick, New Jersey: Rutgers University Press, 1964), Tugwell: A Chronology.

47. Ibid., Chronology.

48. Rexford G. Tugwell, *To the Lesser Heights of Morningside: A Memoir* (Philadelphia: University of Pennsylvania Press, 1982), 238, and Afterword, by Otis Graham, 251–52.

49. Ibid., p. 251.

50. "96.2, Central Office Records of the Farmers Home Administration and Its Predecessors," National Archives Guide to Federal Records, http://www.archives.gov/research/guide-fed-records/groups/096.html.

51. Bernard Sternsher, *Rexford Tugwell and the New Deal*, Chronology.

52. Conkin, *Tomorrow a New World*, 86.

53. Interview with Roy Stryker, Autumn 1952, includes Dorothea Lange, Arthur Rothstein, John Vachon et al., Dorothea Lange Archives, Oakes Gallery, Oakland Museum, Oakland, California, copy in Roy E. Stryker Papers, Special Collections, Ekstrom Library, University of Louisville, 6.

54. Ibid., 16

55. William Stott, *Documentary Expression and Thirties America* (Chicago, London: University of Chicago Press, 1986), 212fn.

56. He returned in the early 1940s to serve as governor of Puerto Rico.

57. Roy E. Stryker, Untitled reflection on life and work, January 3, 1941, in Roy E. Stryker Papers.

58. Stryker, Roy E., R. G. Tugwell, and Thomas Monro, *American Economic Life and the Means of Its Improvement* (New York: Harcourt, Brace and Company, 1925).

59. Stott, *Documentary Expression and Thirties America*, 212.

60. Interview with Roy Stryker, Autumn 1952, 23.

61. Ibid., 1–6.

62. Ibid., 12.

63. Ibid., 35–36.

64. Oral history interview with Walker Evans, October 13 and December 23, 1971, Archives of American Art, Smithsonian Institution, on website at http://www.aaa.si.edu/collections/interviews/oral-history-interview-evans-11721.

65. Interview with Roy Stryker, Autumn 1952, 52–53.

66. Roger G. Kennedy, text, *When Art Worked: An Illustrated Documentary by David Larkin* (New York: Rizzoli International Publications, Inc., 2009), 293.

67. Roy E. Stryker Papers, reviewed by the author in October 2007 and April 2011; Microfilm of FSA Project files, Library of Congress, Prints and Photographs, reviewed by the author in April 2010. The general concept of the "good bureaucrat" originally came from R. Pruger, "The Good Bureaucrat," *Social Work* 18 (4) (1973): 26–31.

68. Oral history interview with Carl Mydans, April 29, 1964, Archives of American Art, Smithsonian Institution, transcript, 2–3.

69. Interview with Roy Stryker, Autumn 1952 discussion, 45–46.

70. F. Jack Hurley, *Marion Post Wolcott—A Photographic Journey* (Albuquerque: University of New Mexico Press, 1989), 36–38.

71. John Collier, "Documentary Image," Willard D. Morgan, General Editor, *The Encyclopedia of Photography—Volume Seven* (New York, Toronto, London: Greystone Press, 1974), 1175.

72. Robert L. Reid, "Documenting Arthurdale: Looking at New Deal Photography," *A New Deal for America, Proceedings from a National Conference on New Deal Communities*, Bryan Ward, ed. (Arthurdale, West Virginia: Arthurdale Heritage Inc. 1995), 163 and 166–67.

73. Ibid., 163.

74. Ibid., 166.

75. Roy Stryker, Letter to Dorothea Lange, Roy E. Stryker Papers, date noted on letter as "March ?, 1936."

76. College Art Association Catalogue, undated, Roy E. Stryker Papers.

77. Jeff L. Rosenheim, "'The Cruel Radiance of What Is': Walker Evans and the South," *Walker Evans* (New York: The Metropolitan Museum of Art, in association with Princeton: Princeton University Press, 2000), 69–72.

78. Interview with Roy Stryker, Autumn 1952, 12.

79. Ibid., 12–14.

80. Gilles Mora and Beverly W. Brannan, *FSA: The American Vision* (New York: Abrams, 2006), 352.

81. Maria Morris Hambourg, "A Portrait of the Artist," *Walker Evans*, 5–7.

82. Bernarda Bryson Shahn, *Ben Shahn* (New York: Harry N. Abrams, Inc., Publishers, 1972), 345.

83. Hambourg, "A Portrait of the Artist," *Walker Evans*, 9–13.

84. Bernarda Bryson Shahn, *Ben Shahn*, 17.

85. Ibid.

86. Hambourg, "A Portrait of the Artist," 15–22.

87. Douglas Eklund, "Exile's Return: The Early Work, 1928–34," *Walker Evans*, 39.

88. Ibid., 38.

89. Agnes Sire and Jean-Francois Chevrier, *Henri Cartier-Bresson/Walker Evans, Photographing America 1929–1947* (London, New York: Thames & Hudson, 2009), 11–12.

90. Rosenheim, "'The Cruel Radiance of What Is': Walker Evans and the South," *Walker Evans*, 67–69.

91. Bernarda Bryson Shahn, *Ben Shahn*, 346.

92. Jerry L. Thompson, essay, *Walker Evans at Work* (New York: HarperCollins Publishers, 1994), 112.

93. Jeff L. Rosenheim and Douglas Eklund, *Unclassified: A Walker Evans Anthology* (Zurich, Berlin, New York: Scalo, in association with The Metropolitan Museum of Art, New York, 2000), 179.

94. Jeff L. Rosenheim, "'The Cruel Radiance of What Is': Walker Evans and the South," *Walker Evans*, 72–74.

95. Oral history interview with Roy Emerson Stryker, 1963–1965, Archives of American Art, Smithsonian Institution. On Web site at http://www.aaa.si.edu/collections/interviews/oral-history-roy-emerson-stryker-12480.

96. Bernarda Bryson Shahn, *Ben Shahn*, 134.

97. He apparently visited there in 1937, when he took one of the most endearing photographs of life in the Arthurdale community at Reedsville (p. 101).

98. He also returned to photograph there in July 1937.

99. Oral history interview with Roy Emerson Stryker, 1963–1965, Archives of American Art, Smithsonian Institution.

100. F. Jack Hurley, *Portrait of a Decade: Roy Stryker and the Development of Documentary Photography in the Thirties* (Baton Rouge: Louisiana State University Press, 1973), 50–54.

101. Mora and Brannan, *FSA*, 352. Shahn returned to do posters for the Office of War Information in 1942–43.

102. "Photograph for Painting," in Ben Shahn: *Passion for Justice*, produced, edited, and written by Susan Wallner, PBS, 2002.

103. Bernarda Bryson Shahn, *Ben Shahn*, 169.

104. Thompson, *Walker Evans at Work*, Chronology.

105. Bernarda Bryson Shahn, *Ben Shahn*, 350.

106. Peter Gaalassi, *Walker Evans & Company* (New York: The Museum of Modern Art, 2002).

107. Walker Evans, in Thompson, *Walker Evans at Work*, 229.

108. Ben Shahn, "How an Artist Looks at Aesthetics," *Journal of Aesthetics and Art Criticism*, September 1954, 46–51, in Bernarda Bryson Shahn, Ben Shahn, 329.

109. Oral history interview with Arthur Rothstein, May 25, 1964, *Archives of American Art*, Smithsonian Institution. On Web site at http://www.aaa.si.edu/collections/interviews/oral-history-interview-arthur-rothstein-13317.

110. Arthur Rothstein Archive, http://arthurrothsteinarchive.com.

111. Carl Mydans. *Carl Mydans, Photojournalist, with interview by Philip B. Kunhardt, Jr.* Summer 1984 (New York: Harry N. Abrams, Inc., 1985), and Mora, FSA, 350.

113. Ibid.

114. Carl Mydans, *More Than Meets the Eye* (New York: Harper & Brothers, 1959).

115. Edwin Locke, "Personal History," Memorandum to Mr. George Barnes, Stryker Papers, undated.

116. Roy Stryker, letter to Edwin Locke, Stryker Papers, January 3, 1938.

117. Roy Stryker, letter to Houghton Mifflin Company, Stryker Papers, March 31, 1938.

118. F. Jack Hurley, *Marion Post Wolcott: A Photographic Journey* (Albuquerque: University of New Mexico Press, 1989), 118, and Linda Wolcott Moore, "The Photography of Marion Post Wolcott," http://people.virginia.edu/~ds8s/mpw/mpw-top.html.

119. Moore, "The Photography of Marion Post Wolcott."

120. Ibid.

121. Hurley, *Marion Post Wolcott*, 20–21.

122. Paul Strand, Letter to Roy Stryker, June 20, 1938, Stryker Papers.

123. Roy Stryker, letter to Marion Post Wolcott, July 14, 1938, Stryker Papers.

124. Hurley, *Marion Post Wolcott*, 33.

125. Nicholas Natanson, *The Black Image in the New Deal: The Politics of FSA Photography* (Knoxville: University of Tennessee Press, 1992), 84.

126. Marion Post Wolcott, Telegram to Roy Stryker, Stryker Papers, September 27, 1938.

127. Linda Wolcott Moore, e-mail to the author, February 15, 2010.

128. Hurley, *Marion Post Wolcott*, 43–44.

129. Linda Wolcott Moore also pointed this out on her Web site.

130. Hurley, *Marion Post Wolcott*, 121–47.

131. Mora and Brannan, *FSA*, 351.

132. Mora and Brannan, *FSA*, 353.

133. Ibid.

134. Miles Orvell, ed., with Introductory Texts, *John Vachon's America: Photographs and Letters from the Depression to World War II* (Berkeley, Los Angeles, London: University of California Press, 2003), 305–6.

135. Ibid., 305–6.

136. Ibid., 305–6.

137. Mora and Brannan, *FSA*, 353.

138. "The Photographs of John Collier Jr.," The American Image, http://americanimage.unm.edu/biography.html.

139. John Collier, "VITA," Roy E. Stryker Papers.

140. Oral history interview with John Collier, January 18, 1965, *Archives of American Art*, Smithsonian Institution. On Web site at http://www.aaa.si.edu/collections/interviews/oral-history-interview-john-collier-12715.

141. George and Louise Spindler, Foreword, in John Collier, Jr., *Visual Anthropology: Photography as a Research Method* (New York et al.: Holt, Rinehart and Winston, 1967), x.

142. Mora and Brannan, *FSA*, 348.

143. John Collier, Oral history interview, January 18, 1965.

144. Ibid.

145. Arthur Sidney Siegel, 1913–1978, unpublished notes for resume provided by The Art Institute of Chicago, March 2012.

146. Larry A. Viskochil, "Arthur Siegel: A Life in Photography, 1913-1978," *Chicago History: The Magazine of the Chicago Historical Society*, Summer 1981, Volume X, Number 2, 66-73.

147. John A. Cuthbert, *Early Art and Artists in West Virginia: An Introduction and Biographical Directory* (Morgantown: West Virginia University Press, 2000). Thumbnail descriptions of Evans and Shahn were included in the biographical directory.

148. Arthur Rothstein, *Documentary Photography* (Boston, London: Focal Press, 1986).

149. Letter from Roy E. Stryker to Harry J. Carman, December 22, 1938, Roy E. Stryker Papers.

150. *Pare Lorentz, FDR's Moviemaker, Memoirs and Scripts* (Reno, Las Vegas, London: University of Nevada Press, 1992), 28.

151. Pare Lorentz, *The Roosevelt Year* (New York, London: Funk & Wagnalls, 1934).

152. Robert L. Snyder, *Pare Lorentz and the Documentary Film* (Norman: University of Oklahoma Press, 1968), 83.

153. Undated list of comments in Stryker Papers.

154. Jerry B. Thomas, "'The Nearly Perfect State': Governor Homer Adams Holt, the WPA Writer's Project and the Making of West Virginia: A Guide to the Mountain State," *West Virginia History,* 52 (1993), 91–108. Also online at www.wvculture.org.

155. Stryker occasionally sent color film to the photographers, and their use of it depended in part on where they were when it became available to them.

Acknowledgments

THIS BOOK HAS BENEFITED from the contributions of a great many people over a number of years.

I first learned about the photographs from Ronald L. Lewis, professor emeritus of history at West Virginia University. John Cuthbert, Curator of the West Virginia and Regional History Collection, WVU Libraries, and Fred Barkey, professor emeritus of history at the Marshall University Graduate College, served as consultants on initial research and mini-exhibits related to the southern coalfields photographs.

Ken Sullivan, executive director of the West Virginia Humanities Council, and current and former staff, Becky Caldwell, Michael Keller, Pam LeRose, Amy Saunders, and Debby Sonis, as well as members of their Board of Directors, have provided invaluable support and consultation.

I am most indebted to the Library of Congress for continuing to carry out its mission to preserve the photographs and make them easily accessible.

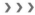

Beverly W. Brannan, curator of photography, and Barbara Orbach Natanson, head of reference services, both in the Prints and Photographs Division, and Carl Fleischhauer, a digital preservation specialist, have all been incredibly helpful.

Administrators and staff at other archives who have gone out of their way to assist me include Delinda Stephens Buie and her staff at Special Collections, Ekstrom Library, University of Louisville; Donald Davis at the American Friends Service Committee Archives in Philadelphia; and staff at the Archives of American Art at the Smithsonian Institution; the Franklin D. Roosevelt Presidential Library Archives; the Harvard Art Museums; the Metropolitan Museum of Art Image Library and Walker Evans Archive; and The Art Institute of Chicago.

During my two visits to Louisville the Ursuline Sisters and their staff were welcoming and supportive. The sisters who were from West Virginia or had served in the state told moving stories about their experiences.

I am very grateful to the Kanawha Public Library, with special thanks to Melissa Adkins, who handled interlibrary loans; the West Virginia State Library at The Culture Center; and all of the libraries that responded to requests for materials. Current and former staff of the West Virginia Division of Culture and History, including Greg Carroll, Joe Geiger, and Adam Hodges, have also helped with various aspects of this project.

Mark Crabtree, a Morgantown photographer, has been very generous in sharing his research on Walker Evans's work in West Virginia and in introducing me to local residents who remember the times.

Christy Bailey, Pat Church, and other staff of the Coal Heritage Highway Authority in Oak Hill have been exceptional partners in facilitating grant support and touring mini-exhibits. Cleeta Mullins, of the former Coalfields Convention and Visitors Bureau, also served in this role.

The editors of *Goldenseal* and *Wonderful West Virginia* magazines, and the past editor of *W.Va. South*, as well as newspapers in Beckley, Charleston, Morgantown, Welch, and other communities, have taken our work with the New Deal photographs to a wider audience.

I have gained many insights from hearing the stories of people from throughout West Virginia. I look forward to learning more following the publication of this book.

Jenine Culligan, senior curator at the Huntington Museum of Art, was instrumental in the initial

selection of the photographs in this book. I appreciate very much the written contributions from Carl Fleischhauer and Jerry Thomas, who also critiqued my work. Others who provided comments and, in some cases, detailed editing, included Colleen Anderson, Beverly Brannan, Robert Bridges (on the initial proposal), Becky Caldwell, Mark Crabtree, Joyce Ice, Carrie Mullen, Brian O'Donnell, Kristina Olson, Rick Rivard, Emily Roles, Greg Sava, Debby Sonis, and Deborah Zinn.

Carrie Mullen, director of the West Virginia University Press, has been an amazing and professional cheerleader, resource, and facilitator. She and her staff, including Floann Downey, Abby Freeland, Rachel King, and Than Saffel, have made this book possible.

Jesse and Ry Rivard are constantly inspiring with their creativity, work ethic, and love for the state. They continue to teach me more than I ever knew there was to learn.

—Betty Rivard

Bibliography

Anderson, Maggie. *Windfall: New and Selected Poems*. Pittsburgh: University of Pittsburgh Press, 2000.

Brannan, Beverly W. and David Horvath, ed. *A Kentucky Album*. Lexington: University Press of Kentucky, 1986.

Bridges, Robert, Kristina Olson, and Janet Snyder, eds. *Blanche Lazzell: The Life and Work of an American Modernist*. Morgantown: West Virginia University Press, 2004.

Carr, Carolyn Kinder. *Ohio, a Photographic Portrait, 1935–1941: Farm Security Administration Photographs*. Akron: Akron Art Institute. Distributed by Kent State University Press, 1980.

Carter, John Franklin. *The Rectory Family*. New York: Coward-McCann, 1937.

Cohen, Stu, ed. with a foreword by Peter Bacon Hales. *The Likes of Us: America in the Eyes of the Farm Security Administration*. Boston: David R. Godine, 2009.

Collier, Jr., John, with a foreword by George and Louise Spindler. *Visual Anthropology: Photography as a Research Method*. New York: Holt, Rinehart and Winston, 1967.

Conkin, Paul K. *Tomorrow a New World: The New Deal Community Program*. New York: Da Capo Press, 1976.

Cook, Blanche Wiesen. *Eleanor Roosevelt*. Vol. One. New York: Viking, Penguin Group, 1992.

——. *Eleanor Roosevelt*. Vol. Two. New York et al.: Penguin Group, 1999.

Crump, James. *Walker Evans Decade by Decade*. Ostifilden, Germany: Hatje Cantz Verlag, 2010.

Cuthbert, John A. *Early Art and Artists in West Virginia: An Introduction and Biographical Directory*. Morgantown: West Virginia University Press, 2000.

Dixon, Penelope. *Photographers of the Farm Security Administration: An Annotated Bibliography 1930–1980*. New York & London: Garland Publishing, Inc., 1983.

Evans, Walker. *American Photographs*. New York: Museum of Modern Art, 1938.

——, *Walker Evans*. New York: Aperture Foundation, 1993.

Fleischhauer, Carl and Beverly W. Brannan, eds. *Documenting America, 1935–1943*. Berkeley: University of California Press, 1988.

Fones-Wolf, Ken and Ronald L. Lewis, ed. *Transnational West Virginia: Ethnic Communities and Economic Change, 1840–1940*. Morgantown: West Virginia University Press, 2002.

Gelassi, Peter. *Walker Evans & Company*. New York: The Museum of Modern Art. Distributed by Harry N. Abrams, Inc., 2000.

Hambourg, Maria Morris, et al. *Walker Evans*. New York: The Metropolitan Museum of Art in association with Princeton University Press, Princeton, 2000.

Hurley, F. Jack. *Marion Post Wolcott—A Photographic Journey*. Albuquerque: University of New Mexico Press, 1989.

———. *Portrait of a Decade: Roy Stryker and the Development of Documentary Photography in the Thirties.* Baton Rouge: Louisiana State University Press, 1972.

Kao, Deborah Martin, Laura Katzman, and Jenna Webster. *Ben Shahn's New York: The Photography of Modern Times.* Cambridge: Fogg Art Museum, Harvard University Art Museums, and New Haven and London: Yale University Press, 2000.

Kennedy, Roger G. text. *When Art Worked: An Illustrated Documentary by David Larkin.* New York: Rizzoli International Publications, Inc., 2009.

Lash, Joseph P. *Eleanor and Franklin: The Story of Their Relationship, Based on Eleanor Roosevelt's Private Papers.* New York: New American Library, 1973.

Lewis, Ronald L. *Transforming the Appalachian Countryside: Railroads, Deforestation, and Social Change in West Virginia, 1880–1920.* Chapel Hill, London: University of North Carolina Press, 1998.

Little, Richard S. and Margaret Little. *Arthurdale: Its History, Its Lessons for Today.* Morgantown: West Virginia University Foundation, 1976.

Lorentz, Pare. *FDR's Moviemaker, Memoirs and Scripts.* Reno, Las Vegas, London: University of Nevada Press, 1992.

———. *The Roosevelt Year.* New York, London: Funk & Wagnalls, 1934.

McLeish, Archibald. *Land of the Free.* New York: Harcourt, Brace and Company, 1938.

Mellow, James R. *Walker Evans.* New York: Basic Books, 1999.

Melville, Annette. *Farm Security Administration, Historical Section: A Guide to Textual Records in the Library of Congress.* Washington: Prints and Photographs Division, Library of Congress, 1985.

Miller, Lawrence McK. *Witness for Humanity: A Biography of Clarence E. Pickett, Wallingford.* Pennsylvania: Pendle Hill Publications, 1999.

Mora, Gilles and Beverly W. Brannan. *FSA: The American Vision.* New York: Abrams, 2006.

Morse, John D., ed. *Ben Shahn.* New York: Praeger Publishers, 1972.

Mydans, Carl. *Carl Mydans, Photojournalist, with an interview by Philip B. Kunhardt, Jr.* New York: Abrams, 1985.

——— . *More Than Meets the Eye.* New York: Harper & Brothers, 1959.

Natanson, Nicholas. *The Black Image in the New Deal: The Politics of FSA Photography.* Knoxville: University of Tennessee Press, 1992.

O'Neal, Hank. *A Vision Shared: A Classic Portrait of America and Its People, 1935–1943.* New York: St. Martin's Press, 1976.

Orvell, Miles, ed. with Introductory Texts. *John Vachon's America: Photographs and Letters from the Depression to World War II.* Berkeley, Los Angeles, London: University of California Press, 2003.

Pickett, Clarence. *For More Than Bread.* Boston: Little, 1953.

Pohl, Frances K. *Ben Shahn*. Petaluma, California: Pomegranate Communications, 1993.

Pratt, David, ed. *The Photographic Eye of Ben Shahn*. Cambridge: Harvard University Press, 1975.

Remsburg, Rich. *Hard Luck Blues: Roots Music Photographs from the Great Depression*. Urbana: University of Illinois Press, in association with the Library of Congress, 2010.

Roosevelt, Eleanor. *This I Remember*. New York: Harper and Brothers, 1949.

Rosenheim, Jeff L. and Alexis Schwarzenbach, eds. *Unclassified: A Walker Evans Anthology*. Zurich, Berlin, New York: Scalo, in association with The Metropolitan Museum of Art, New York, 2000.

Rothstein, Arthur. *Documentary Photography*. Boston: Focal Press, 1986.

——. *Photojournalism, Garden City*. New York: Amphoto, 1979.

——. *The Depression Years as Photographed by Arthur Rothstein*. New York: Dover Publications, Inc., 1978.

Rylant, Cynthia, with photographs by Walker Evans. *Something Permanent*. San Diego et al.: Harcourt Brace & Company, 1994.

Schlesinger, Jr., Arthur M. *The Age of Roosevelt: The Crisis of the Old Order, 1919–1933*. Boston: Houghton Mifflin Company, and Cambridge: The Riverside Press, 1957.

——. *The Age of Roosevelt: The Coming of the New Deal, 1933–1935*. Boston, New York: Houghton Mifflin Company, A Mariner Book, 2003. Reprinted from 1958.

——. *The Age of Roosevelt: The Politics of Upheaval, 1935–1936*. Boston, New York: Houghton Mifflin Company, A Mariner Book, 2003. Reprinted from 1960.

Shahn, Bernarda Bryson. *Ben Shahn*. New York: Harry N. Abrams, 1972.

Shahn, Ben. *The Photographs of Ben Shahn*. Introduction by Timothy Egan, Washington, D.C.: Library of Congress in association with Giles, 2008.

Shahn, Ben. *The Shape of Content*. Cambridge: Harvard University Press, 1957. Reprint, New York: Vintage Books, 1969.

Sire, Agnes and Jean-Francois Chevrier. *Henri Cartier-Bresson/Walker Evans, Photographing America 1929–1947*. London, New York: Thames & Hudson, 2009.

Smith, Jean Edward. *FDR*. New York: Random House Trade paperbacks, 2008.

Snyder, Robert L. *Pare Lorentz and the Documentary Film*. Norman: University of Oklahoma Press, 1968.

Steichen, Edward. *The Bitter Years, 1935–1941*. New York: Museum of Modern Art, 1962.

Sternsher, Bernard. *Rexford Tugwell and the New Deal*. New Brunswick, New Jersey: Rutgers University Press, 1964.

Stott, William. *Documentary Expression and Thirties America*. Chicago, London: University of Chicago Press, 1986.

Stryker, Roy E., R. G. Tugwell, and Thomas Monro. *American Economic Life and the Means of Its Improvement*. New York: Harcourt, Brace and Company, 1925.

Stryker, Roy E. and Nancy Wood. *In This Proud Land: America 1935–1943 as Seen in the FSA Photographs*. Greenwich, Connecticut: New York Graphic Society, 1973.

Sullivan, Ken, ed. *The West Virginia Encyclopedia*. Charleston, West Virginia: West Virginia Humanities Council, 2006.

Szarkowski, John, Introduction. *Walker Evans*. New York: Museum of Modern Art, 1971.

Thomas, Jerry Bruce. *An Appalachian New Deal—West Virginia in the Great Depression*. Morgantown: West Virginia University Press, 1998, 2001.

Thompson, Jerry L. Essay. *Walker Evans at Work*. New York: HarperCollins Publishers, 1994.

Trotter, Joe William Jr. *Coal, Class, and Color: Blacks in Southern West Virginia, 1915-32*. Urbana: University of Illinois Press, 1990.

Tugwell, Rexford G. and Afterword by Otis Graham. *To the Lesser Heights of Morningside: A Memoir*. Philadelphia: University of Pennsylvania Press, 1982.

Viskochil, Larry A. "Arthur Siegel: A Life in Photography, 1913–1978." *Chicago History: The Magazine of the Chicago Historical Society* X, no. 2 (Summer 1981): 66–73.

Wolcott, Marion Post. *Marion Post Wolcott: FSA Photographs*. Introduction by Sally Stein. Carmel, California: Friends of Photograph, 1983.

——— . *The Photographs of Marion Post Wolcott*. Introduction by Francine Prose. Washington, D.C.: Library of Congress in association with Giles, 2008.

Articles and exhibit notes

Behner, Mary. Journals, edited by Christine M. Kreiser. *West Virginia History* 53 (1994), 61–94. http://www.wvculture.org/history/journal_wvh/wvh53-5.html.

College Art Association Catalogue, undated, Roy E. Stryker Papers, Ekstrom Library, University of Louisville.

Collier, John. "Documentary Image," Willard D. Morgan, General Editor, *The Encyclopedia of Photography—Volume Seven*. New York, Toronto, London: Greystone Press, 1974.

"Documentary Photographs from the Files of the Resettlement Administration," Foreword by R.G. Tugwell, Exhibit notes, College Art Association, on national tour, 1936–37, Roy E. Stryker Papers, Special Collections, Ekstrom Library, University of Louisville.

"First Annual Report," Resettlement Administration, Washington, D.C., 1936.

"General Information Concerning the Purposes and Policies of the Division of Subsistence Homesteads," Circular No. 1, United States Department of the Interior, Division of Subsistence Homesteads, Washington, November 5, 1933.

Goldenseal Magazine. Charleston: West Virginia Division of Culture and History. Numerous articles used as background information.

"My Body Will Blacken," including "Coal Industry, and the Miner in American Art," Robert Bridges, and "Heroism, Hardship and the Lure of the Mines in American Art," Amy

Bowman, 2008, notes for exhibit at Clay Center for the Arts and Sciences, Charleston, West Virginia, 2010.

"Pictures from the FSA." *U.S. Camera Annual*, 1938, New York, 43–75.

Pruger, R. "The Good Bureaucrat," *Social Work* 18, no. 4 (1973): 26–31.

Reid, Robert L., "Documenting Arthurdale: Looking at New Deal Photography," *A New Deal for America: Proceedings from a National Conference on New Deal Communities*. Edited by Bryan Ward. Arthurdale: Arthurdale Heritage, Inc., 1995, 155–79.

"Report of the Child Relief Work in the Bituminous Coal Fields, September 1, 1931 to August 31, 1932," American Friends Service Committee.

Roosevelt, Eleanor, "Subsistence Farmsteads," *Forum 91* (April 1934): 199–201.

Roosevelt, Franklin Delano, "FDR's remarks following Home Subsistence Auditorium," April 24, 1934, Franklin D. Roosevelt Presidential Library and Museum, print copy provided to author.

Roosevelt, Franklin Delano. Address at Arthurdale, West Virginia, May 27, 1938, John T. Woolley and Gerhard Peters, The American Presidency Project [online]. Santa Barbara, California. On website at http://www.presidency.ucsb.edu/ws//?pid=15647.

"Seven Stranded Coal Towns," Division of Research, Work Projects Administration, Research Monographs, SSIII.

Steichen, Edward. "The FSA Photographers," *U.S. Camera Annual*, 1939, New York.

Stryker, Roy E. "Documentary Photography." *The Complete Photographer* 21 (April 10, 1942): 1364–74. Revised version in *The Encyclopedia of Photography Volume Seven*, edited by Willard D. Morgan. New York: Greystone Press, 1974.

Stryker, Roy, "Suggestions for Community Photographs," undated, Roy E. Stryker Papers, Special Collections, Ekstrom Library, University of Louisville.

Stryker, Roy. Untitled reflection on life and work, January 3, 1941, Roy E. Stryker Papers, Special Collections, Ekstrom Library, University of Louisville.

Stryker, Roy E. and Paul H. Johnstone. "Documentary Photographs," *The Cultural Approach to History*. Ed. by Caroline F. Ware. New York: Columbia University Press, 1940.

"The Farm Security Photographer Covers the American SMALL TOWN," unsigned and undated, in Roy E. Stryker Papers, Special Collections, Ekstrom Library, University of Louisville.

Thomas, Jerry B. "'The Nearly Perfect State': Governor Homer Adams Holt, the WPA Writers' Project, and the Making of *West Virginia: A Guide to the Mountain State*," *West Virginia History*, Volume 52 (1993), 91-108. Also online at http://www.wvculture.org.

Wolcott, Marion Post. Keynote address, Women in Photography conference, Syracuse, New York, October 10–12, 1986.

Original and microfilm documents

American Friends Service Committee Archives, Philadelphia, letters and reports, via email.

Collier, John, Transcript of a tape made for Roy Stryker, March, 1969, Roy E. Stryker Papers, Special Collections, Ekstrom Library, University of Louisville.

Franklin Delano Roosevelt and Eleanor Roosevelt Papers, Franklin D. Roosevelt Presidential Library Archives, Hyde Park, letters, reports, and speeches.

Interview with Roy Stryker, Autumn 1952, includes Dorothea Lange, Arthur Rothstein, John Vachon et al. Dorothea Lange Archives, Oakes Gallery, Oakland Museum, Oakland, California, copy in Roy E. Stryker Papers, Special Collections, Ekstrom Library, University of Louisville.

Microfilms, Library of Congress Prints and Photographs Reading Room, Washington, D.C., FSA Project files.

Oral History Interviews, Archives of American Art, Smithsonian Institution, Washington, D.C., John Collier, January 18, 1965; C.B. Baldwin, February 24, 1965; Walker Evans, October 13–December 23, 1971; Carl Mydans, April 29, 1964; Arthur Rothstein, May 25, 1964; Ben Shahn, April 14, 1964, January 17, 1965, and October 3, 1965; Roy Stryker, 1963–1965; Rexford and Grace Tugwell, January 21, 1965; John Vachon, April 28, 1965; Marion Post Wolcott, January 18, 1965; aaa.si.edu/collections/oralhistories/transcripts or via printed transcripts.

Roy E. Stryker Papers, Special Collections, Ekstrom Library, University of Louisville, letters, transcripts, photographs, and miscellaneous materials.

Unpublished documents about Arthur Siegel, provided by The Art Institute of Chicago via email to the author, March 2012.

Online resources

Note: All Web sites accessed between June 2010 and March 2012.

"Arthur Siegel," Museum of Contemporary Photography, Chicago, http://www.mocp.org/collections/permanent/siegel_arthur.php.

Arthur Siegel Papers, The Art Institute of Chicago, Ryerson & Burnham Archives Finding Aids, http://digital-libraries.saic.edu/cdm4/document.php?CISOROOT=/findingaids&CISOPTR=11798&REC=12.

"Carl Mydans: Photographs, 1935–1948," http://library.duke.edu/exhibits/carlmydans/.

Collection: Digital Archive: Farm Security, Indiana University, Bloomington, Libraries, http://www.libraries.iub.edu/index.php?pageId=1001916.

Department of Photography, "Walker Evans (1903–1975)", *Heilbrunn Timeline of Art History*, New York: The Metropolitan Museum of Art, 2000, http://www.metmuseum.org/toah/hd/evan/hd_evan.htm (October 2004), Walker Evans Collection, http://www.metmuseum.org/collections/search-the-collections?ft=walker=evans, and Walker Evans Archive, http://www.metmuseum.org/search-results?ft=walker+evans+archive&x=5&y+7.

Exhibit of photographs of Logan and McDowell Counties by Russell Lee and Earl Dotter, http://www3.cet.edu/appalachianinstitute/ and http://www.wju.edu/ai/exhibits/downtowns/.

FDR Usher's Log, April 24, 1934, Pare Lorentz Film Center, Franklin D. Roosevelt Presidential Library and Museum, http://www.fdrlibrary.marist.edu/daybyday/daylog/april-24th-1934/ with link to photograph at http://www.fdrlibrary.marist.edu/daybyday/resources/april-1934-5/.

Francis, Henry W., Report, Williamson, West Virginia, December 7, 1934, Franklin D. Roosevelt Library, Hopkins Papers, Box 66, http://newdeal.feri.org/hopkins/hop04.htm. See also Reports from Clarksburg, West Virginia, November 25, 1934, http://newdeal.feri.org/hopkins/hop09.htm and December 1, 1934, http://newdeal.feri.org/hopkins/hop12.htm.

"Hard Times—Arkansas Depression Era Photos: Photographs of Arkansas and Arkansans from 1935 to 1940 by the Photographers of the Farm Security Administration," 2010, http://www.oldstatehouse.com/exhibits/virtual/hard_times/edwin_locke/default.asp.

Harvard Art Museums, Ben Shahn Collection, enter "Ben Shahn" under search, http://www.harvardartmuseums.org/collection/.

"Introduction to Frances Benjamin Johnston, 1864–1952," *Clio Visualizing History*, http://www.cliohistory.org/exhibits/johnston/introduction.

Moore, Linda Wolcott, "The Photography of Marion Post Wolcott," http://people.virginia.edu/*ds8s/mpw/mpw-top.html.

National Archives, photographs of Lewis Wickes Hine, http://www.archives.gov/research/arc/topics/labor/.

National Archives Guide to Federal Records, Records of the Farmers Home Administration, Record Group 96.2, Central Office Records of the Farmers Home Administration and Its Predecessors, 1918–59 (bulk 1935–59), 1972–75, http://www.archives.gov/research/guide-fed-records/groups/096.html#96.2.

Photographs, unless otherwise identified, are from the Library of Congress, Prints and Photographs Division, http://www.loc.gov/pictures/collection/fsa and http://memory.loc.gov/ammem/fsahtml/fahome.html.

"Photograph for Painting," in *Ben Shahn: Passion for Justice*, produced, edited, and written by Susan Wallner, PBS, 2002.

Roosevelt, Eleanor, "My Day," Eleanor Roosevelt Papers Project, George Washington University, http://www.gwu.edu/, May 16, 1938; May 28, 1938; May 30, 1939; January 1, 1953; October 17, 1960; other dates.

Roosevelt, Franklin D., Address at Arthurdale, West Virginia, 5/27/38, John T. Woolley and Gerhard Peters, The American Presidency Project [online], Santa Barbara, California, http://www.presidency.ucsb.edu/ws//?pid=15647.

Shorpy Historic Photo Archive, http://www.shorpy.com.

Sullivan, Ken, The West Virginia Encyclopedia, Charleston, West Virginia Humanities Council, http://www.wvencyclopedia.org.

Sutters, Jack, "The Eleanor Roosevelt Connection," American Friends Service Committee, http://afsc.org/story/eleanor-roosevelt-connection. Also, "From Coal to Furniture," http://afsc.org/story/coal-furniture.

"The Photographs of John Collier Jr.," The American Image, http://americanimage.unm.edu/biography.html.

West Virginia Division of Culture and History Online Exhibit, "The Omar Project," http://www.wvculture.org/museum/omar.html.

West Virginia Division of Culture and History Archives, photographs, http://www.wvculture.org/history/wvmemory/photointro.htm/.

"West Virginia History on View: Photographs from the West Virginia and Regional History Collection." West Virginia University Libraries, http://images.lib.wvu.edu/cgi/i/image/image-idx?page=index;c=wvcp.

ABOUT THE AUTHORS

Betty Rivard is an award-winning fine art landscape photographer (http://www.bettyrivard.com). She has researched and coordinated three exhibits of FSA photographs of West Virginia and contributed articles about the FSA Project to *Wonderful West Virginia*, *Goldenseal*, and *West Virginia South* magazines. She is a Social Worker Emeritus with graduate degrees in education and social work from West Virginia University and a BA in political science from the University of California at Berkeley. She traveled to every county in West Virginia during her 25-year career as a social worker and planner with the state.

Carl Fleischhauer is a digital preservation specialist at the Library of Congress. He is the coauthor of *Documenting America, 1935–1943*, a book about the Farm Security Administration/Office of War Information photographs. In the 1970s, he worked for the public television station based at West Virginia University and contributed to a Library of Congress documentary project about the Hammons family of Marlinton, West Virginia.

Jerry Bruce Thomas, Professor Emeritus, Shepherd University, is the author of *An Appalachian New Deal: West Virginia in the Great Depression* and *An Appalachian Reawakening: West Virginia and the Perils of the New Machine Age*, both published by West Virginia University Press.